MW00610424

Iowa Stereographs

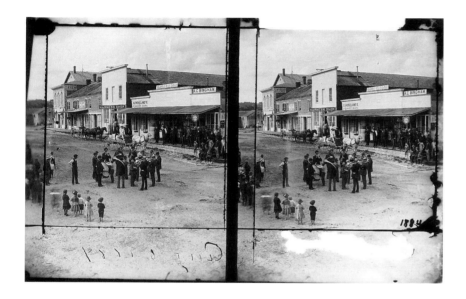

A Bur Oak Original

Views of Bellevue, Iowa, and Vicinity.

WALDRON & WILSON, PHOTOGRAPHERS, MARION, - - IOWA.

LOOKING NORTH FROM NORTH BLUFF.

Mary Bennett & Paul C. Juhl

Iowa Stereographs

Three-Dimensional Visions of the Past

UNIVERSITY OF IOWA PRESS Ψ Iowa City

University of Iowa Press,
Iowa City 52242
Copyright © 1997 by
the University of Iowa Press
All rights reserved
Printed in the United States
of America

Design by Richard Hendel

http://www.uiowa.edu/~uipress

No part of this book may be
reproduced or used in any form
or by any means, electronic or
mechanical, including photocopying
and recording, without permission
in writing from the publisher.
All reasonable steps have been
taken to contact copyright holders
of material used in this book. The
publisher would be pleased to make
suitable arrangements with any
whom it has not been possible to
reach.

The publication of this book
was supported by the generous
assistance of the University of
Iowa Foundation.

Printed on acid-free paper

Library of Congress
Cataloging-in-Publication Data

Bennett, Mary (Mary J.)
Iowa stereographs: three-
dimensional visions of the past / by
Mary Bennett and Paul C. Juhl.
p. cm.—(Bur oak original)
Includes bibliographical references
(p.) and index.
ISBN 0-87745-606-2 (cloth)
1. Iowa—History—Pictorial
works. 2. Stereoscopic views—
Iowa. I. Juhl, Paul C., 1944–
II. Title. III. Series.
F622.B465 1997
977.7—dc21 97-24362

02 01 00 99 98 97 C
5 4 3 2 1

Page i

*A band playing on an Elkader street,
August 1884. Taken by D. C. Hale,
Elkader. This contact print from an
original glass plate negative shows the
full framing of the image along with
the photographer's lines for cutting
and mounting the dual photographs
on a stereo card. 5 x 8 1/4. D. C. Hale
Collection, State Historical Society of
Iowa, Iowa City.*

Page ii

*"Looking up the Mississippi,"
Bellevue (Jackson County), 1880s.
Taken by Waldron & Wilson, Marion.
Publisher: Waldron & Wilson, Views
of Bellevue, Iowa, and Vicinity.
Cabinet mount; beige.*

TO THE GIRLS

and the ANDERSEN, BREITENKAMP, VEGORS, BLUE, *and* JUHL *families*

History has its background and its foreground,

and it is principally in the management of its

perspective that one artist differs from another.

MACAULEY

CONTENTS

ACKNOWLEDGMENTS

My love affair with historical photography goes back years, but until I scanned the Juhl collection, I had never seriously experienced the virtual reality presented by nineteenth-century stereographs.

Talented collaborators like Paul C. Juhl, JoAnn Burgess, and Jamie Beranek provided expert assistance and hours of diligent research for this project. JoAnn's careful assemblage of information on Iowa's professional photographers permits researchers to pinpoint accurately the existence and duration of studios throughout the state.

JoAnn and Paul have located photographic evidence of these studios in all their variety — whether permanent structures, attachments to houses, or converted railroad cars and wagons. These hard-to-find images show skylights, advertising panels, and kiosks exhibiting the photographer's work — and occasionally the photographer.

Jamie Beranek has dedicated countless hours to the refinement of the State Historical Society of Iowa's photograph collection. His background research on the Juhl collection has enhanced our knowledge and therefore the value of the images. He verified locations, specific buildings, and dates, all in an attempt to place each stereograph in the proper historical context for interpretation. He has mastered the classification and care of thousands of images and negatives, and his work with the Juhl collection has been particularly thorough.

Matthew Carpenter patiently assisted with researching the lives of the photographers, using census records, county histories, and other library resources to help identify patterns of behavior

among these professionals. Vicki Schipul worked on perfecting our computer database, which allowed us to categorize the images and gauge the total output of individual photographers.

I am forever indebted to Steven Blaski, who faithfully edited the manuscript, offering choice words and elegant touches. My gratitude also extends to Lowell Soike and Becki Peterson, who provided assistance and encouragement at a critical stage. Thanks also to Jan Olive Nash, Joyce Giaquinta, and Shar Grant for continuing to inspire me to persevere.

Robert Burchfield provided the kind of support that goes beyond words. His eagle eye and attention to detail seem minor compared to the valuable insights he offered to the overall project. Together, we share a passion for history, which colors the way I look at the world and shapes my ideas about these images.

Paul is really the person responsible for this book, and for that I thank him.

<div align="right">MARY BENNETT</div>

Numerous individuals provided information or assistance, including members of the National Stereoscopic Association, based in Columbus, Ohio. Their publication, *Stereo World*, contains indispensable articles dealing with early photography and stereographs.

Staff at museums, libraries, and local historical societies throughout the state cooperated with our search, including the Grout Museum in Waterloo, the MacNider Library in Mason City, the Putnam Museum in Davenport, Luther College Archives in Decorah, and the Center for Dubuque History at Loras College in Dubuque. Thanks also to the National Anthropological Archives and Library of Congress, Prints and Photographs Division, in Washington, D.C.

Descendants of the stereographers shared many stories and family photos that gave us insight into the lives of these photographers. Thanks to Ruth Risk, Aletha Frericks, Mary Mickelson Ahrenholtz, Eunice Emmert, and Chuck and Marilyn Townsend. Iowans like Elva Johnson of Albert City and Mary Holman of Center Point even remember having their pictures taken by one of the stereographers.

Roger Osborne was especially generous with his research on Samuel Root. Scott J. Reis, of Loras College, and Heidi Larson, of Luther College, provided copies of their research papers. Dedicated enthusiasts like Mary Noble contributed extensive research on the photographers of Mitchell County.

Perhaps of greatest importance, my friend Gary Widel gave me the precious gift of time to collect my views, write down my thoughts, and research stereo photography.

PAUL C. JUHL

PREFACE

No matter how many times I look through a stereoscope at an Iowa stereograph, I still come away with a sense of wonder. A moment that has been frozen in time is mine to contemplate, details of nineteenth-century life that may not have been recorded in any other manner. I sometimes feel as if I could step into the photo and become a part of the past.

The interest I have in stereographs can be traced to my childhood. By the time I was a boy visiting in the homes of my great-grandmother and great-aunts, the stereoscope had already lost its place of honor in the library case or on the marble-top center table. It had been relegated to a plaything, something to occupy the children when their parents were talking in another room. In an era of radio and limited television, it was still a wonder for a boy from a country school to see the sights of the world. The stereographs may have been part of Keystone's World Tours; I don't really remember. But I do recall the delight I found in looking at them through the viewer. The big oak table with the lace-covered tablecloth was the perfect place to lay out the views and take myself out of rural Webster County, Iowa, for a few hours. I could hear my parents and relatives talking in the adjacent room about the prices of corn and beans while I visited the pyramids of Egypt and the slums of Bombay.

Years later, in the 1970s, my parents' friends Gene and Loveta Wasson of Blairsburg, Iowa, casually mentioned one day that Gene's father had been a stereo photographer in Decatur, Illinois, at the turn of the century. This sparked my curiosity, and although at the time I didn't have much interest in antiques, I began to look for the "Wasson" views. I found about two hundred images —

some were of local Illinois scenes, others were of world sights, similar to those produced by the large nationwide distributing companies such as Keystone and Underwood & Underwood.

Living in Clinton, Iowa, and prowling the shops along the Mississippi River, I happened into a shop in Bellevue, Iowa, in the mid-1980s. It was here that I first saw cards by an Iowa photographer. They were two faded views by Waldron & Wilson of Marion, Iowa. Since I had developed a lifelong interest in Iowa history, I wondered how many such cards existed and whether they would show views of Iowa in the later part of the nineteenth century. I began a quest that has continued to this day: collecting stereographs of Iowa scenes.

I established trading partners across the United States who helped me search for Iowa views while I supplied them with views of their states that I had found. I also began to gather information about the men and women who made the views. The search was not easy. Many antique dealers and Iowa historians had never seen an "Iowa" card, and many did not even know they had ever existed.

As my collection slowly grew, I came to understand the historical significance of my hobby. The views depicted an Iowa that other forms of photography did not seem to show, since early photography was basically limited to portraiture. The dimensional aspect of the stereograph lent itself to shots of landscapes, churches, street scenes, or schools. Some stereographs are possibly one of a kind. Others, after more than a hundred years of neglect, were few in number, although many copies may have originally been made.

When I moved to Iowa City in 1985, I contacted the State Historical Society of Iowa, and it was then that I met Mary Bennett. In examining my collection, she could not only identify details

but also put the images in their proper historical context. Perhaps even more important, she recognized that these stereographs were a vital part of Iowa's history that must be saved for future generations. She found funding for making copy negatives, she sought help in doing research on the views, and she encouraged my collecting. Each year I would bring in the annual "harvest," and Mary and I would spend a few hours looking over each one. After the publication of her book, *An Iowa Album*, in 1990, we began to think about publishing a book on Iowa stereographs. We wanted to create a visual book and, at the same time, one that would give credit to an early Iowa profession, that of stereo photographer.

I consider myself not simply a collector but, perhaps more appropriately, a preservationist. The images in this book might easily have been lost and never seen again. Obviously, there is still much work to be done, and the task of preserving stereographs needs to continue.

PAUL C. JUHL

Iowans owe a great debt to dedicated individuals like Paul C. Juhl who gather together scarce resources for the study of our cultural past. Without the important contributions of private collectors, who have the time and money to ferret out these rare treasures from Iowa's past, our documentary record would be very incomplete. The Juhl collection is now approaching two thousand stereograph views of Iowa — images quite literally rescued from oblivion and put in the hands of serious researchers and ordinary folk.

Placing these images in historical context is not as easy as one might suspect, as little has been

written about Iowa's cultural life in the Gilded Age. In a way, we must rely on the unfettered visual vocabulary in these stereograph images to unravel the mysteries of life in that era. Even without an interpretive text to explain the complex social, economic, and political issues of the day, we can get a strong sense of this generation of Iowans from the legacy of photographs left behind. We offer here Iowa views that have been sequestered for nearly a hundred years, hoping that these stereographs will stimulate the imagination of historians who have yet to thoroughly explore this period in the state's history.

All place-names refer to Iowa unless otherwise noted. Quotations in the captions are from original labels or imprints on the stereographs. Captions sometimes begin with a phrase identifying the basic elements in the image so as to provide a distinctive description of the image. The publisher and series title are noted, along with the color of the stereograph mount on the front and opposite or back side. Standard sizes for stereographs vary slightly, but most measure between 3 1/2 x 7 inches for a stereo mount and 4 x 7 inches for a cabinet mount. Characteristically, the cardboard mount was curved to enhance perception of depth. Unless otherwise noted, all stereographs come from the Juhl collection. Reproductions may be obtained by writing to the State Historical Society of Iowa, 402 Iowa Avenue, Iowa City, Iowa 52240. A directory with more biographical information is available from the authors.

MARY BENNETT

INTRODUCTION

The historical imagination needs to be nurtured, and photography remains a powerful force for doing so. Stereographs, perfect artistic and technical manifestations of an age long gone, preserve a distinctive three-dimensional vision. The creators of these images were deliberately recording the modifications in American life that occurred in the second half of the nineteenth century. Except for a handful of daguerreotypes or carte-de-visites, stereographs are the first landscape photographs of Iowa. Photographers traveled outside the portrait studio to sell more images but also to test their skills and search for artistic expression. We can vicariously share the dreams of these midwesterners by absorbing the surviving imagery.

Although this particular selection of images focuses solely on Iowa, the views offer a representative look at American life in this era while also offering a broad sample of a singular genre of photography. Moreover, the specific examination of this generation of photographers, numbering more than 350, provides insights into the demographics of the professional trade of photography. By looking at biographical material, advertising literature, and the remaining examples of their work, it is possible to discover patterns of behavior, marketing strategies, mobility, and longevity. We also obtain a clear sense of the eccentric nature of some photographers who went to great lengths to create images of terrific historical value and great artistic merit.

Stereographs offer not just a world of wonderment but an actual reality that once existed. The magic moment arrives when the eyes focus on a single, multidimensional image. In some respects, these images appear as tableaux of the past. Some views are reminiscent of the Thorne miniature

rooms at the Art Institute of Chicago, each crafted with great technical precision and exquisite historical detail. It is similar to looking through the peephole of a shadow box, except that the view is much richer and more accurate. Incredible details and nuances appear — all the textures, frays, and flaws of the real world.

The best way to view these images is through a stereoscope, even if you have to adjust your line of vision slightly. It might take a little practice, but anyone can learn to locate the point at which the double images merge into one. The stereoscope also provides crucial magnification to bring out the minute details that might otherwise be obscured. With a hand-held stereoscope, the stereograph card is usually placed in a holder. The curved eyepiece helps to shield side vision so the viewer concentrates on the illuminated image in the foreground. The most expensive stereoscopes were mounted on pedestals or wooden viewing boxes with revolving wheels.

The plastic stereoscope included with this book will enhance your viewing of the images. Place the device as close to your eyes as possible while holding the stereograph image ten to twelve inches away. Slowly move the device a few inches away from your eyes until you find the point at which the images merge and remain in focus. The three-dimensional effect will be apparent as long as you hold this position. Be patient in searching for the magic moment — it can be elusive at times.

Although now virtually forgotten, the work of Iowa's stereo photographers is worth recovering and reconsidering. This book focuses on these lost artisans.

Iowa Stereographs

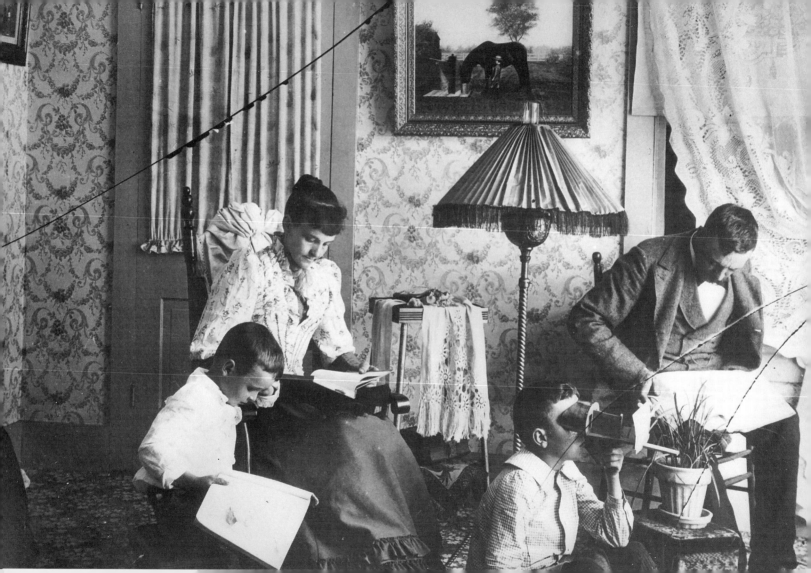

1 STEREOSCOPIC VISION

Stereoscopic vision was intended to work on the same principle as the human eye. As we look at an object, each eye sees a slightly different view. The brain combines the two into one three-dimensional view. The inventor of stereo photography, Sir David Brewster, determined that a similar effect could be created by placing twin photographs side by side on a mount. Stereo photographers used a special camera with twin lens about 2 1/2 inches apart, approximately the same distance that separates our eyes. By using a stereoscopic instrument with dual lens, it became possible to see a single image with depth and dimension. Brewster's 1856 treatise, *The Stereoscope*, foretold the promise of stereoscopic vision when applied to architecture, engineering, amusement, and education.

Stereoscopic viewing devices ranged from wooden boxes containing stereographs to stereoscopes mounted on pedestals, but when Oliver Wendell Holmes developed a hand-held stereoscope viewer in 1860, stereo photography caught on with the masses. The idea was to see the scene as if you were there. Stereoscopic vision, like binocular vision, seems to replicate closely our own vision but at the same time enhances it by magnifying the image. It also modifies our thinking by making it possible to use our visual sense differently and by allowing us to record visual elements not apparent in photographs created with monocular vision.

Victorians living in the Gilded Age in America held a deep fascination for visual pleasures — they used mirrors to create multiple reflections and a larger sense of space — and favored refracted light patterns and prismatic colors shining from leaded windows or crystal glassware. Optical

The E. E. Neal family in Keota, ca. 1895. "This picture is the photographer's self-portrait with family." The boy is looking through a stereoscope. State Historical Society of Iowa, Iowa City.

viewing devices came in many sizes and shapes. Parlor fixtures like the kaleidoscope and the stereoscope were popular in America in the 1870s and beyond, designed to give pleasure to the eye and stimulate the imagination. It is no coincidence that Brewster, the inventor of the stereoscope, had earlier invented the kaleidoscope. The scientific mania for experimenting with light and lens, and the use of chemicals to preserve the images, led to the discovery of photography in 1839. Photography, as a development of the Industrial Revolution, came into being because of this fascination and ultimately was a democratizing influence on society — purely by capturing the visual essence of society and transmitting ideas with some degree of accuracy and impartiality.

Stereo photography was introduced in America in 1850, soon after its invention in England. The first stereo views were daguerreotypes and may have been seen by only a fairly exclusive set of people, probably among the wealthy elite or scientific community. By 1854, glass stereoscopic transparencies were exhibited in Chicago, the first time they were seen in the West. Once the glass plate negative was common, photographers became excited again by the possibilities of a three-dimensional image and took to the field. A steady market for this new form of photography encouraged many portrait gallery operators to create images that documented America's emerging industrial and urban landscape, along with remote frontier scenery. Between the 1860s and 1910, millions of stereographs were created, including thousands of Iowa views.

Within this period of mass popularity came the refinement of the art of stereo photography, which was later somewhat undermined when commerce shifted from an entrepreneurial base to large-scale industry. Perhaps the most innovative stage occurred after the Civil War, when stereographs became more widely available. Stereo photographers working in the Midwest from the

mid-1860s to 1880 created unique regional documents focusing on a particular locale or landmark. The style and quality varied and often reflected the idiosyncratic tastes of the individual photographer. The art at that time, before scientific investigation led to standardization of the photographic process, was governed entirely by rule of thumb.

The physical attributes of the stereograph alter over time, and each has a distinctive appearance, unlike that of any other stereograph, even if the same imprint or scene exists elsewhere. Haphazard mounting led to uneven edges and slightly skewed angles. Some photographers clearly had difficulty mastering all of the principles of stereo photography, but generally one side of the stereograph was intended to be dominant, so it was printed darker. Another technique involved having the background of the picture in focus on one side of the stereograph while the other side of the stereograph had a different focus. Given the distance between the double lens on the stereo camera, a slight adjustment for peripheral vision was achieved by exposing more of the left side of the frame on the left side, while the right half of the stereograph exposed more of the right side. These methods were combined with compositional style to enhance the perception of depth and dimension.

The most successful landscape views have a distinct vanishing point, which enhances the depth of field and sets objects off in relief, helping to create a realistic sense of proportion and scale. Photographers chose camera angles carefully to maximize the effect and often climbed to the highest prospects to capture the best shot. Sometimes people or animals were included in the foreground of the composition to provide a sense of scale. The concept of treating a landscape as a platform for panoramic views and the use of perspective for composition can be traced as far back

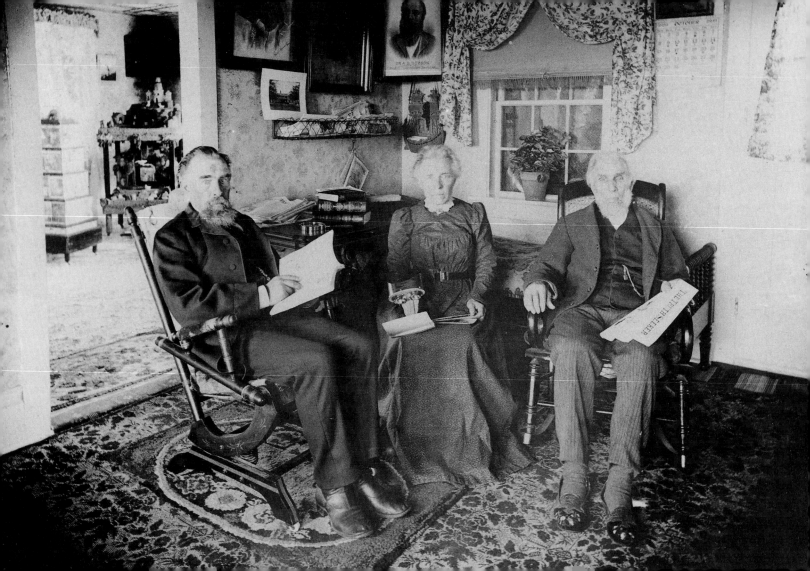

as the Renaissance. Aware of traditional pictorial conventions, stereo photographers mimicked the art world by appropriating classical compositional styles or by choosing subject matter in response to popular trends. The center of the photograph was usually placed at eye level, which could present a problem when the camera focused on a prairie landscape with an expansive sky. Originally, stereo cameras could not capture the bright light, and the sky would appear to be washed out. Improvements in photography later permitted spectacular shots of the sky, including lightning or clouds.

The heyday of local stereo photography, based on the use of wet collodion glass plate negatives, was soon superseded by new influences in photography, such as the introduction of dry plate negatives. Once amateur photographers came on the scene, the very nature of seeing was altered irrevocably, and stereographs produced after the mid-1880s reflect a more spontaneous, close-up point of view, like a snapshot, rather than sharing the characteristics of earlier nineteenth-century photographs. As more individuals and families acquired cameras, it was less likely that they would employ a local photographer to create special stereo views.

Moreover, stereo photographers could not compete with the huge commercial market that developed when it became possible to mass-produce and distribute stereographs. Large publishing houses monopolized the market by issuing sets of stereo views on a wide range of topics. For example, one company offered four thousand distinctive views of the Centennial Exposition in Philadelphia in 1876. Though most commercial publishers sold actual photographs mounted as stereo views, companies created a secondary market by issuing multicolored stereo views using a

Sarah Jane Kimball, who lived on a farm in Jones County, was fascinated by photography. She is pictured here with her stereoscope and stereo views while her brother, Merrill, and her father, Abner, enjoy their reading. October 29, 1899. 6 x 8 1/8. Sarah Jane Kimball Collection, State Historical Society of Iowa, Iowa City.

photo-lithographic process. In the 1890s, Underwood & Underwood, along with other firms, even recruited college students to peddle stereographs door-to-door like encyclopedia salespeople.

The images from this era, intended to appeal to a broad audience, placed less emphasis on local scenery. The subject matter varied widely — from standard views to ridiculous (and sometimes racist and sexist) humor. By 1910, cast-iron viewers in penny arcades offered amusement park visitors a chance to see ten stereo views for a penny. Despite the commercial exploitation of the medium, which brought a change in subject matter and the degradation of the quality of imagery through halftone printing processes, individual stereo photographers continued to pursue this art form in a classical sense, documenting their own local areas.

For the most part, stereographs were still designed to be both entertaining and enlightening, and major publishers continued to seek Iowa views for their catalogs. Stereographs were immensely popular as a form of home entertainment and served as an important educational resource in the days before film, radio, and television. Leisure time was limited and vacation trips were not as common as they are now, so families would gather to take fantasy trips by looking at boxed sets of views of Niagara Falls, Yellowstone, or the Chicago World's Fair.

Geography lessons in school and at home were enhanced by photos of exotic places such as Egypt and the Far East. Many public and school libraries across the nation acquired large sets of stereograph cards for instructional purposes. The universal fascination with stereo photography generated a curiosity about the outside world while fostering a sense of identity and pride in one's own home environment. Typically, the categories or subjects found among views representing major cities around the world are similar to those reflected in the views of Iowa's towns and cities.

This reinforces the notion that stereo photographers practicing in Iowa were responding to a keen public interest in America's growing empire and, in particular, the centrality of the Midwest to this experience.

Stereo photography is significant because it was a worldwide phenomenon, capturing the imagination of a public eager to adopt it as a new source of visual information — a precursor to a century dominated by multimedia communication. In an era when many people were self-educated, these views offered an important supplement to their daily reading of books and illustrated magazines. Besides the three-dimensional aspect, the distinguishing feature of the stereograph — especially those issued in series — was the informative text accompanying each image, which served as a reflection of the dominant values in that period and facilitated interpretation of the image.

Although no longer heralded among the visual arts, stereoscopic vision revolutionized the cultural, historical, and intellectual nature of the world. Here we use Iowa as the backdrop for examining the apex of this phenomenon in the nineteenth century. The remnants of this pictorial tradition offer an amazing record of the intricacies of daily life and a direct glimpse at places far away in time. Be forewarned, however: The use of a stereoscopic device is critical if the viewer wishes to experience the astonishing reality presented by three-dimensional images and therefore comprehend the full impact of this genre of photography.

Sketch of a stereoscopic camera, showing the dual lens designed to expose a pair of images simultaneously. Mounted, the center of each image would be as far apart as the human eyes, hence creating a three-dimensional effect. A stereoscopic box camera for 5 x 8 glass plates cost $30 or $35 with a single swing (which would enhance landscape and architectural photography). Source: Earle, *Points of View*, p. 21.

STEREOSCOPIC MUSEUM

There is on exhibition one door south of Webster's grocery the best show of stereoscopic views that we have ever seen outside of the large cities. There are 59 revolving stereoscopes, each containing 59 views, embracing distinguished men and women, cities, parks, streets, harbors, bridges, conservatories, statuary, centennial views, and, in brief, everything to illustrate the peoples and products of America, Europe, Asia and Africa, and the isles of the seas. It affords an opportunity for sight-seeing that ought to be improved.

Howard County Times *(Cresco),*
October 6 and 13, 1881

STEREOSCOPES

24c

STEREOSCOPES AND VIEWS NEVER WERE MORE POPULAR THAN AT THE PRESENT TIME.

With the large assortment of views which we list, there is an endless amount of entertainment to be obtained from an outfit of this kind, at a very small expense. We do not list the cheapest line of stereoscopes made, for we cannot conscientiously recommend them to our customers.

YOU CAN MAKE BIG MONEY SELLING THESE STEREOSCOPES AND VIEWS.

Our 36-cent views readily bring $1.00 per dozen. Our colored views, for which we ask you only 54 cents, will sell easily for $1.50, and our best grade views should never be sold at retail for less than $3.00 per dozen. Our 24-cent stereoscopes sell like hot cakes at from 75 cents to $1.00 each.

In hunting through art stores for stereoscopic views I found almost always the same answer: "We have no call for them, they are out of date." Emil de Neuf, "Stereoscopic Views," American Annual of Photography and Photographic Times Almanac, 1894

A Sears, Roebuck & Co. catalog for 1902, showing advertisements for stereoscopes of all kinds. By 1904, the company was selling stereo views for pennies, undermining the local market, as did other mass distributors. Sears was able to offer a fifty-card set of lithoprint stereo views for thirty-five cents; for fifty cents a stereoscope would be included.

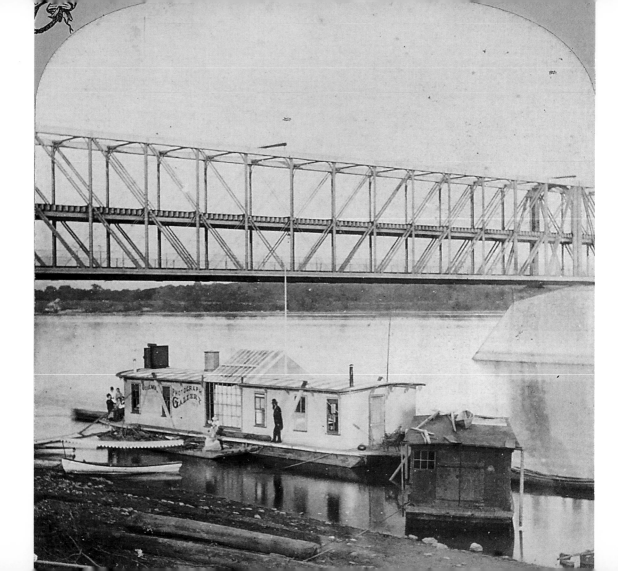

Iowa stereographs are three-dimensional images that document the idealistic visions of the Gilded Age as portrayed in private homes, public buildings, businesses, and the surrounding pastoral landscape. Pictorially, these stereographs hint at how Iowans joined other Americans in the pursuit of economic, intellectual, and emotional well-being, fostered by westward expansion and the growth of industry and agriculture. By documenting the ambitions of settlers and town builders, the Iowa stereographs reflect typical patterns of socialization and show how community life evolved in terms of a built environment. The pioneer generation who had relocated in the nation's heartland wanted to demonstrate how attractive and respectable life had become. As might be expected, midwesterners found comfort in the familiar and mimicked the styles of their ancestral homes and villages.

Stereo photographers who succeeded as commercial entrepreneurs had a knack for choosing subject matter that would sell. Often, their work displayed fine artistic sensibilities as well. The most priceless landscape photography of the era was created by seasoned practitioners who devoted years of their lives to perfecting their skills. The extravagant claims of beauty and wonder found on their backlists or in their advertisements are not just marketing hyperbole. As participants in what they considered to be the taming of the West, they were caught up in the romance of empire building. While photographing part of the national experience, and thus enriching our historical memory, these artists were motivated to earn a decent living.

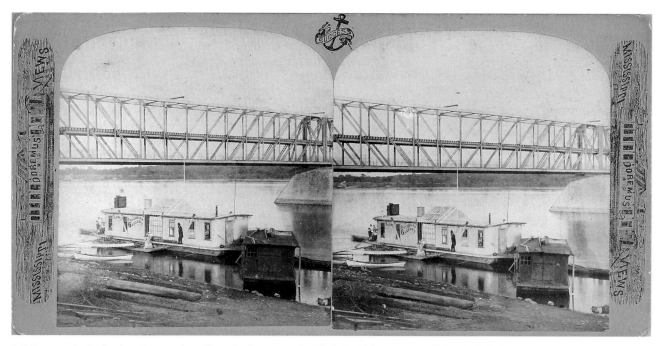

J. P. Doremus had a floating photography gallery, the *Success*, on the Mississippi River, ca. 1877. Taken by J. P. Doremus, Paterson, New Jersey. Publisher: J. P. Doremus, Doremus' Mississippi Views. Stereo mount; orange, opp. pink. A replica of a large camera was mounted on the roof of the *Success*, as seen on the left. The small boat on the right, behind the *Success*, had a printing "gallery" and workroom.

The boat is a little palace in itself, complete in all its appurtenances. The deck is 18 x 76 feet, on which there is built a miniature house. Upon entering the inside of the boat, one is ushered into the reception room 8 x 16 feet, fitted up handsomely with marble top table, water cooler, and oil paintings, chromos, carved brackets, etc., showing taste and lavish expenditure.—Two doors in the left lead, one into a toilet room six feet square and the other into a room 6 x 9 feet, for the use of Mr. Doremus. Folding doors open into the operating room 14 x 30, at the end of which is a door leading to a private dining room and private parlor. . . . The whole is finished in the best style, with projecting roof handsomely bracketed. Inside there is a profusion of moulding on the ceiling and sides of the room, each room to be moulded and painted in a different style with regard to the best artistic effect.

 Doremus's 1877 pamphlet Floating Down the Mississippi

It is important to remember that nineteenth-century photographers focused on the pleasant and picturesque aspects of life, aiming their product toward more affluent, middle-class citizens. There are therefore inherent limits on the types of information available or the possible meanings to be derived from this imagery. Subject matter was dictated by commercial motivations, prevailing social conventions, and the innate curiosity of the photographer. Aesthetically pleasing shots would sell best, so it is not surprising that photographers neglected the less desirable aspects of community life, though some did capitalize on disasters as newsworthy items.

Moreover, they seldom wasted precious negatives on scenes that did not render the best perspective for creating a three-dimensional effect. Technical factors may have been the overriding influence when a photographer was considering where to point his or her camera. Studio photography depended on a great deal of natural lighting, either from large storefront windows or from skylights positioned overhead or on the side of a studio building. On the road, interior photography would have required the burning of flash powder to light a room bright enough for the collodion wet plate negative.

Unless the photographer could recoup his or her expenses by selling multiple copies of first-rate images, the process of stereo photography was too expensive to engage in. The public was familiar with the popular press — for example, *Harper's Weekly* — which published wood engravings or lithographs derived from photographs. The actual photographs, now widely available in stereographic format, offered clarity and superior tonal range that were impossible to achieve in nineteenth-century printing practices.

Compared to that of artistic renderings, the realism of photography was indisputable. Artists,

lithographers, and engravers sometimes failed to capture a scene's subtleties or majesty because of the restrictions of their medium or because they felt the need to manipulate the image for pictorial effect. Previously, artists were relied upon to create pencil and chalk sketches, watercolors, and oil paintings of western scenery to visually explain geological formations or landscape variations. Photographs were transformed in the printing process and published as artwork in government survey reports and popular periodicals throughout the 1870s, filling the public's imagination with romantic visions of western expansionism.

Photographers like William Henry Jackson, Timothy H. O'Sullivan, and Carleton E. Watkins are well known in photographic history, primarily for their stereographic views documenting the exploration of the West. Although Iowa stereo photographers are not recognized on such a grand scale and the locales they visited were not as exotic as the Rocky Mountains, Yellowstone, or the Colorado River valley, their Iowa images are nonetheless an important legacy for all Americans. The scenic beauty of some regions of the state can indeed rival the magnificent scenery of the Far West.

Enthralled with the promise of a bright future and unlimited opportunity, the stereo photographers were just a segment of a larger group of Iowans fascinated by the lure of life in America's Garden of Eden and driven by a desire to settle the West. The photographers who operated portrait studios and engaged in landscape photography were regarded as professionals by their peers in the community. Highly skilled and undoubtedly individualistic in nature, the local photographer was an important fixture in most towns. Some experienced ample prosperity, as evidenced by those who lived in fine homes, owned the first auto in town, or opened branch businesses in nearby villages.

While they were pioneers of photojournalism, documenting common experiences, stereo photographers were early innovators in the field of advertising as well. The strong market for photographs — which they helped to create through their advertisements — demonstrates a popular interest not only in portraiture but in images that would promote local commerce and show the attractions of the state. Such images would draw visitors and settlers and reinforce a belief that the good life could be found in Iowa. The promotional images helped to perpetuate American ideals of progress and material gain, while offering proof that a near perfect existence could be achieved in the fertile heartland.

Prospering as portrait photographers, these entrepreneurs undoubtedly saw the artistic and financial potential of the current craze for the stereograph, which used twin photographs to create a sense of depth. Along with an eager public audience, they were intrigued by this format, realizing that the perception of depth would enhance landscape photography. The overwhelming popularity of the stereograph had created a steady market for new material, as more and more Americans spent evenings in their parlors viewing local, national, and foreign scenes through hand-held or pedestal stereoscopes. These visionary photographers apparently concluded that stereo photography was an ideal way to capture and market the natural beauty of the West as epitomized by Iowa. A prosperous portrait gallery probably allowed the photographer to take this risk. Although people were being inundated with views from all over the world, customers would pay for views of their own city, home, or favorite hangouts. Anxious to portray their state as a land of contentment, Iowans would share and exchange these views with distant relatives and friends.

Stereographs were often marketed in sets or series, and avid collectors would check the backlist

(a catalog or list imprinted on the reverse of each card) to see what other views were available in that series. According to an advertising brochure, J. P. Doremus intended to photograph an assortment of "wild western scenery, embracing views of towns and cities, lumbermen sorting logs and building their rafts; scenes on the 'Diamond Jo' line of steamboats, and a number of beautiful and picturesque bits of scenery." The notations on the reverse of stereo cards disclose the creative mentality of nineteenth-century stereographers and of those who collected the images. Variations include the owner's personal numbering system, stamps used like bookplates to identify the owner, and handwritten descriptions of the scenes depicted.

Prepared with ingenuity, these visual treasures represent the life's work of a rare breed of photographers. The images impart some wisdom about the times, symbolizing the hopes and aspirations of the first generation of Iowans. The photographs place us in the mind-set of bustling expansionists who wanted a record of a world they thought to be progressing toward civilization. Often we see stark, newly modified landscapes with tidy fences and young trees around homes or temporary wooden storefronts along dirt roads.

Frequently, the photographer stopped to document a building under construction or just recently completed, and one can sense the impatience of this generation in their quest to make a home in the West. Later images reveal more refined communities with varied options for entertainment and commerce. Rapid settlement in the middle of the nineteenth century, followed by two decades of post–Civil War economic growth and social progress, transformed the state and nation. Pictorially, these stereographs capture the period following the initial pioneer settlement, documenting an era in Iowa before twentieth-century impulses began to influence life.

The direct evidence presented by these images, revealed in their remarkably lifelike qualities, surprises the viewer by showing precisely the level of sophistication (or lack of it) that one might find in the state. The rustic brick and frame structures photographed in the late 1860s and early 1870s have been mostly torn down or remodeled; the surviving buildings barely remain intact, quickly disappearing from Iowa's older main streets and countryside. Though some present-day buildings — especially public institutions — are recognizable in stereographs from the 1890s to the early 1900s, these stereo views open a window on a very specific and brief period of Iowa history. Stereo photographers were witness to a narrow span of time, and they used their cameras to create a fairly complete portrait of Iowans in the Gilded Age, thereby enhancing our understanding of midwestern life in general.

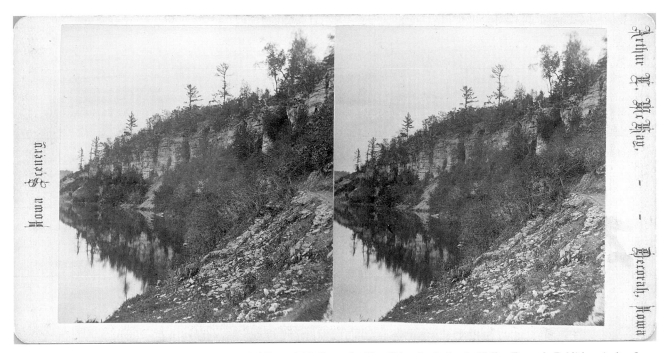

"Upper Iowa river scenery—The Pallisades," Decorah (Winneshiek County), 1880s. Taken by Arthur L. McKay, Decorah. Publisher: Arthur L. McKay, Iowa Scenery. Stereo mount; yellow.

The making of stereoscopic pictures is one of the most lucrative departments of photography, and the number and variety of subjects everywhere obtainable of the "wonders of the world" together with the vast assortment of historical views, and local bits of interest make a collection of endless extent and beauty.

John C. Browne, *"A Practical Suggestion of Stereo-Landscape Negatives,"* Photographic Mosaics, *1874*

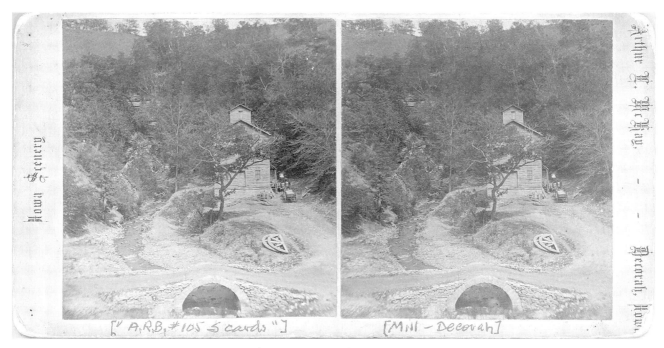

Dunning Springs mill with a culvert in front, Decorah (Winneshiek County), 1870s. Taken by Arthur L. McKay, Decorah. Publisher: Arthur McKay, Iowa Scenery. Stereo mount; yellow. Note the wooden form the stonemason used to support the arch in the stone bridge.

"Prairie near Durant, Iowa" (Cedar County), n.d. Taken by unknown photographer. Cabinet mount; pink; opp. orange. The back of the card has a handwritten note: "4 Instantaneous Lawn."

Stereo. Views of Elkader and Vicinity.

Elkader is the county seat of Clayton county, is centrally located in one of the most fertile tracts of land in the world, and situated both sides of the Turkey river, which here furnishes one of the best water powers in the West. Population 1400. Public school house cost $12000. Banking, milling and other facilities not excelled.

The following is a list of views of the town and vicinity,

PHOTOGRAPHED AND PUBLISHED BY

G. M. DEMPSIE,

ELKADER, - - - IOWA.

Orders by mail promptly filled. Retail price $3.00 per dozen. Furnished to dealer at the usual rates:

No. 1 Elkader from east.
" 2 " " west.
" 3 " " north from Lover's Leap.
" 4 Lover's Leap, north.
" 5 Looking up Turkey River.
" 6 Down the River.
" 7 Chimney Rock, half mile up river.
" 8 Park Rock, 1 mile south.
" 9 Ruins of Dam, destroyed June 25th, 1875.
" 10 Iowa Eastern Train, at depot.
" 11 Elkader Water Power.
" 12 Iron Bridge, over the Turkey at Elkader.
" 13 Front Street, west.
" 14 Front Street, east.
" 15 Putting last plank on New Dam.
" 16 Public School.
" 17 From Tipton House east, No. 1.
" 18 " " " No. 2.
" 19 " " " No. 3.
" 20 " " " south.
" 21 The Centennial Picnic.
" 22 Clayton County Jail.
" 23 Up the Turkey.
" 24 Cedar Street.

IOWA'S
SUMMER HOME
—AT—
BELLEVUE, IOWA.

Bellevue is situated on the west bank of the Mississippi river, 415 miles north of St. Louis, and 160 miles west of Chicago, on the C. M. & St. P. R. R., and at its junction with the Bellevue and Cascade railway. It affords one of the most pleasant and home-like resorts that is to be found in the Northwest. The scenery is grand, while being bold and rugged, it affords an extended river view of nearly thirty miles. In addition to its scenery, it has pleasant drives, good boating and fishing.

SELECT SERIES.

Including thirty numbers, making a selection of the most prominent points at Bellevue and vicinity, from Springside to Pulpit Rock.

1—Kilborn Falls.
2—Moonlight Scene—Mississippi River.
3—Cliffs, South Bluff.
4—North Bluff.
5—Springside—Looking North.
6—Steamer Sidney.
7—Looking North—From North Bluff.
8—Bellevue Falls.
9—Lake Reiling.
10—Table Rock—North Bluff.
11—Picnic Grounds—Near Bellevue Falls.
12—Cliffs of North Bluff.
13—Rocks of Bellevue.
14—Cliffs of North Bluffs—Chasm.
15—Drive to the Caves.
18—Sunnyside—Looking West.
19—Cliffs of North Bluffs.
20—Moonlight—Lake Reiling.
22—Looking West—From North Bluff.
23—Pulpit Rock.
24—Bellevue Avenue.

Backlists advertise the grand scenery, fertile land, water power, railroads, and general attractiveness of the West.

A carriage on a newly constructed road, Keokuk (Lee County), 1870s. "Stereoscope Views by E. P. Libby, Artist, 78 Main St. Keokuk." Publisher: E. P. Libby. Stereo mount; yellow. Notice how trees have been recently cleared to build this road. Seeking a national audience, Libby sold a photograph of the Des Moines Rapids Canal for publication as an engraving in *Harper's Weekly*, September 15, 1877.

Keep a stock of stereoscope boxes of various styles to finish. At this time there is nothing better than those known in the trade as the "Holmes Scope." They should and probably will, become as popular as the album; keep a good stock of stereoslides, and larger views; have as many of your own taking of objects of local interest in your own neighborhood as you can, *but do not limit yourself or patrons to those only; seek by purchase or exchange to keep a good selection for sale and exhibition, and may we suggest—for study.*

"Landscape Photography," Photographic Times, *June 1878 [emphasis added]*

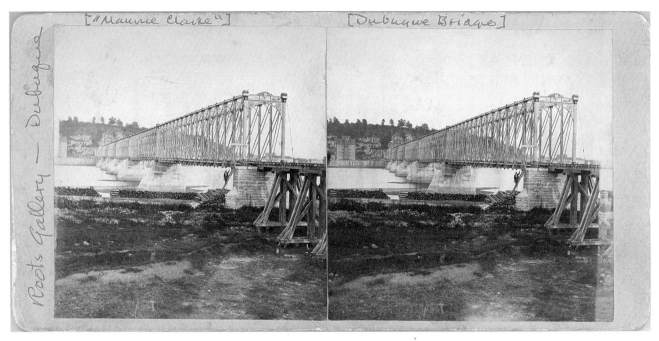

"Dubuque Bridge" Dubuque (Dubuque County), 1870s. Taken by Root, Dubuque. Publisher: Root's Gallery, Scenery on the Mississippi and Tributaries in the Vicinity of Dubuque, Iowa, Emporium of Stereoscopic Views. Stereo mount; pink, opp. orange. Root used a classic compositional technique to render a three-dimensional effect by placing the bridge on a diagonal line across the frame.

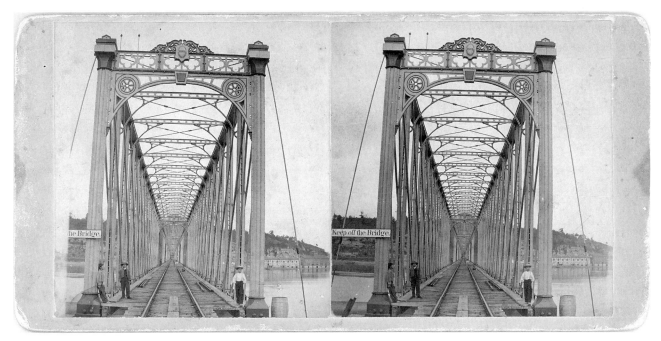

"Bridge over the River at Dubuque" (Dubuque County), 1870s. Taken by Root, Dubuque. Publisher: Root's Gallery, Scenery on the Mississippi and Tributaries in the Vicinity of Dubuque, Iowa. Emporium of Stereoscopic Views. Stereo mount; yellow. Another common point of view for the photographer's camera was looking directly through a bridge to create the illusion of distance.

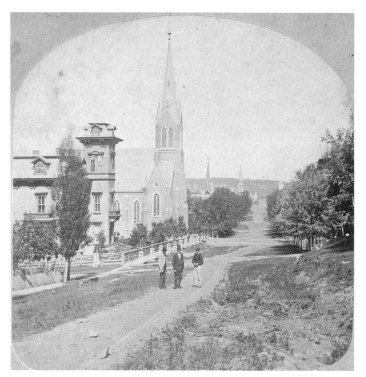

"Main Street, Decorah" (Winneshiek County), ca. 1876. Taken by A. L. Dahl, De Forest, Landscape Photographer, Wisconsin. Publisher: Andrew L. Dahl. Stereo mount; green. The roads of northeast Iowa were well traveled by stereo photographers, including Dahl, who was based in Wisconsin. He sold his views for 25 cents apiece or $2.50 per dozen, postpaid.

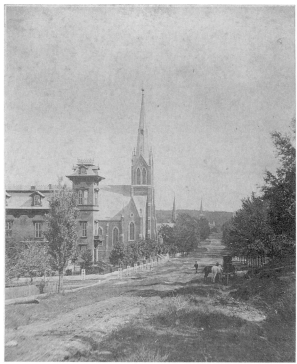

"14. Views on Broadway," Decorah (Winneshiek County), ca. 1880s. Taken by Hover & Wyer, Decorah. Publisher: Hover & Wyer, Stereoscopic Views In and About Decorah, Iowa. Cabinet mount; yellow. This later view, taken from virtually the same spot, shows a decorative iron roof railing on the building at the left. The photographers may have left their horses and wagon in the shade while taking this shot.

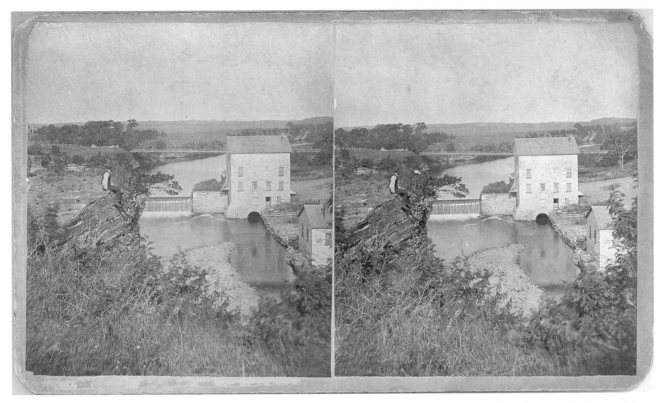

"No. 173. Mill, from Grand View Cliffs," Iowa Falls (Hardin County), 1880s. Taken by I. L. Townsend, Iowa Falls. Publisher: I. L. Townsend, Iowa Falls and Vicinity. Cabinet mount; orange, opp. pink. The dramatic height of the limestone bluff was captured when Townsend perched his camera high above the mill.

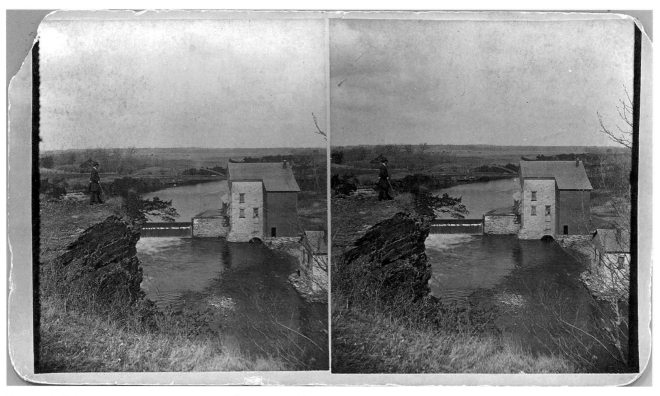

"No. 173. Mill, from Grand View Cliffs," Iowa Falls (Hardin County), 1880s. Taken by I. L. Townsend, Iowa Falls. Publisher: I. L. Townsend, Iowa Falls and Vicinity. Cabinet mount; orange, opp. pink. Townsend returned to the site to record the addition of a wooden section to the side of the stone mill. The river is higher, and spring buds appear on the branch at the right. He used the same series number for the updated view.

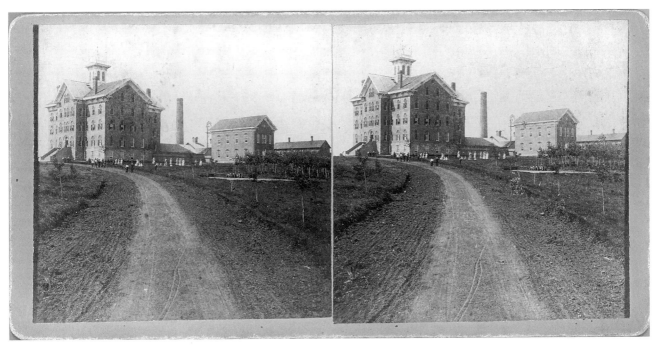

Iowa Soldiers Orphans Home, which later became the main building for the University of Northern Iowa, Cedar Falls (Black Hawk County), 1870s. Taken by Jordan & Macy, Cedar Falls. Publisher: Jordan & Macy, Stereoscopic Views of Cedar Falls & Vicinity. Stereo mount; orange, opp. pink.

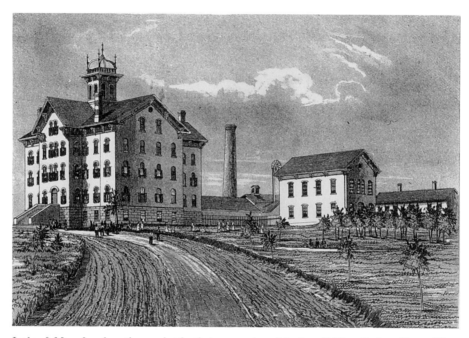

Jordan & Macy found another market for their stereo view of the Iowa Soldiers Orphans Home. They sold a single image to the Andreas Atlas Company in Chicago for publication in its Iowa atlas of 1875.

Mr. Macy was reared on a farm and received a common school education. In 1870 he came to Vinton and took instructions in photography and also at Marshalltown. He located in Cedar Rapids, Iowa, in company with H. A. Jordan, where he remained about one year; then traveled with a portable gallery after which he located at Belle Plaine, where he remained two years, after which, in 1880, he came to Vinton, where he opened a gallery and has ever since been engaged in the business. He has worked up a business of about $2,500 annually. He also has a branch gallery at Dysart, Tama County.

Portrait and Biographical Album of Benton County, *1887*

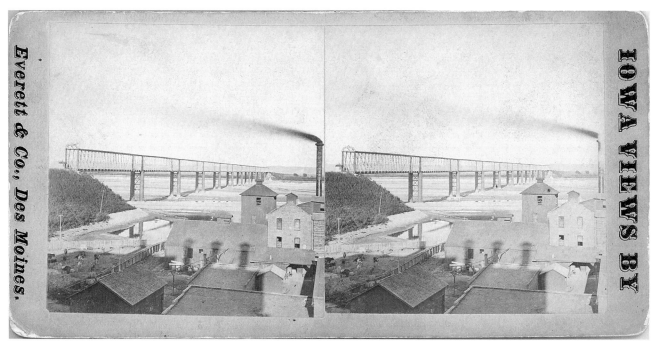

"Omaha Bridge," Council Bluffs (Pottawattamie County), 1870s. Taken by Everett, Des Moines. Publisher: Everett & Co., Iowa Views. Stereo mount; green, opp. beige. By 1869, with the completion of the transcontinental railroad, westward expansion pushed past Council Bluffs. The cattle in the stockyard at left may indicate that the factory smokestack and buildings are part of a slaughterhouse.

With the aid of this instrument we now possess the means of transmitting to posterity the exact image of all that is physically remarkable in the present day, at least so much as can be appreciated by the sense of vision.

Illustrated London News, *March 20, 1852*

Coyle's photo studio,
Monticello (Jones County),
ca. 1880.
Taken by F. A. Coyle,
Monticello. Publisher: F. A.
Coyle. Cabinet mount; orange,
opp. pink. The man in the
upstairs window is leaning
on a rack for exposing printing
frames to the sun. Coyle
advertises frames, albums, and
stereoscopic views on the large
sign, while a kiosk displays
pictures. The small cart or
wagon parked under the
stairway is possibly the
photographer's portable
darkroom.

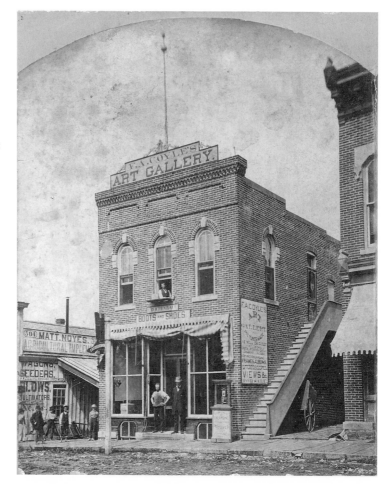

3 IN THE STUDIO AND OUT IN THE FIELD

The economic viability of a career in photography depended on skill, perseverance, and an ability to promote oneself. At best, most photographers could earn only a modest living, and only the most versatile and creative could maintain a business for more than a few years. There is a definite pattern of mobility among photographers during this era, as they struggled to establish a clientele for a relatively cheap product. For some, the itinerant nature of the business was not unlike the life of the traveling peddlers and other skilled artisans who moved around among scattered rural communities.

Those photographers successful enough to build or occupy small-town storefronts found portraiture to be the mainstay of their business. The local portrait gallery sometimes offered a degree of elegance and refinement not unlike the legendary salons of artists and poets. The more flamboyant photographers fostered a sense of cultural and artistic enrichment within their galleries. Displaying opulence perhaps a bit unusual for the sedate towns of the Midwest, the studios were designed to help the photographers establish a reputation for quality wares and therefore gain prominence and popularity in the community. The fancy decor of the gallery was intended to lend an air of respectability to the establishment, creating an environment suitable for ladies and gentlemen — if not the lower classes, who could seldom afford the luxury of a formal portrait.

A visit to the local photo studio was quite an experience for nineteenth-century Iowans. Affluent families might have multiple portraits taken for the family album, but many people could not afford to have a studio portrait made. Within a person's lifetime, perhaps only two or three formal

portraits would be made, so it was certainly a special occasion, requiring careful preparations in dress and appearance. As much as for sitting in front of the camera, visitors to the portrait gallery came for the ambience and the excitement of participating in one of the greatest fascinations of the age.

Photographers found ingenious ways to attract customers to their studios, promising to produce artistic portraits unrivaled by anyone else. Their excessive boasting appears on the imprints on the reverse of carte-de-visite and cabinet card portraits, as well as in the newspaper advertising of the day. Perhaps most intriguing are the oft-repeated statements that "duplicates of this picture can be furnished at any time" and "all negatives preserved," indicating the photographer's interest in luring in and keeping long-term customers.

Surviving images of the photography studios and galleries reveal a surprising array of building types and unbelievable conveyances. Photography galleries operated on boats on the Mississippi and other waterways, on railroad cars that could be transported from town to town and parked on a side track for a few days, or on ordinary wagons traveling through the countryside. Even if a photographer prospered enough to have a studio in town, photographs show temporary shacks or tents, small frame structures, and occasionally a two-story brick storefront.

Photography studios often were situated on the top floor of commercial buildings because of the need for a roof skylight to provide as much natural light as possible for taking pictures. In other locations the studio skylight might extend across one wall of the building, even reaching two stories in height. The prevalence of skylights in certain districts of larger cities like Davenport and Des Moines indicates how studio proprietors would cluster in one area where foot traffic was

probably high. Tracing the city directory listings over the years shows it was common for one photographer to pass on a properly outfitted space to a successor. Newspapers frequently reported on fires that wiped out entire studios and their contents, forcing photographers to move or quit the business altogether.

A major determinant in the subject matter of photography in this era was available technology. Photographers were constrained by the need for bright sunlight. Wet plate photography demanded long exposure time and the immediate use of a darkroom to prepare and process the negative. Bright sunlight was also used to make a print, with the negative sandwiched in a glass printing frame and set on the windowsill or exposing shelf.

Rapid developments in camera and lens created a new venue for photographers who wished to explore the realm of the outside world. Although stereo views had been around since the dawn of photography with daguerreotype stereo views, the most dramatic revolution in stereo photography came in post–Civil War America. Job seekers found photography to be a readily acquired skill that allowed them to act as entrepreneurs in the newly founded towns of the Midwest. To prevail beyond a few months or years, however, a photographer had to possess an innate artistic ability or a tremendous gift for marketing a custom-made luxury product to people of modest incomes.

Those who gained notoriety and permanence were probably in the business for the love of it, not because they anticipated getting rich. Photographers dealt with uncertain markets for their products, and stereo photography provided an opportunity to branch out and expand their business while allowing them to escape the stuffy confines of the studio. How could they resist the temp-

tation to spend a pleasant day outdoors in the field instead of cooped up in the studio waiting for patrons to visit? Locating a scene of natural beauty or tinkering along the roadside must have been a welcome relief from the studio, where the smell of chemicals pervaded and customers preened, demanding that the photographer bring out their best physical attributes.

Of course, a tremendous amount of labor was required to conduct a photographic excursion. Fieldwork meant carting around equipment ranging from a tripod, camera, and glass plate negatives to a potpourri of photographic chemicals, beakers, trays, and stands. The portable darkroom could be stored in a box or built on a wagon, but each trip necessitated bringing a heavy yet fragile load of supplies.

The time-consuming nature of taking a picture can hardly be understood by today's standards. Each shot took several minutes to compose. The site had to be selected, the camera stabilized on a tripod, and the exposure carefully calculated. The entire process was close to experimental; each glass plate negative was individually prepared as the photographer responded to the shifting conditions of lighting, weather, and temperature. The more seasoned practitioners had no problem creating perfect exposures, but success came only with trial and error, and multiple exposures were commonly taken from the same location or vantage point. Given the variance in conditions and in how the photographic chemicals might react, smart photographers tried to maximize their chances of going home with at least one quality image.

Still, it is difficult to fathom exactly how they were able to eke out a decent living from photography; many probably practiced a second trade. For the amount of time and effort required to create landscape photographs, photographers may not have reaped an income commensurate

with their expenditure. Photographs were relatively cheap, and the market for stereograph views vacillated over the years. Photographers advertised a variety of photographic formats (enlarged crayon portraits, stereographs, or tintypes) and supplemented their business by selling picture frames, albums, and artwork.

Landscape photography nonetheless offered an alternative source of income, especially if a series of views was taken and customers could be encouraged to acquire an entire set of photographs. Selling stereoscope viewing devices along with mass-marketed stereographs from around the country and globe also generated income for the photographer. The desire for unique local views to intersperse within a collector's set of stereographs created a distinctive niche for photographers looking to expand their trade.

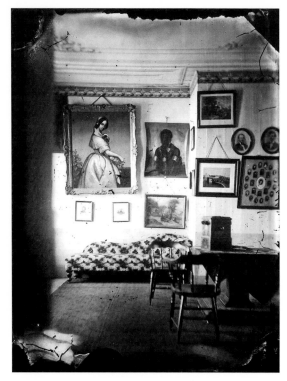

This shot of Wetherby's gallery in the early 1870s features a wooden stereoscopic viewing box on the table and samples of his oil paintings and photographs. Note the rough edges of the print, due to uneven coating of the collodion on the wet glass plate negative. Isaac A. Wetherby Collection, State Historical Society of Iowa, Iowa City.

Muscatine Sept 11th 66

Mr I A Wetherby Iowa City

Dr Sir I write to you to ask your opinion upon the subject of getting up a photographers association similar to the Dental association You are aware that at present in most Localities the People instead of the Photographers run the Business establishing such prices as they choose upon our Labor. I see that the Dentists are much benefitted by their uniform prices & unity of action. Should we who are devoted to the practice of our profession Band our selves together in a like manner we must Recv. like advantages. Please write me what you think of the plan I am going to work in earnest in this matter & want all who think it a good move to do the same hoping to hear from you soon I Remain Very Respectfully,

J. G. Evans Wetherby Collection

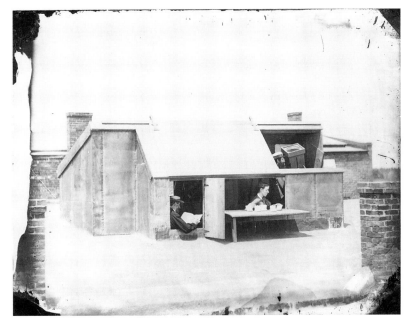

This rare photo shows the rooftop of Isaac A. Wetherby's gallery on Clinton Street in Iowa City about 1870. Wetherby's solar camera is visible in the open skylight on the right. The woman is exposing plates to natural sunlight to create prints. Wetherby may have climbed on top of this roof to create the bird's-eye view of the Old Capitol shown on page 160. Isaac A. Wetherby Collection, State Historical Society of Iowa, Iowa City.

In the wet-plate days, when photographers were limited to the relatively insensitive printing-out paper, the only light source bright enough to enlarge with was the sun. A cumbersome enlarger, the solar camera, *had been invented by David A. Woodward in America in 1857. The exposures were hours long, and the camera, mounted on the roof, had to be turned with the sun. Quantity was out of the question.*

Newhall, History of Photography

Iowa City Iowa Aug 4th 1880

J.W. Cone in acct for Pictures

for 1871

March 17th (as Per Neg Back) J. W. Cone - 6	$1.50
~~1/2 doz Photos of Wife~~	
May 12th to 2 gems J. W.	.50
do 15th (Neg Back) 1/2 doz of J. W. Cone	1.50
June 19th ~~(do) 1/2 doz of Mrs. Cone~~	
J. W. Cone to 1/2 doz photos	1.50
	$5.00

1872

~~Dec 2nd to Photos of J. W. Cone~~	~~.50~~

1875

April 9th to 1. 8 x 10 Solar V Frame of Mrs. Cone	$3.50
& B.S. Cone to 1 - 8 x 10 Solar	3.00
do 2 gems	.50
	$7.00

1876

June 3d to 2 - 10 x 12 Large Photos W Frames of Father & Mother	$6.00
do 2 gems	.50
June 21st to 4 Large Copies of Father. Mother.	6.00
& 1/2 doz card Photos	2.00
	$14.50

1877

June 10th to 1/2 doz of Baby.	1.25
August 17 2 gem of Wife	.50
Oct 2 to 1 - 8 x 10 Solar of Wife	3.00
do 4 gems of Baby	1.00
Dec 25th 2 gems of Baby	.50
	$6.25

1878

June 3d to 1/2 doz Photos of Boy	$1.50
do 1/2 doz of Baby	$1.50
April 3d to one & one half doz photos of Mr. Cone	4.00
	$7.00

Mr. & Mrs. Cone

Ordered 12 - 10 x 12 Solar of ~~Father & Mother~~	
Printed 6 of Mrs. Cone & 3 of Mr. Cone & the Negative got Broke	$9.00
Mr. Cone collected Balance on	
Mrs. Freer's case on Settlement	$2.50

Wetherby Collection

Wetherby's account book documents the difficulty of making a living from photography. J. W. Cone and his family visited Wetherby's studio in an attempt to capture the various stages of their family life for posterity. Wetherby failed to convince Cone to purchase extra photos of his wife as evidenced by the orders crossed out. Ironically, Wetherby finally secures a large order of expensive 10 x 12 Solar prints but he breaks the glass plate negative in the process of printing. Though he evidently cultivated an eight year relationship with this particular customer, it appears he reaped a total income of $51.25 —only a few dollars each year. Even with many customers throughout Iowa City and Johnson County, Wetherby had competitors in the trade so photographers were keen on expanding their business with stereo photography.

"This is our house. It does not make very much of a picture . . . ," Clear Lake (Cerro Gordo County), 1881. Taken by H. S. Mather, Clear Lake. Publisher: H. S. Mather, Views In and Around Clear Lake. Stereo mount; green. Notice the skylight in the roof of the studio. Another view shows a signpost for the studio on the corner.

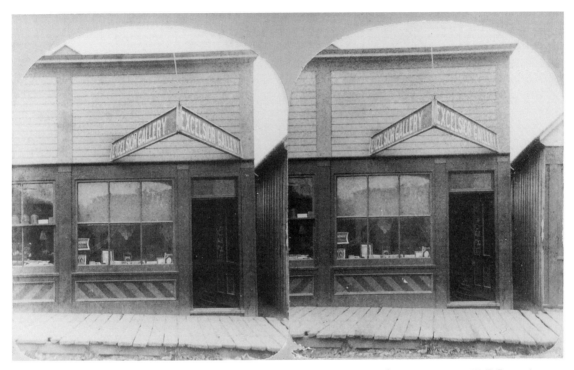

Exterior photo of W. E. Benton's Excelsior Gallery, Missouri Valley (Harrison County), 1880s? Taken by W. E. Benton? Cabinet mount; orange, opp. lavender. Angrick Collection, State Historical Society of Iowa, Des Moines.

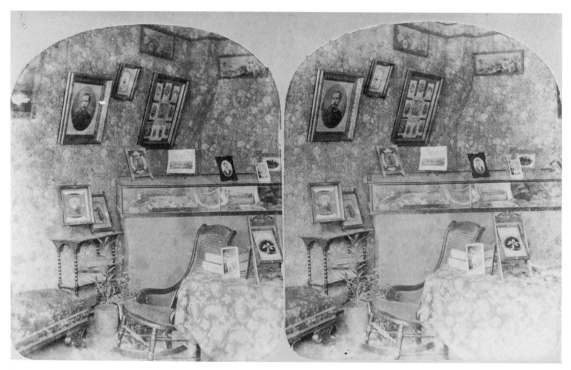

Interior photo of W. E. Benton's Excelsior Gallery, Missouri Valley (Harrison County), 1880s? Taken by W. E. Benton? Cabinet mount; orange, opp. lavender. Notice the variety of frames, easels, and pictures for sale. Angrick Collection, State Historical Society of Iowa, Des Moines.

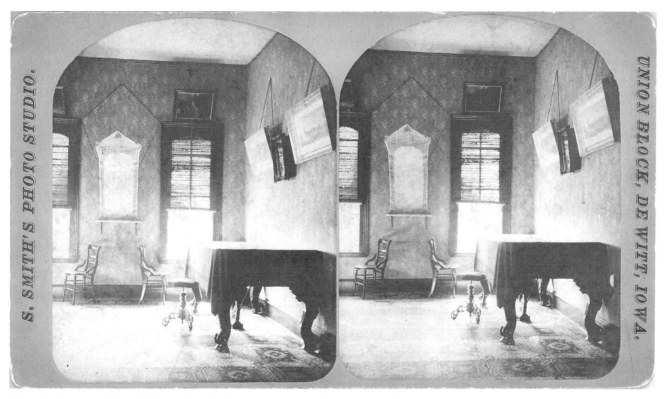

S. SMITH'S PHOTO STUDIO.

UNION BLOCK, DE WITT, IOWA.

"Reception Room in Gallery," Sylvester Smith's photo studio, De Witt (Clinton County), ca. 1881. Taken by Sylvester Smith. Cabinet mount; orange, opp. pink. The mirror and two picture frames have been covered with gauze cloth for some reason, perhaps to protect them until they were sold to customers. The harmonium suggests the ambience of a salon where music is played.

In 1869, they decided to come west, and accompanied Mr. [William H.] Brewer's father's family. They began to improve a farm in Tarkio Township and after one year's effort concluded that was not their calling. They then removed to Red Oak, where Mr. Brewer engaged in selling groceries for three years, meeting with fair success. January 1874 found him established in a photographer's car on the site now occupied by the First National Bank in Shenandoah. He had learned the art at Red Oak, and had fitted up his car intending to devote some time traveling. Finding the business in Shenandoah more lucrative than he had anticipated he concluded to remain there permanently, and secured a gallery that had been abandoned by his predecessor, becoming a fixture of that rapidly growing town. His business increased in such proportions that in 1882 he was able to erect his present valuable brick block. It is 25 x 70 feet, with a commodious store-room on the ground floor, and photographers parlors and residence on the second floor. . . . In this most attractive occupation Mr. and Mrs. Brewer have found their calling, and they have spared no pains or expense to excel. They never allow a poor photograph to leave their studio, and by producing the choicest work they have an immense custom.

Biographical History of Page County, 1890, referring to William H. Brewer

Sketch of the interior of Boyd's photo gallery from the back of a cabinet card, Des Moines (Polk County), 1870s. Reflecting mirrors, skylights, displays and exhibits, and a piano were common accoutrements in the gallery. Boyd's apparently featured a stuffed peacock. Courtesy JoAnn Burgess.

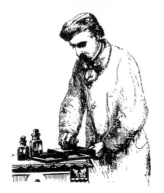

Polishing the plate

Sensitizing the plate

Illustration of the sequence of polishing, coating, sensitizing, and developing the plate. Source: Newhall, *History of Photography*, p. 48.

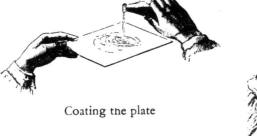

Coating the plate

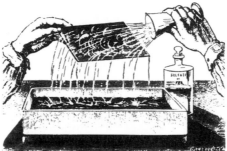

Developing the plate

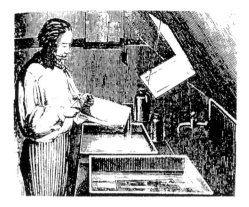

Photographer washing a glass plate in the darkroom.

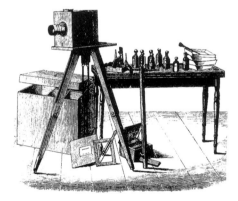

Illustration of photographic equipment including chemicals and supplies necessary for wet plate photography.

The main steps in making a collodion negative:

1 *Polishing.*

2 *Covering with a thin coat of collodion and potassium oxide, and draining off the excess.*

3 *Sensitizing (in the darkroom) in a bath of silver nitrate until it turned yellow.*

4 *Mounting (while still wet) in a dark slide.*

5 *Exposing in the camera by uncapping the lens for a measured time.*

6 *Removing from the dark slide (in the darkroom) and developing in pyrogallic acid.*

7 *Rinsing the developed negative in clean water.*

8 *Fixing in 'hypo' (hyposulphite of soda).*

9 *Washing thoroughly in running water.*

10 *Drying.*

11 *Finally (and optionally) varnishing to protect the emulsion.*

Ford, Kodak Museum

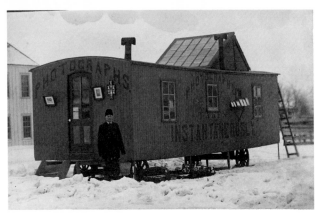

Photo cars like this one parked in Montezuma were quite common, traveling about the countryside. Some were pulled like wagons while others were converted railroad cars. Note the skylight on the roof, the shelf on the side for exposing plates, and the photos on display near the door. 1885. Taken by Robert L. Garnett, Montezuma (Poweshiek County). 4 1/4 x 6 1/2. State Historical Society of Iowa, Iowa City.

Toledo. Tama Co. Iowa.

July. 6 1866.

Mr. Wetherby,

I am offering the car building that I bought in the spring for sale at $180. As you requested me to write you a line when I wished to sell. I thought perhaps you would like to hear of such a bargain I am aware that the lumber it contains could not be bought in the lumber yard here today for less than that but it is an object with me to dispose of it this month.

Respectfully Yours,

H. A. Edwards

Wetherby Collection

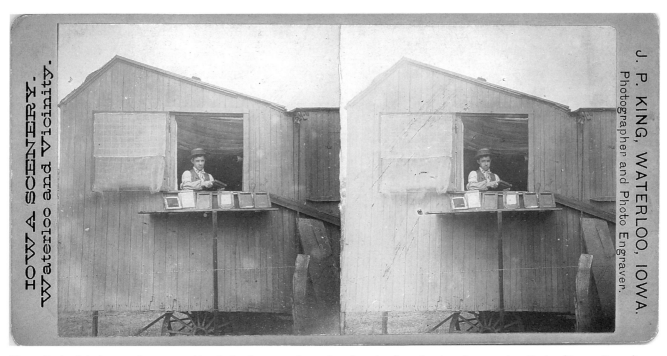

IOWA SCENERY.
Waterloo and Vicinity.

J. P. KING, WATERLOO, IOWA.
Photographer and Photo Engraver.

"Car at Festina." A photography wagon with printing frames used to make solar prints from the glass plate negatives, Festina (Fayette County), September 1894. Taken by J. P. King, Waterloo. Publisher: J. P. King, Series A. Stereo mount; orange, opp. pink. The backlist for the views King took that day appears on page 144. His stereographs stated: "Send 20 cents for 1; 50 cents for 3; $1 for 6; $2 for one dozen Views."

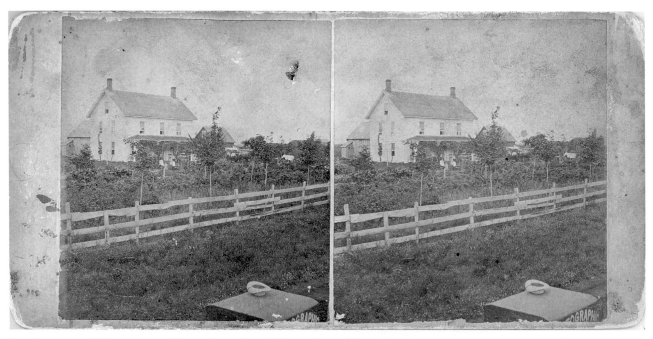

"R. Gilkerson and Millers residence," Marshalltown (Marshall County), n.d. Taken by unknown photographer. Stereo mount. The sign on the photographer's wagon in the foreground is barely visible. A hat has been placed upside down on the top of the wagon.

Backlists for
H. N. Twining
and M. M. Mott.

H. N. TWINING,

Makes all kinds of

OUT-DOOR VIEWS,

Such as Houses or Barns, Large or for Stereoscopes. Leave Orders at C. W WILLIAMSON'S, No. 308 Jefferson Street, Burlington, Iowa.

LIST OF STEREOSCOPIC VIEWS.

No. 1. Corner of Arch and Main Streets, Looking Southeast
" 2. Railroad Bridge, Crossing Mississippi River, from Vinegar Hill.
" 3. Corner of Washington and Fifth Streets, Looking South.
" 4. North Main Street, From Central Block.
" 5. Jefferson Street, From River Front, Looking West.
" 6. View of Aspen Grove Cemetery, Burlington, Iowa.
" 7. Corner of Jefferson and Fourth Streets, Looking North.
" 8. Washington Street, From River Looking West.
" 9. Iowa and Fifth Streets, Looking South.
" 10. Winton's Bluff, Looking Northeast.
" 11. " " " Southwest.
" 12. " " " North.
" 13. Corner of Valley and Fourth Streets, Looking West.
" 14. Corner of Division and Main Streets, Looking North.
" 15. Corner of Washington and Fourth Streets, Looking East.
" 16. Corner of Third and Columbia Streets, Looking South.
" 17. From Arch Street, Looking down South Main.
" 18. Corner of Valley and Boundary Streets, Looking North.
" 19. View of River, From the Corner of Third and Franklin Streets
" 20. High School Building.
" 21. View of Scenery at Starr's Cave.
" 22. "
" 23. "
" 24. Corner of Washington and Fourth Streets, Looking South.
" 25. Corner of Boundary and Valley Streets, Looking East.
" 26. Corner of Columbia and Main Streets, Looking South.
" 27. Division Street, from Main, Looking West.
" 28. Corner of Division and Fourth Streets, Looking North.
" 29. Corner of Fourth and Jefferson Streets, Looking West.
" 30. Corner of Boundary and Jefferson Streets, Looking East.
" 31. Corner of Fourth and Jefferson Streets, Looking East.
" 32. South Main Street, from Division
" 33. Columbia Street, from River Front, Looking West.
" 34. North Hill, from Vinegar Hill.
" 35. B. & M. Railroad Yard.
" 36. Corner of Third and Franklin Streets, Looking South.
" 37. Corner of Fifth and Division Streets, Looking North.
" 38. Market House, on day of Fireman's Parade.
" 39. Foot of Jefferson Street, on day of Firemen's Parade.
" 40. Cedar Rapids Railroad, from the Bluff.
" 41. Corner of Franklin and Seventh Streets, Looking South.
" 42. View of Burlington, from the East side of the River.

For Sale at Book Stores and Eggleston's News Depot.

I WILL KEEP TO THE HEAD OR KILL THIS MULE.

Duplicates of this Picture can be had at
any time by, calling at, or addressing

M. M. MOTT'S

✦NEW✦EXCELSIOR✦GALLERY✦

—AT—

ANAMOSA, (JONES CO.) IOWA,

Making views of Country Homes a
specialty. Am prepared to attend to a
call at a moments' warning.

MOTT✦ ANAMOSA'S PHOTOGRAPHER.

NEW

PHOTOGRAPH

GALLERY!

JORDAN & MACY,

Directly Opposite Carter House,

CEDAR FALLS.

Messrs. Jordan & Macy respectfully inform the Citizens of Cedar Falls and Vicinity, that they have opened a

FIRST-CLASS

Photograph Gallery,

As above, and are now ready to make

Any Kind and Style of Photograph Work.

CALL AND EXAMINE OUR SPECIMENS AND GET OUR PRICES.

Good Work Guaranteed on Cloudy or Rainy Days! 46

P. C. HUFFMAN & LADY,

Photographic Artists

All kinds of work pertaining to the art done in the best of style.

WAUKON, - - - IOWA.

J. C. WILSON.

PHOTOGRAPHER

Is om de andere maand in Le Mars,

Gedurende den zomer van 1874.—

TOWNSEND The Premium Photographer

TAKES CHILDREN'S

Pictures in Half Second BY THE New Lightning Process.

Bring on your babies A full line of FRAMES, CHROMOS, and the only

STEREOSCOPIC VIEWS OF IOWA CITY

a1478 PRICES AS LOW AS THE LOWEST. wly

TOWNSEND'S Corner Clinton and Washington sts, PRE UM IOWA CITY, IOWA. GALLERY.

LUCELIA CARPENTER,

PHOTOGRAPHER.

The only First-Class Gallery in the City.

PRICES GUARANTEED THE LOWEST.

West Side Main Street, Parkersburg, Iowa.

Newspaper ads for Jordan & Macy, Huffman & Lady, T. W. Townsend, Lucelia Carpenter, and J. C. Wilson. Wilson's text translates as "is every other month in Le Mars, during the summer of 1874."

Newspaper ad for J. Paul Martin.

ESTABLISHED, 1870.

Best Appointed Gallery in the City.

J. PAUL MARTIN'S PHOTO GALLERY.

Corner Eighth and Keeler Streets,

BOONE, IOWA.

OUR PRICES.—While we do not belong to that class of picture takers who are so anxious to practice on some body that they will take a man's picture and black his boots for *five cents*, yet our prices will *always* be as low as good reliable work can be produced or procured anywhere.

[J. Paul Martin] had a running newspaper feud with another Boone photographer named S. L. Mastin. One of Martin's "Card to the Public" in the Boone County Democrat *stated: "I wish to caution the public of the city of Boone and Boone County not to have any large pictures taken from one-half size to life size, at any gallery, or any other place or Places in the city or county, as I hold letters of patent on the said pictures for the city of Boone and Boone County. Any person having any of the above pictures taken after the publication of this notice, lay themselves liable to prosecution to the full extent of the law. The pictures are enlarged and colored in oil colors. Specimens can be seen at our Star Gallery. I have been informed that other parties in the city have been making these pictures."*

Boone County Republican, *May 24, 1876*

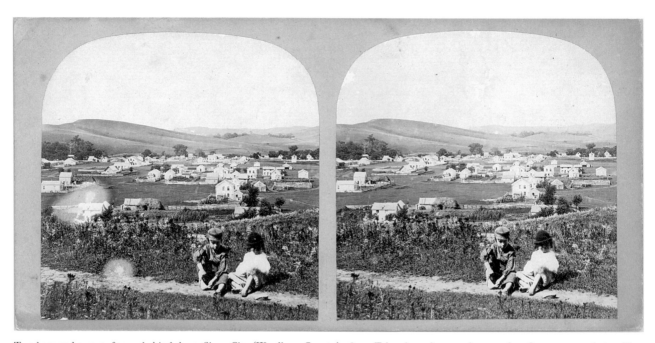

Two boys and a part of town behind them, Sioux City (Woodbury County), 1870s. Taken by unknown photographer. Stereo mount; beige. The children lend an immediate foreground to this image, with the Loess Hills as a vanishing point. Fences neatly mark plats of land featuring houses and barns scattered across the landscape rather than clustered tightly together as in large urban areas.

4 IOWA VIEWS

Iowa stereographs exhibit a captivating array of styles, compositions, and subject matter. Although thousands of unique Iowa views were created in the heyday of stereo photography, the few that still exist are indeed relics of the past. Selecting a sample was a tremendous task, although the proliferation of certain types of images became a determining factor. For example, the two most photographed subjects of the period seem to have been the Grinnell tornado in 1882 and the new state capitol in Des Moines, also in the 1880s. The sheer number and diversity of images on these two topics alone demonstrate the importance of stereo photography. Enlarged, framed landscape photos could have been easily made, but people preferred the three-dimensional reality of the stereograph.

Typically, stereo photographers documented Iowa's landscape and scenic areas, homes, churches, schools, businesses, government buildings, and public institutions. They sought out popular recreation sites and made a habit of recording leisure-time activities among Iowa's middle and upper classes. Their customers, wanting a tangible reminder of the good life they were enjoying in Iowa, bought souvenir views as keepsakes or to send to family and friends who were far away.

Stereo photographers were comprehensive in their coverage of the state, often securing a view from the exact spot where some other photographer had stopped. The commonalities among images or points of view are readily apparent, indicating that photographers were familiar with the pictorial lexicons of their day. The standards for the composition, lighting, and posing of subjects were well understood by these professionals, and high-quality images predominate. Oc-

casionally, mistakes occurred when a photographer misjudged the scene or used the fickle equipment and chemicals improperly. The images that follow are but a faint impression of the overall magnitude of stereo photography in Iowa.

FROM THE HIGHEST POINT

In a world of airplanes, space travel, and skyscrapers, the term "bird's-eye view" seems more than a little antiquated. It is now fairly easy to command a high position, often much higher than a bird can fly. In the age of stereography, however, the public was fascinated by the marvels of balloon ascension, a relatively new phenomenon. Artists had tried to capture imaginary bird's-eye views of towns to sell as lithographs, with details of the landscape, streets, and prominent buildings. Photographers were more limited in seeking out the pinnacle, for they actually had to reach the highest point in order to portray the view.

In rugged northeast Iowa, especially along the meandering Mississippi River valley, or in the western part of the state, near the Missouri River, it was easy to find a bluff or a rock outcropping that offered a memorable vista. The surrounding landscape or city view could be blended into the distance of the horizon, featuring the turn of the river, the wooded hills and valleys, or the beginning of the distant prairie. As Iowa's land flattened in the central and western plains, bird's-eye views were created from the top of the tallest building in town, often the just-completed courthouse, school, or grain elevator. Bird's-eye views were popular among the citizens of a town who wanted to show family back East how the West was developing.

The photographer's artistic ability came into play, as a dog, child, or tree placed in the foreground lent a sense of depth against the far background. Bird's-eye views were not easy to achieve. They required hauling cameras, plates, and equipment to the high point, which was usually a very precarious perch. Weather conditions could vary from the heat of an August day to the frosty chill following a winter ice storm. Later examples often show business streets from the second-story window or roof, indicating that the photographer did not travel far from the studio.

Iowa's natural landscape still features many of these early vantage points. We can return to the hills above McGregor where Theo Farrington took photos of his city; compare views by Samuel Root taken on Madison Hills above his own home looking out over Jackson Square; or see a view similar to G. M. Dempsie's views of tiny Clayton. Likewise, some of the historic buildings where photographers took their views also remain. T. W. Townsend, an Iowa City photographer, climbed the steps to the cupola of the Old Capitol to photograph a panorama of Iowa City; the Ensminger brothers carried their cameras to the top of the Wapsipinicon mill to record scenes of Independence before and after the devastating fire of 1874.

Venturing into the field to climb to the highest point was indeed an exciting and prosperous experience. The photographers' bird's-eye views document not only the buildings and scenery but also the people going about their daily lives. Sometimes even the skylight of the photographer's own studio appears, a self-conscious act by the photographer to become part of history.

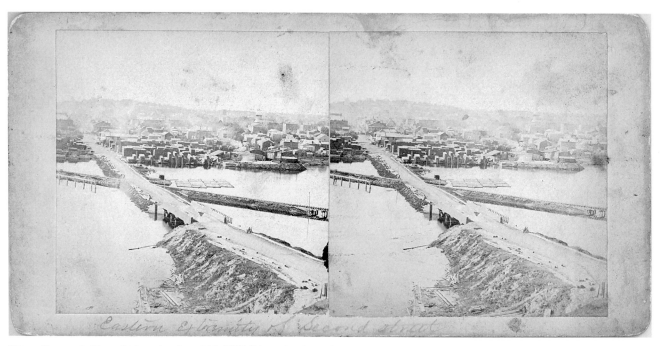

Eastern extremity of Second street

"No. 3. Panoramic View of Muscatine from Irish Hill" (Muscatine County), 1869. Taken by J. G. Evans (probable), Muscatine. Publisher: J. G. Evans. Stereo mount; yellow. "Eastern extremity of Second Street." Stacks of lumber line the shore, and log rafts float on the river.

Our readers will not fail to notice in another column the advertisement of our friend, Evans, of the New Union Photographic and Fine Art Gallery, situated next door to our office. We would advise all who want a good picture of any kind to call on Evans. We feel a degree of satisfaction in recommending this establishment to the public, as it is most certainly the finest and most complete photographic gallery in the state, being a substantial brick 30 by 40 feet, two stories high erected by the proprietor without regard to expense, expressly for the business. It is finished and furnished in superb style, and fronting one of the principal throughfares renders it one of the most pleasant resorts of the city. The walls are decorated with the rarest specimens of the art, making a great feast for those who have an eye for the beautiful. We hope to see his spirit of enterprise substantially appreciated by the public. . . . We have just been shown some photographs taken in the new room which we do not hesitate to pronounce as good as any ever taken in the state. We notice the large show case completely filled with all kinds of fancy frames and cases, photographic albums, etc. which we understand are directly from the manufactory of New York, and are sold cheaper than ever. We would recommend all who visit the city to visit the Union Gallery.

Muscatine Weekly Journal, *July 3, 1863*

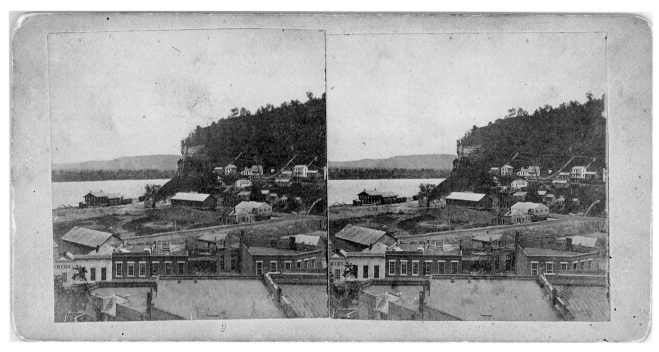

"No. 2." View of homes from top of building with river in background, McGregor (Clayton County), 1870s. Taken by Theo. Farrington, McGregor. Publisher: Theo. Farrington, Views of McGregor and Vicinity. Stereo mount; green. Note the skylight on the roof of the building (near left foreground).

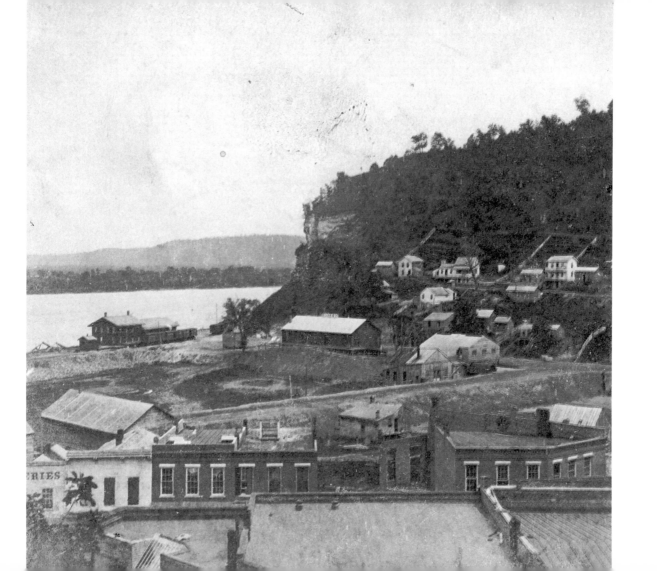

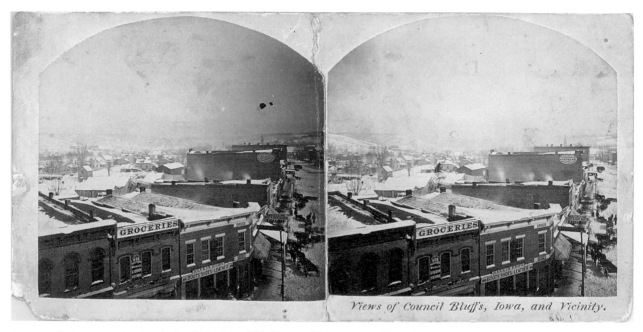

Views of Council Bluffs, Iowa, and Vicinity.

An unusual winter shot, showing the bend of a Council Bluffs street (Pottawattamie County), ca. 1870. Taken by J. Mueller, Council Bluffs. Publisher: J. Mueller, Views of Council Bluffs, Iowa, and Vicinity. Stereo mount; yellow.

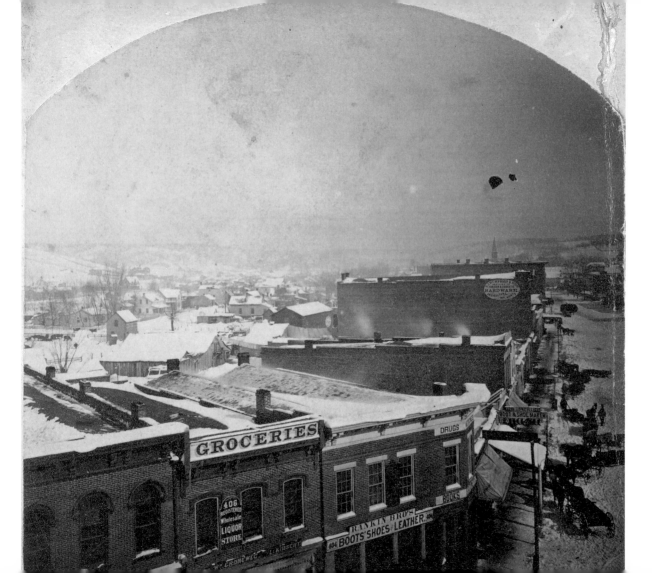

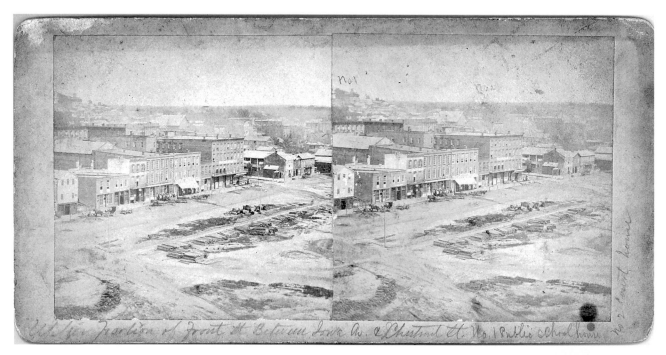

"No. 11. Panoramic View of Muscatine City from Richie's Grain Elevator" (Muscatine County), 1869. Taken by J. G. Evans (probable), Muscatine. Publisher: J. G. Evans. Stereo mount; yellow. "Upper portion of Front St. Between Iowa Av. & Chestnut St. No. 1 Public schoolhouse, No. 2 Court house." Evans was a pioneer in marketing series of panoramic views. Besides the Irish Hill Series, he sold views from Richie's elevator, complete in thirteen scenes; from the schoolhouse cupola, complete in fourteen scenes; and Muscatine Island, complete in six scenes.

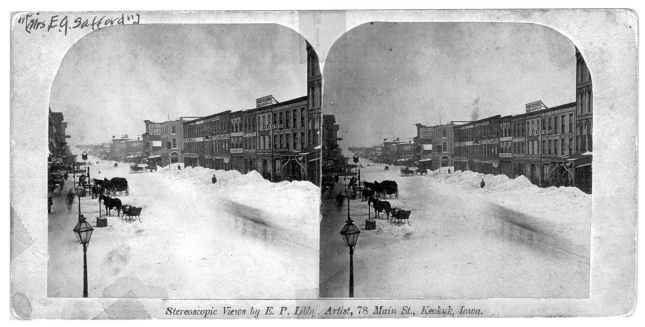

"Mrs. E.G. Safford"

Stereoscopic Views by E. P. Libby, Artist, 78 Main St., Keokuk, Iowa.

Business street, Keokuk (Lee County), 1870s. "Stereoscopic Views by E. P. Libby, Artist, 78 Main St., Keokuk." Publisher: E. P. Libby. Stereo mount; yellow. Notice the lampposts and sleigh and how the rapid movement of a person on the street appears as a blur.

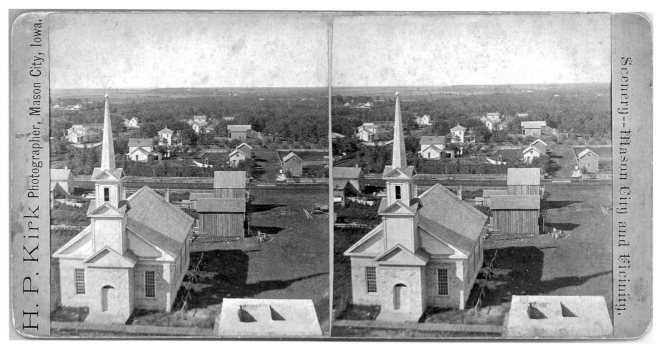

Church with homes in the background, Mason City (Cerro Gordo County), 1880s. Taken by H. P. Kirk, Mason City. Publisher: H. P. Kirk, Scenery—Mason City and Vicinity. Stereo mount; yellow, opp. beige. Truly a bird's-eye view at its best, Kirk's view was taken on a clear day, so that distant landforms are clearly visible, as are clothes hanging out on a line to dry. The lower right corner shows the top bricks of a chimney, very close to the camera.

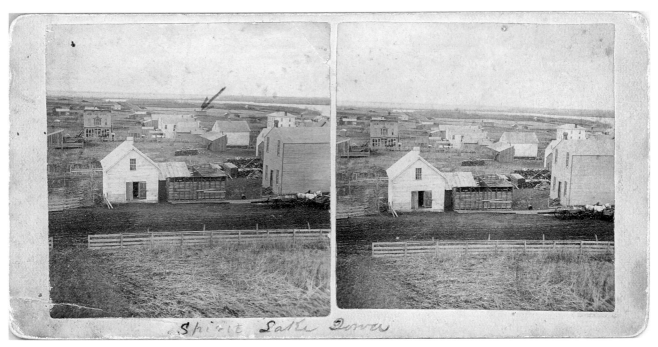

Spirit Lake Iowa

"Spirit Lake Iowa around 1872 or 73" (Dickinson County). Taken by Wm. J. Rood, Spencer. Publisher: Wm. J. Rood. Stereo mount; yellow. A frontier town view shows the stark simplicity of early buildings, although the sign for the New York Store is prominent.

View of the town of Harcourt in distance (Webster County), 1890s. Taken by A. L. Walline, Gowrie. Publisher: A. L. Walline, Swedish and U.S. Stereoscopic Views. Stereo mount; beige. The vastness of the plains is portrayed when snow covers the flat fields surrounding this town.

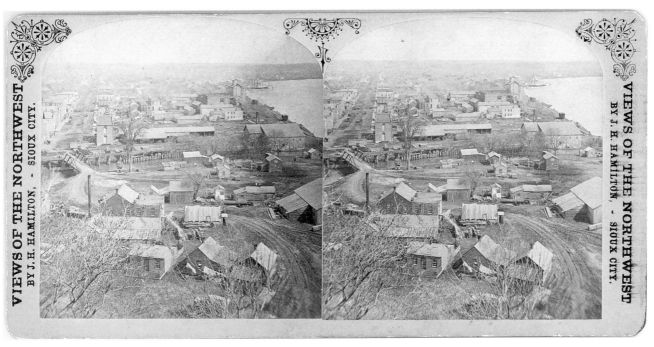

"Sioux City from Prospect Hill" (Woodbury County), 1880s. Taken by J. H. Hamilton, Sioux City. Publisher: J. H. Hamilton, Stereoscopic Views of the Northwest. Stereo mount; orange, opp. pink. Looking east from the top of Prospect Hill provides a view of the Missouri River and evidence of the booming river trade as seen in grain elevators, warehouses, and a distant steamboat. A wagon bridge and railroad trestle cross Perry Creek in the foreground.

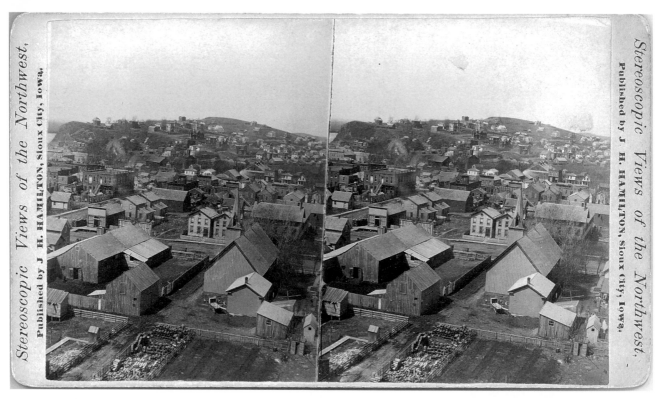

Stereoscopic Views of the Northwest.
Published by J. H. HAMILTON, Sioux City, Iowa.

"Prospect Hill," looking west across the city toward Prospect Hill at upper left, Sioux City (Woodbury County), 1870s. Taken by J. H. Hamilton, Sioux City. Publisher: J. H. Hamilton, Stereoscopic Views of the Northwest. Cabinet mount; beige, opp. yellow. The Missouri River is at the base of Prospect Hill.

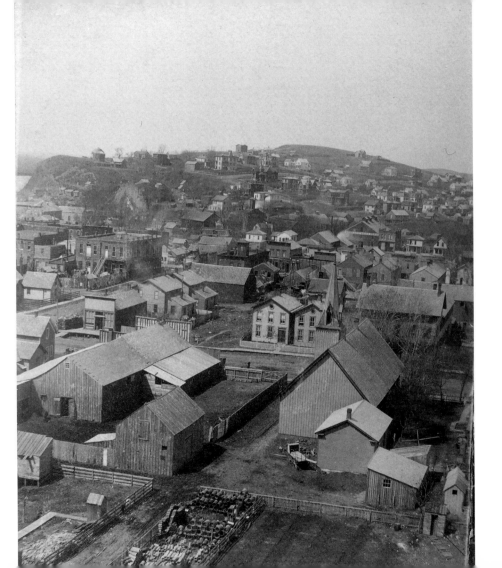

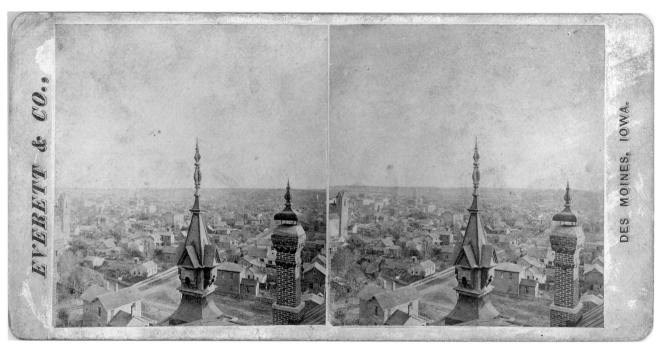

Rooftop view of Des Moines from the top of the Second Ward School House (Polk County), 1870s. Taken by Everett, Des Moines. Publisher: Everett & Co. Stereo mount; yellow. An exterior view of this school appears on page 190.

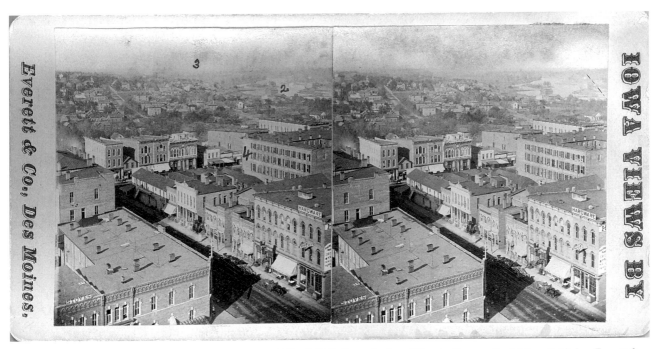

"View of Des Moines from top of C.H. [courthouse] looking N East" (Polk County), 1870s. Taken by Everett, Des Moines. Publisher: Everett & Co., Iowa Views. Stereo mount; yellow. This view predates the construction of the state capitol. The numbers refer to: "1) Fifth St., 2) Des Moines River, 4) Rear of Savery Hotel, the largest in Iowa; 3) Prairies stretching for 15 or 20 miles north of Des Moines." Look closely at the center of the image for a glimpse of a skylight on top of a photographer's studio.

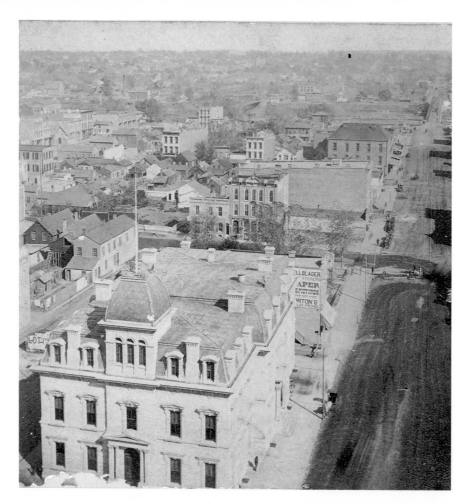

"View from the Court House looking east. I put a dot where the capitol is being built," Des Moines (Polk County), 1870s. Taken by Everett, Des Moines. Publisher: Everett & Co., Iowa Views. Stereo mount; yellow. A street-level view of the mansard-roofed post office can be seen on page 172. Note the changes in the surrounding block in the next view.

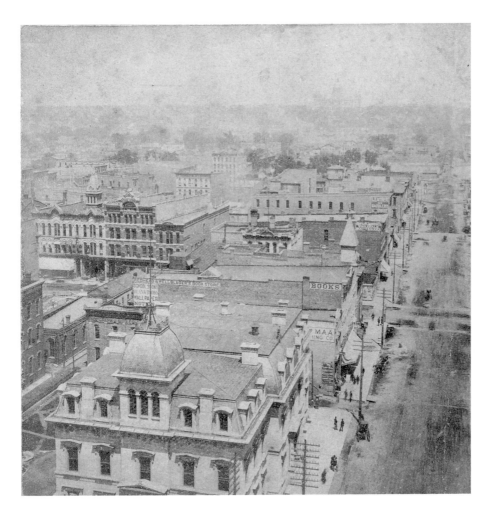

View from the top of the Court House looking east, showing the rapid growth of downtown Des Moines (Polk County), 1880s. Taken by unknown photographer. Stereo mount; pink, opp. orange. A number of new storefronts have filled in the vacant lots visible in the previous image, hiding older buildings from view. Houses have been torn down to make way for commercial structures, and telephone poles appear.

The beauty of the natural landscape attracted the attention of stereo photographers, who, as visual artists, managed to document the reshaping of the landscape to fit the needs of Iowa's small-town and rural dwellers. With a diverse topography, some pockets of the state — those with a particularly scenic river valley, wooded area, or high bluff — offered enticing views that in their own way rivaled the beauty of scenic areas elsewhere in the world. Open spaces, including fields and distant prairies, were photographed to show the wide expanse of the western horizon. Stereographs of unique geological features, like the Pictured Rocks near McGregor, were sure to be popular, as were other images showing the majestic landscape along the Mississippi River.

Iowa had been populated by European Americans for approximately thirty years — one generation — by the time stereo photography appeared. Stereographs reveal a certain level of maturity in terms of how quickly people transformed the state from a wilderness to a replica of "back East." Initially, settlers made use of the Mississippi and Missouri Rivers and inland waterways to bring supplies from markets outside the state, but soon after the Civil War, railroads penetrated the interior of the state. Iowa stood at the crossroads of the nation once the transcontinental railroad was completed, and many travelers would pass through the state or come into contact with its borders, bringing the national culture to its doorstep.

The ability to process and transport farm products to markets elsewhere was of paramount importance, so the first order of business was the construction of bridges and roads. Dams generated water power for gristmills, sawmills provided lumber for construction, and steam power drove

the engines of industry. Vehicles drawn by oxen or horses were the dominant form of transportation, while steamboats, ferries, trolleys, and railroads continued to link communities and serve the needs of commerce. Railroads expanded their major trunk lines with a lacy network of feeder lines to smaller farming communities and built engineering marvels like the bridges captured so vividly by stereo photographers.

These photographers were in the midst of all this development, taking advantage of their mobility to find and document the impact of people on the natural environment. As entrepreneurs, stereo photographers succeeded because of this state of flux, recording how transient and temporary life in Iowa was in the Gilded Age. As artists, they had their finger on the pulse of society and recognized that some of Iowa's features would quickly disappear and that a permanent record of these changes might be valuable beyond the visual pleasure created.

An ox pulling a wagon,
Maquoketa (Jackson County),
1870s. Taken by R. G. Gardner,
Maquoketa. Publisher: R. G.
Gardner. Stereo mount; yellow.

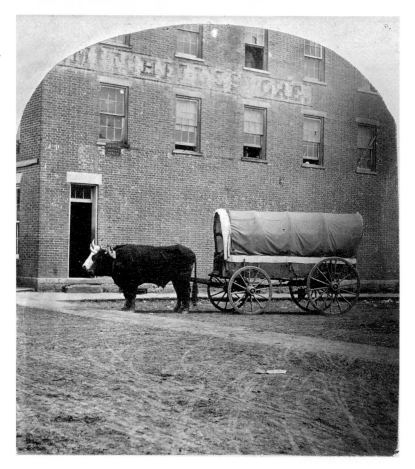

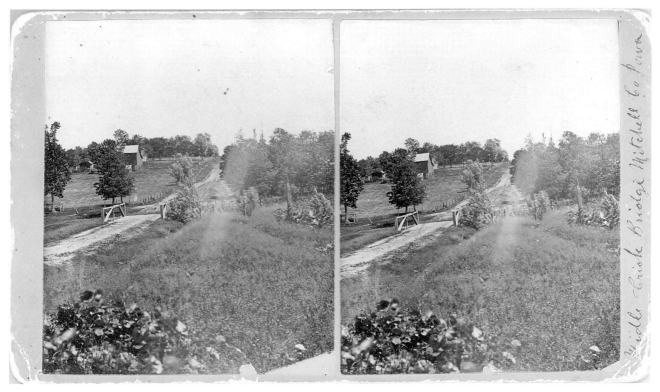

"Middle Crick Bridge Mitchell Co. Iowa," St. Ansgar (Mitchell County), 1885. Taken by A. J. Clausen, St. Ansgar. Publisher: A. J. Clausen. Cabinet mount; orange, opp. pink. Much of the native vegetation is visible in these stereograph views of Iowa's countryside.

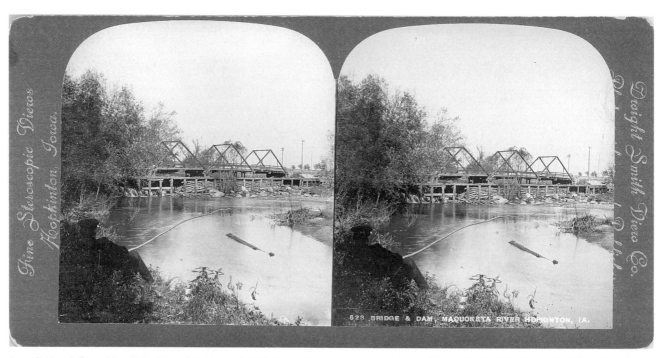

"523. Bridge & Dam, Maquoketa River, Hopkinton, Ia." (Delaware County), ca. 1900. Taken by Dwight Smith, Hopkinton. Publisher: Dwight Smith. Curved stereo mount; gray. Timber bridges and log dams were prevalent even after telegraph poles appeared. A man and his fishing pole are almost hidden in the shadows at the left.

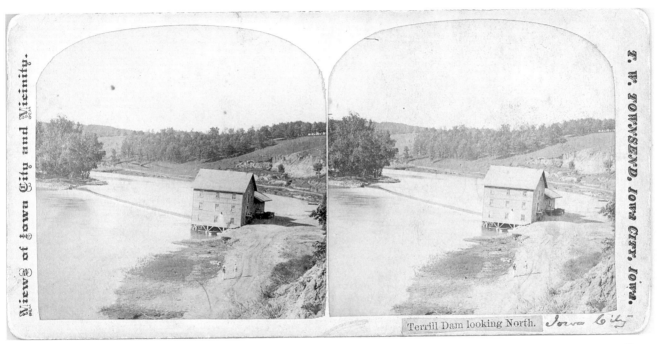

Views of Iowa City and Vicinity.

T. W. TOWNSEND, IOWA CITY, IOWA.

Terrill Dam looking North. *Iowa City*

"Terrill Dam looking North," Iowa City (Johnson County), 1870s. Taken by T. W. Townsend, Iowa City. Publisher: T. W. Townsend, Views of Iowa City and Vicinity. Stereo mount; yellow. State Historical Society of Iowa, Iowa City. Dubuque Street now claims this familiar corridor north out of Iowa City, and the Iowa River has been rechanneled.

"No. 54. Sawmill on the Maquoketa River," Maquoketa (Jackson County), 1870s. Taken by R. G. Gardner, Maquoketa. Publisher: Brady & Co., Philadelphia, Iowa State Scenery. Stereo mount; yellow. Sawmills located throughout the forests of eastern Iowa supplied lumber for building or wood for fuel. Gardner was able to sell his Iowa views to a national distributor.

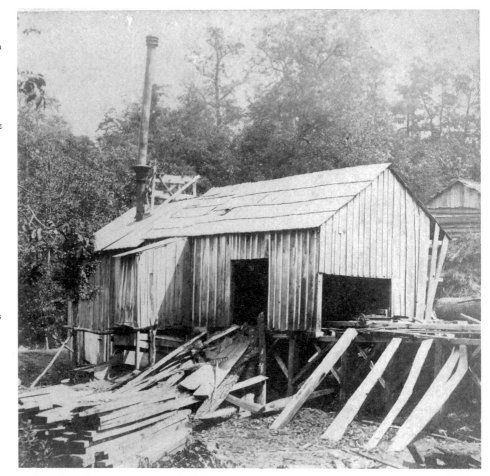

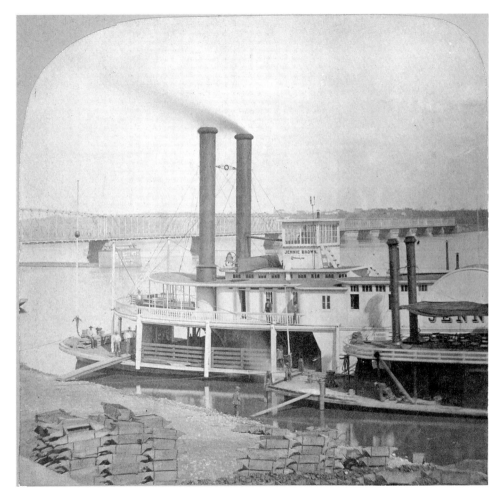

"S.S. Jennie Brown," a steamboat, thought to be on the Des Moines River, 1870s. Taken by unknown photographer. Cabinet mount; orange, opp. pink. On the shore are neatly stacked wooden carriers, probably used to transport goods on and off the boats.

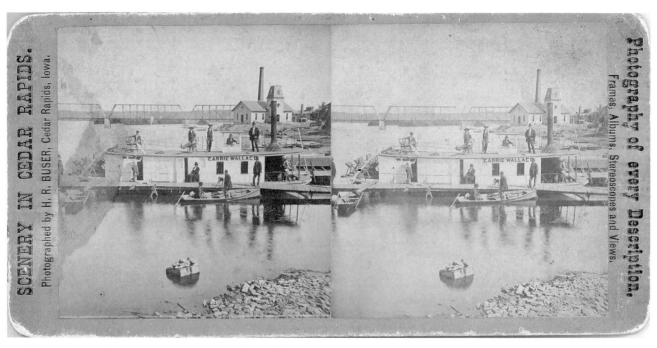

The *Carrie Wallace*, a flat-bottomed riverboat, Cedar Rapids (Linn County), 1870s. Taken by H. R. Buser, Cedar Rapids. Publisher: H. R. Buser, Scenery in Cedar Rapids. "Photography of every Description. Frames, Albums, Stereoscopes and Views." Stereo mount; orange, opp. pink.

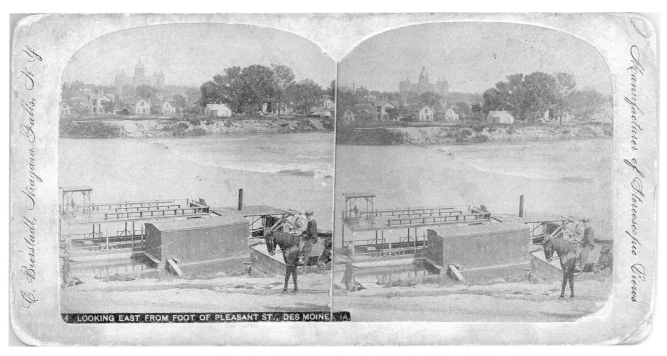

C. Bierstadt, Niagara Falls, N. Y.

Manufacturer of Stereoscopic Views

LOOKING EAST FROM FOOT OF PLEASANT ST., DES MOINES, IA.

"No. 14. Looking East from Foot of Pleasant St., Des Moines" (Polk County), 1880s. Taken by C. Bierstadt, Niagara Falls, N.Y. Publisher: C. Bierstadt. Stereo mount; beige. Ferry service provided the link across rivers before bridges were built. Note the new state capitol looming on the horizon. National distributors like Charles Bierstadt of Niagara Falls, New York, purchased negatives from local photographers, thus expanding the market for Iowa views.

"Before the fire—From the Mill No. 3," Independence (Buchanan County), 1874. Taken by Ensminger Bros., Independence. Publisher: Ensminger Bros. Stereo mount; green. Part of a series of panoramic views taken from the top of the Wapsipinicon Mill before a fire devastated the town on May 25, 1874. The rocks in the riverbed are visible either because the water was shallow and very still or because the camera could not capture the movement of the water.

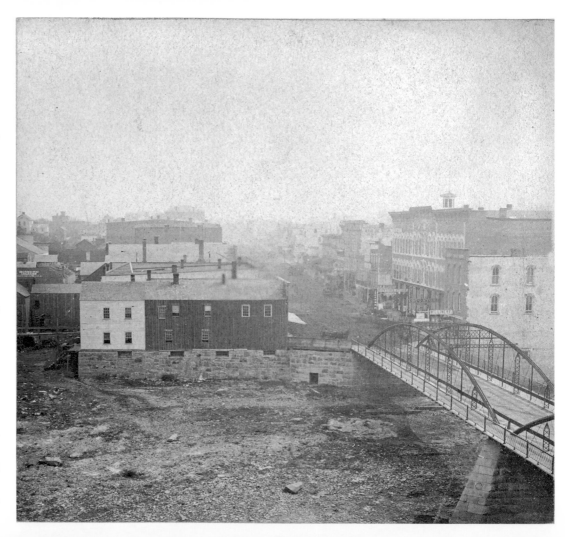

Referring to the Ensminger Brothers of Independence: These young men are sons of Mr. E. M. Ensminger,

a photographer of considerable renown in the east, and from whom they received much valuable knowledge

in the art. This firm has associated itself with the business interests of this community for the past several

years, and are among those men who, by their honorable dealing and complete understanding and

knowledge of their business and never wavering determination to give perfect satisfaction, have won for

themselves a favor with the people that is not only creditable, but assures a business that will be both

satisfactory to themselves and the community at large. Their spirit of enterprise has not been confined

within the walls of their studio, but objects of interest everywhere in the city have been visited and a

negative taken. They have on file an illustrated history of Independence, consisting of stereoscopic views

of the city in its infancy, and when it lay in ruins, made waste by the fire in 1874.

History of Buchanan County, *1881*

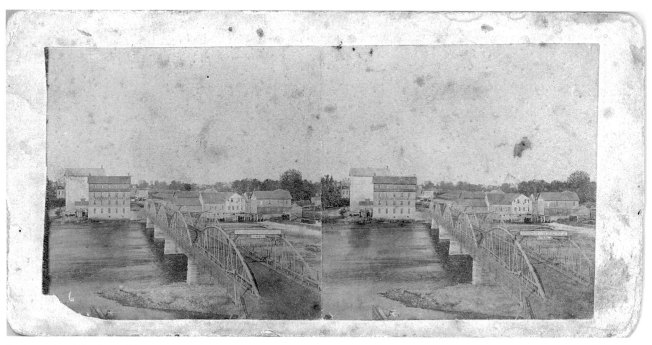

Bridge on the Cedar River. The sign states "Waterloo Woolen Mills," Waterloo (Black Hawk County), 1870s. Taken by J. S. Buser (probable), Waterloo. Stereo mount; pink, opp. orange. Built in the 1870s to replace original wood bridges, bowstring arch bridges like this one were once very common in Iowa.

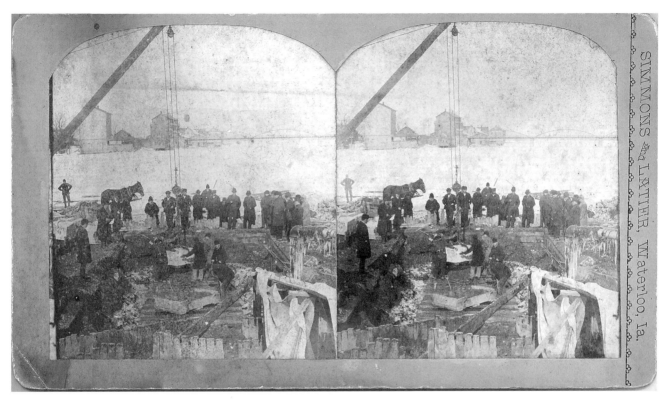

SIMMONS and LATIER, Waterloo, Ia.

Multiple stages of a major bridge-construction project, like this view of a hoist moving a block of stone, were recorded by Simmons & Latier, Waterloo (Black Hawk County), ca. 1889. Taken by Simmons & Latier, Waterloo. Publisher: Simmons & Latier. Cabinet mount; orange, opp. pink. The bridge and Waterloo Woolen Mills seen in the previous stereograph appear here in profile in the background.

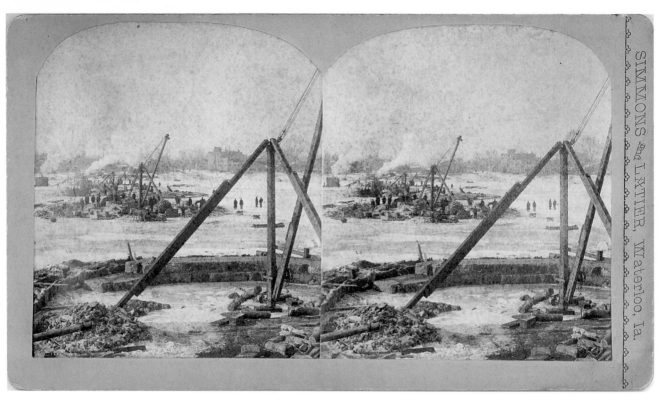

In the winter while the river is frozen, workers build a series of stone bridge piers across the Cedar River, Waterloo (Black Hawk County), ca. 1889. Taken by Simmons & Latier, Waterloo. Publisher: Simmons & Latier. Cabinet mount; orange, opp. pink.

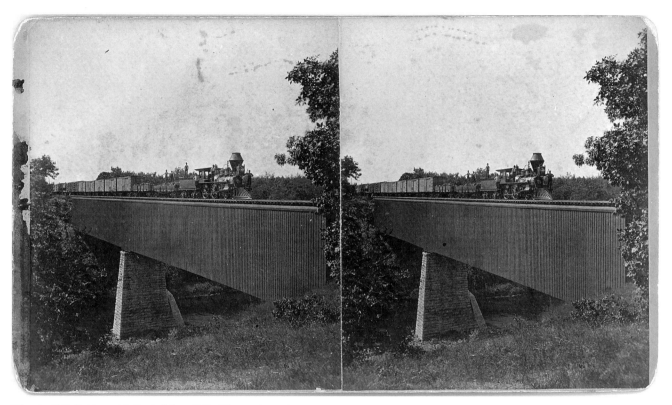

"No. 187. R.R. Bridge, with Train," Iowa Falls (Hardin County), 1880s. Taken by I. L. Townsend, Iowa Falls. Publisher: I. L. Townsend, Iowa Falls and Vicinity. Cabinet mount; orange, opp. pink. Townsend took two views of this bridge. The other is taken from far below, at the base of the bridge, looking up.

"High Bridge on D.M. and N. R.R.," Des Moines (Polk County), 1870s. Taken by J. Everett, Des Moines. Publisher: J. Everett, Des Moines Scenery. Cabinet mount; green. The colossal structural supports for this timber railroad bridge dwarf the humans in the foreround, providing the scale and perspective desired by the photographer.

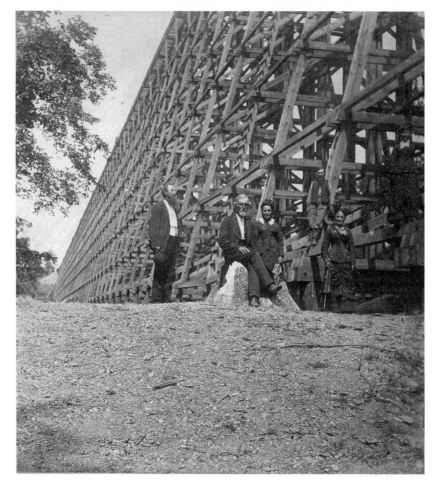

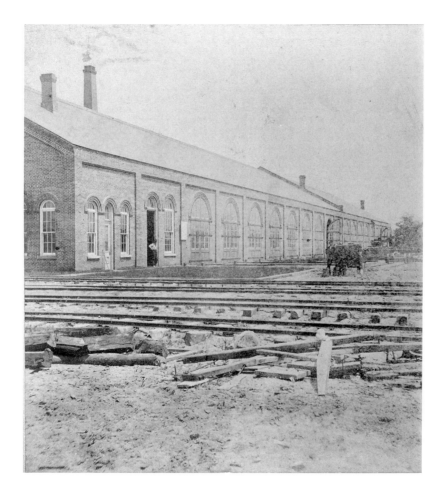

Railroad shops, Cedar Rapids (Linn County), 1880s. Taken by W. F. Kilborn & Rifenburg, Cedar Rapids. Publisher: W. F. Kilborn & Rifenburg, Portrait and Landscape Photographers, Cedar Rapids and Vicinity. Cabinet mount; green. Extensive railroad yards and roundhouses were necessary to maintain the locomotives, cars, and tracks used throughout the state.

In 1863, William Franklin Kilborn came to Cedar Rapids, Iowa, and began the study of photography in the gallery of his uncle Wilbur F. Kilborn. In 1878, William purchased a half interest in his uncle's business and in 1886 became the sole owner. . . . William studied chemistry and experimented with various products succeeding in producing a printing out paper which has worked wonderously ever since. He organized the Western Collodion Paper Company to produce and market this product. In 1894 the Eastman Kodak Company purchased this company and Mr. Kilborn spent a year at Rochester, New York in establishing the manufacture of his invention. When Mr. Kilborn returned to Cedar Rapids he reopened his gallery and also opened a store for the sale of photo supplies, artists materials and pictures. His interest in the manufacture of photopapers did not abate. He felt the method he had invented was to [sic] slow and began experiments in the manufacture of papers so sensitive that they could be printed with artificial light. He was so successful that his paper, under the brand Kruxo, was the second developing paper on the market. The Kilborn Photo Paper Company was organized for the manufacture of this product. The company was founded in 1895 and remained in the hands of the founding family until 1955 when it was sold to C. H. Jordan. Newsletter from Kilborn Photo Products

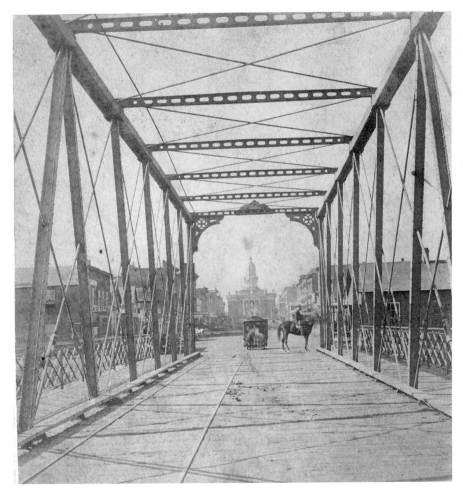

"C.H. [courthouse] Bridge," with a horse-drawn trolley coming across, Des Moines (Polk County), 1871. Taken by Everett, Des Moines. Publisher: Everett & Co., Iowa Views. Stereo mount; yellow. Note the horse droppings in the foreground. The courthouse visible in the distance at the end of the bridge can be seen on page 173.

As small-town entrepreneurs stereo photographers were aware of the changing milieu of America's commercial life and the opportunities available for ambitious and energetic individuals who wanted to work for themselves. An entire generation was caught up in the excitement of an age dominated by westward migration mixed with burgeoning industrialization and consumerism. Change was everywhere, and photography became the technical vehicle for recording, promoting, and capitalizing on the rise of the middle class. Situated in the midst of a countryside surrounded by family farms, the photographers also documented the last gasp of the frontier experience in Iowa as farmers and town builders established new communities across the state.

The work of stereo photographers reflects the various stages of Iowa's settlement, from urban centers refined since the pioneer period to the infant towns in the western part of the state. Town builders, civic leaders, merchants, and politicians fulfilled a self-conscious need to promote their towns in order to sustain the local economy and encourage additional growth. Photographers, like the newspapers and printing establishments in town, played a role equivalent to that of local advertisers, helping to boost trade. By the 1870s, stereo photographers could be found in even the smallest community, in the hope that enough affluent citizens existed to support a portrait studio and serve as potential clients for local views. Moreover, photographers were based in towns because they were dependent on local optical and chemical merchants for regular access to photographic supplies.

Using stereographs as a magnet, the enterprising spirits who developed Main Street hoped to draw more people to their community and instill a sense of hometown pride among residents. Stereographs were taken to glorify progress and change by portraying robust towns with bustling activity. While western towns convey a rougher existence, with dirt roads and false storefronts, Iowa's urban centers showcased grand buildings, paved streets, and other amenities, like gas lampposts.

By the 1890s, Iowans were moving forward because of prosperity brought by ideal farming conditions, the growth of small industry, and expanded educational opportunities. The shift in scale of the buildings on Main Street is dramatically evident from the stereographs, another sign of the rapid displacement or modification of structures built during earlier boom periods. Despite the diverse geographical settings, the images also point to the uniformity of appearance in Iowa's communities, which share many characteristics drawn from the architectural heritage of the nation. Typically, stereo photographers sold pictures of banks, hotels, individual storefronts, and general views of main streets. Brick, stone, and frame structures in a variety of sizes and styles appear, as do elaborately lettered advertising signs, wooden boardwalks, crates packed with goods, hitching posts, and buckboard wagons.

Less frequently, stereo photographers ventured inside to take interior shots; those images that survive offer an especially rare glimpse of early business and industry in Iowa. In fact, the stereograph showing workers near belt-driven machinery (on page 114) is the only one of its kind in the entire sampling of two thousand Iowa stereographs. Similarly, stereo photographers seldom photographed the many smaller businesses or individual artisans and skilled laborers in their com-

munities, making such views as the ones of the cooperage workers or the farm implement dealer even more scarce.

Main Street was both a corridor and a stopping place — the hub of activity for the surrounding rural residents as well as for town dwellers. It was a gathering place for transacting business and socializing with neighbors. By fostering a distinctive local identity and helping to reinforce the ideals of democracy, Iowa's small towns and urban centers epitomized the realization of the American dream, and stereo photographers took note of this historic phenomenon.

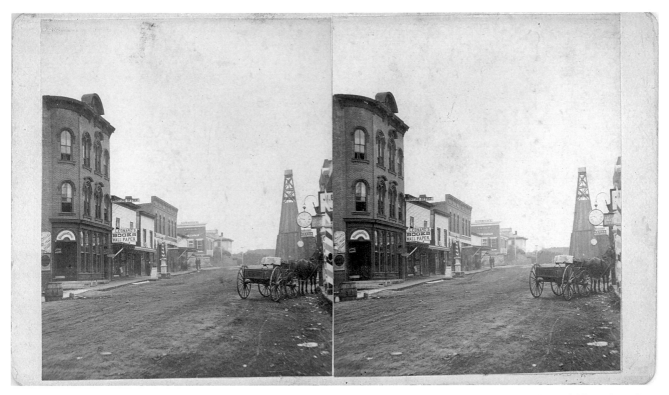

"17. Views on Winnebago Street," Decorah (Winneshiek County), 1880s. Taken by Hover & Wyer, Decorah. Publisher: Hover & Wyer, Views In And About Decorah, Iowa. Cabinet mount; yellow.

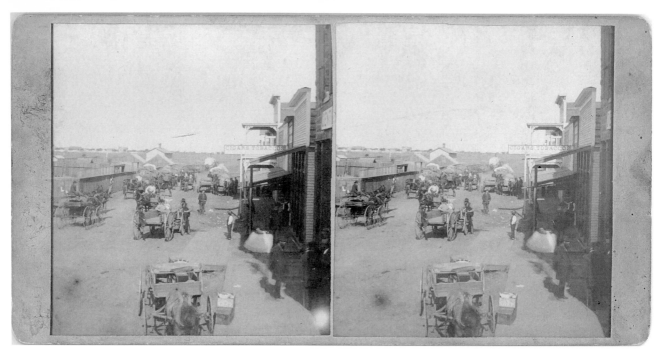

Street scene with wagons and a sign saying "Cigars and Tobaccos," Indianola (Warren County), 1880s. Taken by Mrs. L. A. Schooley, Artist, Indianola. Publisher: Mrs. L. A. Schooley. Stereo mount; green. This view of a frontier community on the flat prairies features buckboard wagons and possibly a covered wagon far down the street.

[W. H. Schooley] married Miss Lydia Gochnaur, in 1861. She was born in Columbiana County, Ohio. Their family consists of five children, Lillie, Minnie, Frank, Maggie, and Emma. Mrs. Schooley has a photograph gallery, and her skill as an artist cannot fail in being as satisfactory to herself as it is creditable to the city.

History of Warren County, *1879*

Main street of Alden (Hardin County), n.d. Taken by H. M. Reynolds, Alden. Publisher: H. M. Reynolds. Stereo mount; pink.

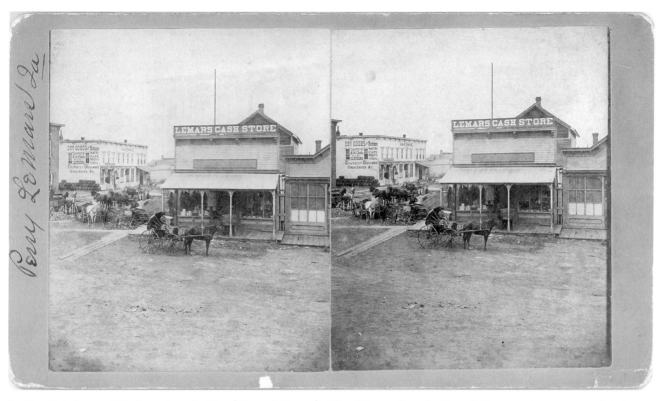

Le Mars Cash Store and Hardware Store, Le Mars (Plymouth County), 1880s. Taken by Perry, Le Mars. Cabinet mount; orange, opp. pink. Some work is going on in the street, possibly the laying of sewer tiles or board sidewalks.

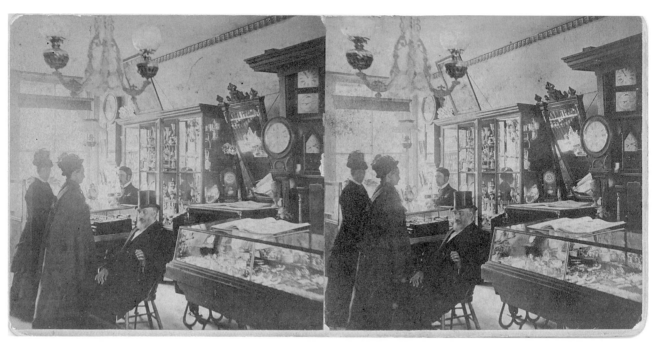

"Compliments of Moses Greer, Jr. Jeweler, Decorah, Iowa" (Winneshiek County), Christmas 1878. Taken by A. W. (Asa) Adams, Decorah. Publisher: A. W. Adams. Stereo mount; yellow. This stereograph was used as a Christmas premium by the merchant Moses Greer, Jr., to attract customers to his shop.

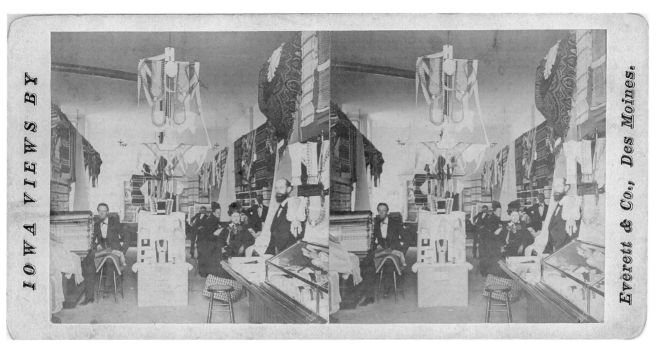

"Interior of Bird's Dry Goods Store at Des Moines" (Polk County), 1870s. Taken by Everett, Des Moines. Publisher: Everett & Co., Iowa Views. Stereo mount; yellow. Interior views of stores are exceedingly rare for this period, but often show creative displays of goods.

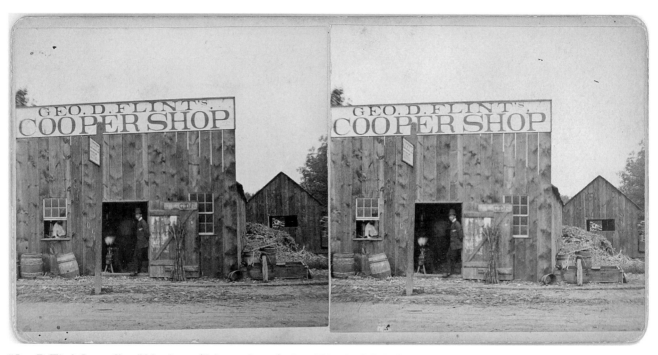

"Geo. D. Flint's Cooper Shop," Manchester (Delaware County), 1870s. Taken by C. B. Mills, Manchester. Publisher: Mills' Premium Photograph Gallery. Stereo mount; pink. "Photographs of all sizes and kinds, in the Latest Styles of the Art."

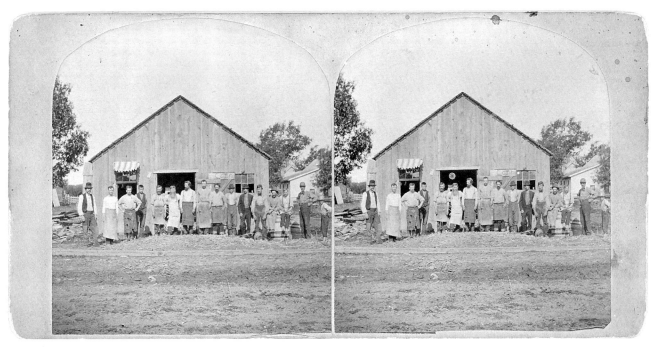

George D. Flint's Cooper Shop with workers in front, Manchester (Delaware County), 1870s. Taken by C. B. Mills, Manchester. Publisher: Mills' Premium Photograph Gallery. Stereo mount; green. Another view in the series shows the back of the shop.

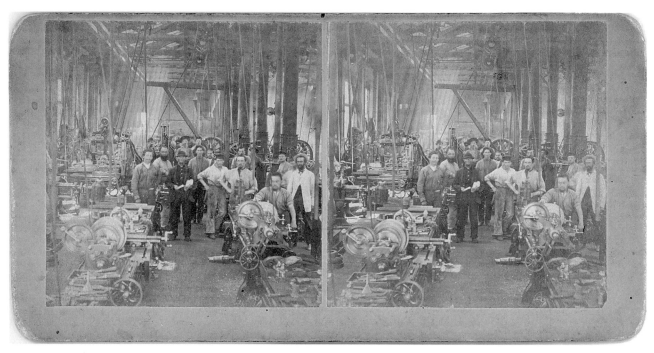

Interior of factory, Waterloo (Black Hawk County), 1870s. Taken by Hickox, Waterloo. Publisher: Hickox & Co. Stereo mount; yellow. The industrial age in America dawned with the coming of steam-powered engines. Note all of the belts extended to the overhead power-drive system.

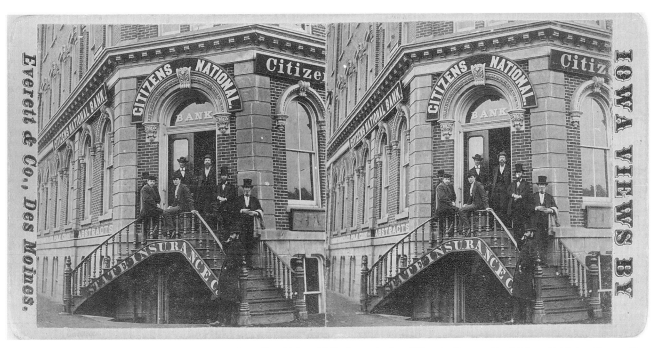

Citizens National Bank, with enterprising spirits in front, Des Moines (Polk County), 1873. Taken by Everett, Des Moines. Publisher: Everett & Co., Iowa Views. Stereo mount; yellow. Distinct social classes existed in Iowa, as is evident in the contrast between this image of capitalists and the portraits of laborers in the previous two images.

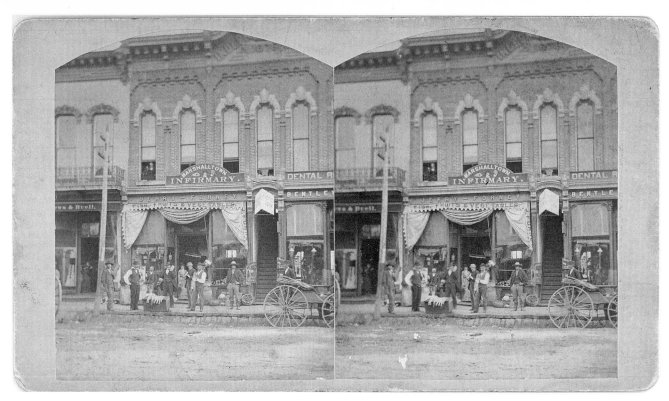

Marshalltown Infirmary and Jerry-Forney Fish, Fruits & Vegetables, Marshalltown (Marshall County), ca. 1880. Taken by Clement, Marshalltown. Publisher: Clement's Art Palace, Cor. Main & Centre Sts. Cabinet mount; beige.

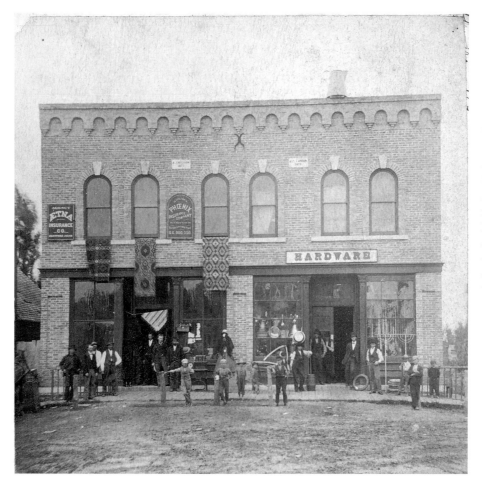

Large brick
building with
a hardware
sign, possibly
in Calmar
(Winneshiek
County), 1870s.
Taken by A. W.
(Asa) Adams,
Decorah.
Publisher: A. W.
Adams. Stereo
mount; yellow.
Note the wares
on display and
the coffeepot
on top of the
building.

Samuel Wise received his early education in the district schools, and as he grew up assisted in the work of the home and at the mill. At the age of seventeen, having heard many stories of sudden wealth acquired in the mines of Colorado, he yielded to the excitement that then prevailed in many regions of the west and crossed the plains to the Rocky Mountains, where he spent a year and a half prospecting and digging for the yellow metal. However, he came to the conclusion that it was not his destiny to become wealthy as a miner, and he returned to Cedar County, Iowa, where in the summer of 1862, he enlisted in Company G, Thirty Fifth Iowa Infantry, to serve for three years in the cause of the Union. After spending a year upon the home farm, he took up photography and was engaged in that business at West Liberty, Iowa, for one year. He then removed to Wilton Junction, where he has ever since continued in the same line, being now the oldest business man in the town. By close application, he has built up a large patronage and enjoys a handsome competence, so that if he desires to do so he may spend the remainder of his life in well earned rest. He also conducts a well equipped jewelry store in connection with his photograph gallery.

History of Muscatine County, *1911*

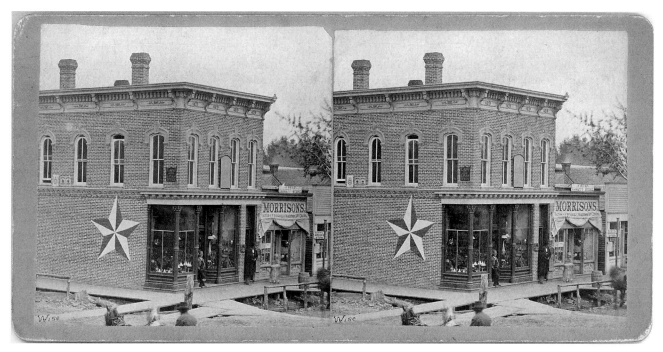

The Star Drug Store on a street corner in Wilton (Muscatine County), 1870s. Taken by S. H. Wise, Wilton. Publisher: S. H. Wise. Stereo mount; orange, opp. pink. The grand two-story brick storefront dwarfs the smaller frame "Cheap Variety Store" and "Scovil Grocery Store" next door.

F. H. Juckett's agricultural implement store, Clarence (Cedar County), 1880s. Taken by J. S. Buser, Waterloo. Publisher: J. S. Buser, Home Scenery. Stereo mount; orange, opp. pink. Juckett also sold other staples—lumber, wood, and coal—to the surrounding farm community.

"Merchants Block—Built in 1877 & later," Waterloo (Black Hawk County), ca. 1877. Taken by J. S. Buser, Waterloo. Publisher: J. S. Buser, Home Scenery. Stereo mount; orange, opp. pink. Note how steps lead down to lower-level stores. Buser took two views of this building, one from a greater distance.

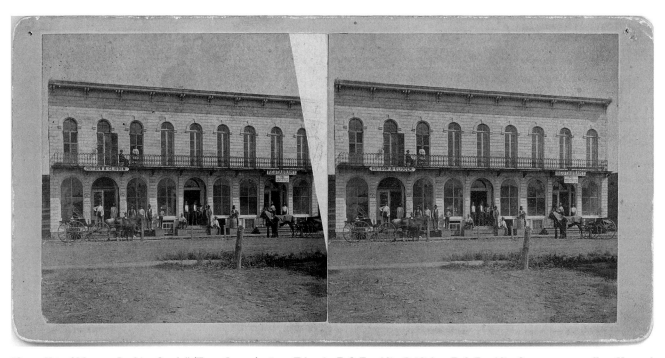

"Street Vue of Montour Looking South," (Tama County), 1870s. Taken by E. S. Franklin. Publisher: E. S. Franklin. Stereo mount; yellow. Unusual for the stonework, arched windows, and decorative iron railing, this structure must have been among the nicest in town.

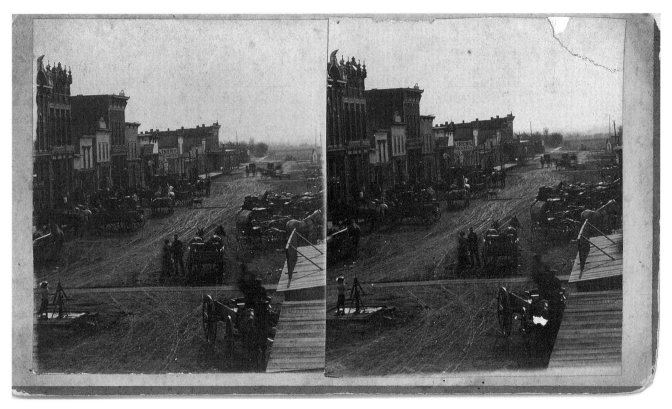

Street scene with town pump in left foreground, Shenandoah (Page County), ca. 1880. Taken by W. H. Brewer, Shenandoah. Publisher: W. H. Brewer. Cabinet mount; beige with gold-bordered mount, opp. pink. The photographer is perched on the second story in order to capture a broader view of the town.

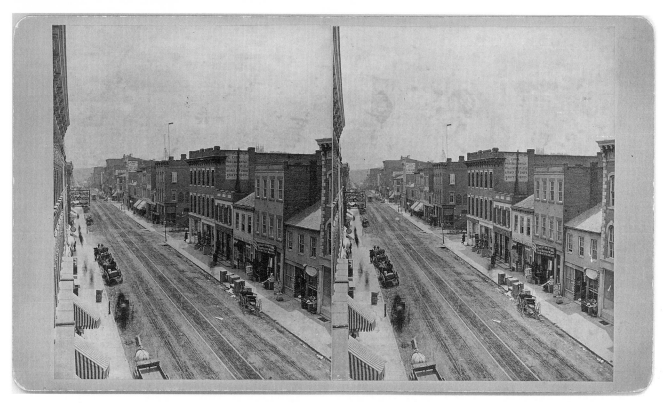

"8. Main Street, West Side, South from cor. Seventh St.," Dubuque (Dubuque County), 1880s. Taken by Grosvenor & Harger, Dubuque. Publisher: Grosvenor & Harger, Views of Dubuque, Iowa. Cabinet mount; orange, opp. pink. Notice the streetcar off in the distance and the crates of unpacked goods on the sidewalk.

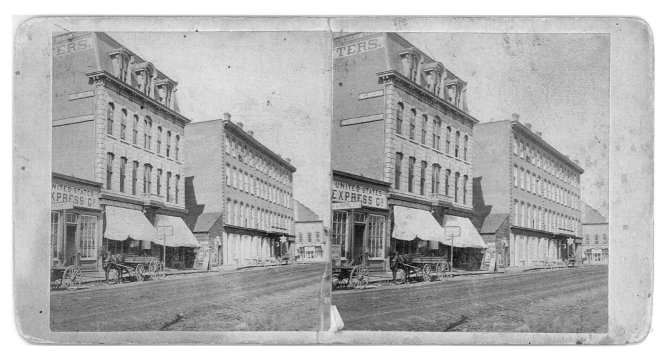

Street scene, possibly Fourth or Walnut, Des Moines (Polk County), ca. 1878. Taken by H. N. Little, Oskaloosa. Publisher: H. N. Little, Glimpses of the Great West. Des Moines Series. Stereo mount; yellow. When one scours these images with an eagle eye, little details emerge. The sign for "H. Cheoung" next to the United States Express Co. office refers to two Chinese merchants, A. R. Shong and Cheoung, listed in 1875 as dealers in teas and spices. The Savery House is at the right.

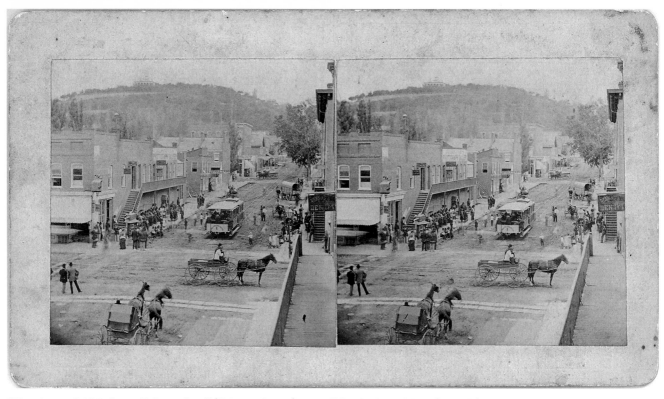

"Direction north Main Street, Dubuque Iowa" (Dubuque County), 1870s. Taken by Samuel Root (probable), Dubuque. Publisher: Samuel Root (probable). Cabinet mount; pink, opp. beige. This apparently shows Dubuque's first streetcar at the corner of 8th and Main. Notice the circular track for turning the car around (in front of car). At the base of the stairway is a photographer's advertising kiosk, topped by an oversized camera. The stairs lead to a "Photography Gallery."

First and foremost, stereographs had a journalistic element meant to satisfy a public eager for visual evidence of historically significant and newsworthy events. The unprecedented marriage of text with photography — which already carried a great deal of credibility in terms of accuracy and authenticity — lent an unusual aura to the medium. Observers of the world were curious to see the latest discovery, national event, or catastrophe portrayed, and stereo photographers responded to this demand by using stereographs to provide full coverage of the story, creating almost an encyclopedia of visual information.

In many respects, all of the Iowa stereographs represent the news of the day by documenting social history, but these particular images demonstrate exactly how stereo photographers capitalized on major events by issuing cards immediately — when public interest was high. Viewers probably liked the sensational quality and the degree of clarity stereographs offered in realistically capturing the extremes of Iowa weather and the results of powerful destructive forces. Railroad wrecks, fires, floods, tornadoes, heavy snowfalls, and any type of unusual natural phenomenon were deemed newsworthy, a guaranteed market for views.

The timely issue of a newsworthy stereograph was an important factor in successful marketing, and clearly the local photographer could deliver pictures faster than the popular press. In lieu of a photograph, the public had to rely on a narrative description of the scene, which could obviously be distorted, or artists' renditions of the scene printed weeks later in literary magazines. For instance, Alexander Simplot, an acclaimed sketch artist for *Harper's Weekly*, executed his own

version of the disastrous Rockdale flood for publication on July 29, 1876 — three weeks after the event. Nonetheless, stereo photographers borrowed a few traits from the field of journalism such as precise dating, headline-like titles, and documentation of various stages of a story. The Rockdale Views stereo card describes the impact of this event, written in a style similar to newspaper stories of the day.

The unusually high number of views of the 1882 Grinnell tornado proves how lucrative this genre of photography was and suggests the intense level of activity surrounding an event. The magnitude of the tornado in people's minds and the national attention drawn to this disaster stemmed from the systematic and comprehensive coverage exemplified in the stereographs that survive.

The use of stereo photography to record natural phenomena extended beyond weather conditions, though weather remains central to the very existence of Iowans. Scientists and scholars around the world had explored some of the infinite possibilities of photography, and they found stereoscopic vision unparalleled in terms of documenting the universe. Stereographs of the moon created with a telescope appeared in 1860, and in Iowa we find three-dimensional views of Amana meteorite specimens and some exceptionally large hailstones that fell on Iowa City.

Being situated in the right place at the right time, Iowa attracted international attention when a total solar eclipse became visible in the state on August 7, 1869. Eminent scientists from around the world — including Mariah Mitchell, one of the first female astronomers — descended on various locations in the state, from Burlington to near Ottumwa and as far west as Des Moines and

Jefferson, to record the event. Stereo photographers, sketch artists, and the press followed closely behind to prepare their firsthand accounts of each expedition team's efforts. Setting up temporary observatories to house their large telescopes, scientists made important new discoveries about the sun's corona, while photographers and artists assisted with the record keeping.

Mother and child watch approaching lightning, Albert City (Buena Vista County), May 28, 1903. Taken by Elving, Albert City. Publisher: Elving. Curved stereo mount; beige.

ROCKDALE VIEWS,

Before and after the Flood of July 4th, 1876.

Rockdale is a village located about two miles southwest of Dubuque, Iowa, containing a gristmill, hotel, store, grocery, meat-market, saloon, and a dozen houses, besides barns and other out-buildings. The Illinois Central Railroad runs through the village in a north and south direction; and the wagon-road through town crosses the railroad near the mill. Catfish creek runs through the village, and a dam crosses it furnishing power for the mill. Just below the dam the stream is crossed by the railroad on a strong iron bridge. On the night of July 4th, 1876, there came a sudden heavy storm which speedily swelled Catfish creek into a raging torrent; this swept away the railroad bridge; and that, crushing against the buildings below, helped the high water in its work of bearing them to destruction. In a moment the entire village was reduced to ruins, and the ruins themselves washed away. A few stones, only, and a single iron rail of the track suspended across the chasm, remain to show where the railroad bridge had been. The mill was the only building that escaped destruction. In one picture may be seen the meat-market, moved back from its foundation and badly wrecked; and near it the grocery, overturned. In another picture may be seen these two buildings on a smaller scale, in the distance. Mr. G. Horn's store, with his dwelling house attached, carried from its foundations and partly overturned, forms the subject of another picture. Mr. Horn and his wife and children saved their lives by sitting all night on the collar-beams in the attic of the store, and clinging to the rafters, with their feet in the water. All the other buildings in the village except those just mentioned were not only swept away, but entirely destroyed, the broken timbers and splintered boards borne down the Catfish to the Mississippi, or lodging in the fields and groves as unrecognizable debris. The hotel, kept by Mr. Kingsley, was borne bodily upon the swollen torrent for some hundreds of rods, when it struck a large tree against which it went to pieces. Mr. Kingsley saved his own life by clinging to the tree. He endeavored to save his wife by dragging her through the chamber window, but her arm broke, and he was finally forced, to save his own life, to let go of her, and she was swept on amid the ruins and drowned. One picture shows Mr. Kingsley in the tree, where he remained from before midnight till after daylight next morning. The same tree may be seen in the background of an other picture, in the foreground of which is another tree, against which another house was driven, and went to pieces. On the body of the tree may be seen places where the bark was knocked off by collision with the building, and in the branches are three men who saved their lives by clinging there all night. The water came up some distance among the branches of this tree, which grows on ground several feet higher than the ordinary level of the stream, (some hundreds of rods from which it stands,) showing the water to have been at least twenty-six feet deep. Of the fifty-one persons residing in the village, thirty-nine were drowned.

Rockdale Views stereo card. The dramatic events are recounted in great detail on this backlist, almost like a sensational newspaper story.

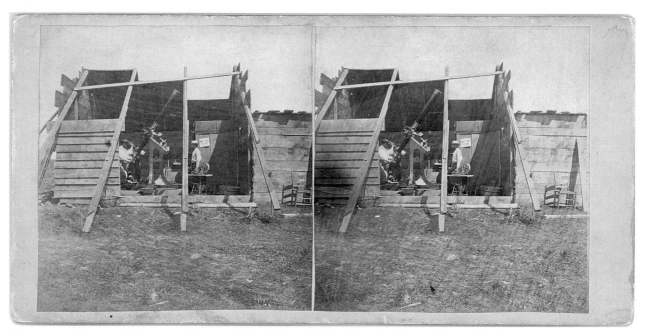

"Observatory of Ottumwa Eclipse party," Ottumwa (Wapello County), 1869. Taken by unknown photographer. Stereo mount; green. Primitive shelters like this were built to house the expedition parties and their telescopes.

The stereoscope has become a necessary adjunct to the telescope and microscope, showing us the true form and configuration of the distant world.

O. G. Mason, "Notes on Photographing Small Objects for the Stereoscope," Photographic Mosaics, *1870*

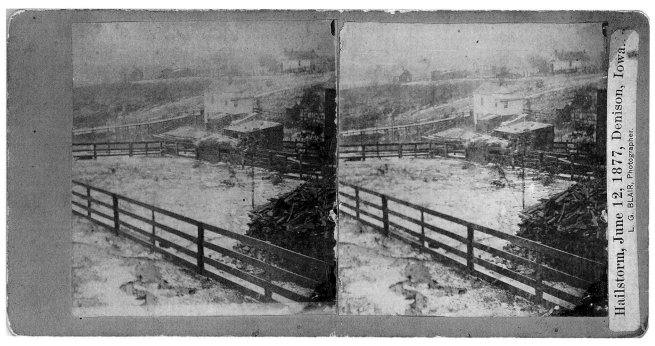

Hailstorm, June 12, 1877, Denison, Iowa.
L. G. BLAIR, Photographer.

"Hailstorm, June 12, 1877, Denison, Iowa" (Crawford County). Taken by L. G. Blair, Ida Grove. Publisher: L. G. Blair. Stereo mount; green.

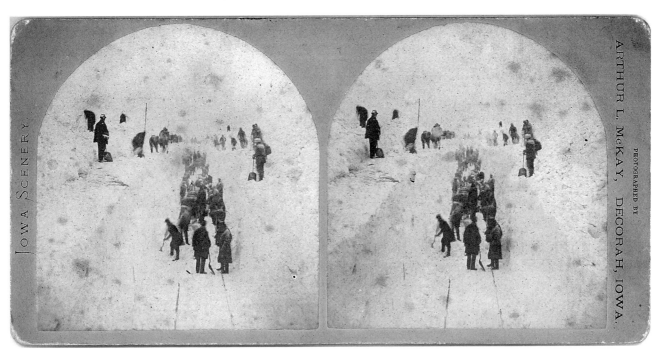

IOWA SCENERY.

PHOTOGRAPHED BY ARTHUR L. McKAY, DECORAH, IOWA.

"No. 129. Clearing the Track—showing cut through the drift, 12 to 15 feet deep"; "McKay's Views, taken on the Iowa Division of the Milwaukee & St. Paul Railroad, between Conover and Ridgway, Iowa, after the great storm of Jan. 7th and 8th, 1873" (Winneshiek County). Taken by Arthur L. McKay, Decorah. Publisher: A. L. McKay, Iowa Scenery. Stereo mount; orange, opp. pink.

"No. 15. Ice Gorge, Muscatine, Iowa" (Muscatine County), 1870s. Taken by J. G. Evans, Muscatine. Publisher: J. G. Evans, Western Scenery. Stereo mount; yellow. Since so many people depended on the Mississippi River for trade and commerce, it was a newsworthy event when ice blocked the river.

Snow scene with man standing in drift, Charles City (Floyd County), 1880s. Taken by Harwood & Mooney, Charles City. Publisher: Harwood & Mooney. Stereo mount; beige. After what was perhaps a record snowfall, it took considerable work to clear the sidewalk for foot traffic.

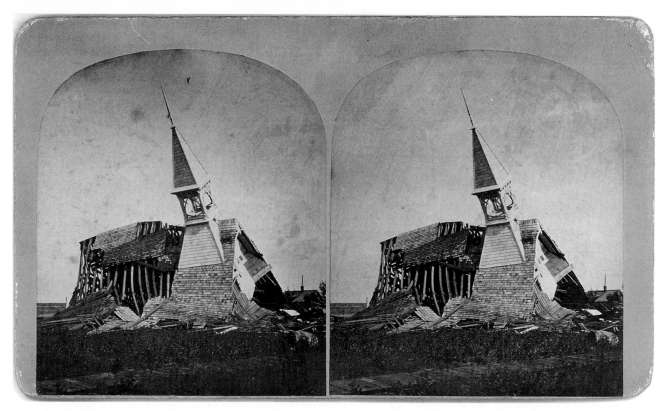

Church destroyed by a tornado, Manson (Calhoun County), 1880s. Taken by B. S. Williams, Manson. Publisher: B. S. Williams, Artistic Studio Effects, and Landscape Photography. Cabinet mount; orange, opp. pink.

Stereographs may really build up new concepts in the mind and not serve merely for a reminiscence.

Mark Jefferson, Journal of Geography, *December 1907*

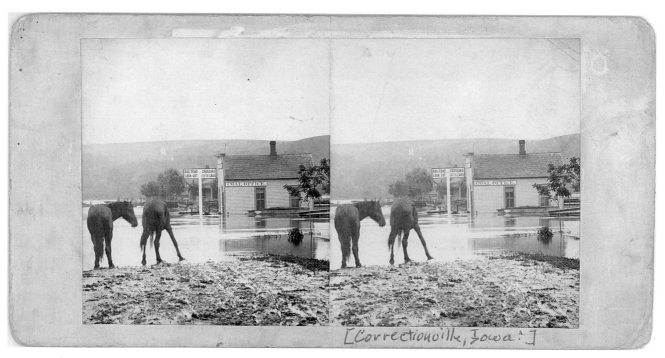

[Correctionville, Iowa?]

Flood of a river with two horses in front of the Coal Office, possibly from Ida Grove (Ida County), 1891. Taken by unknown photographer, possibly from Ida Grove. Stereo mount; yellow, opp. gray.

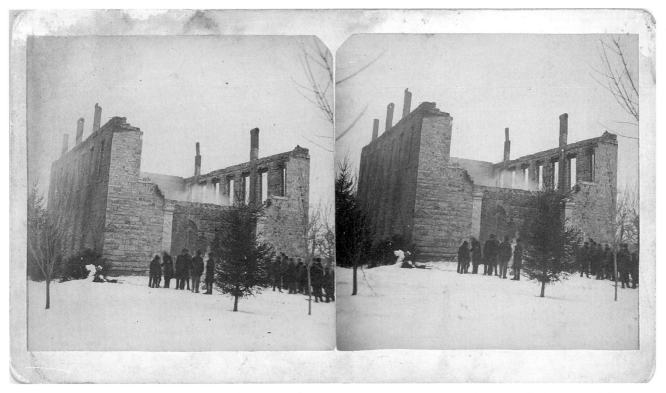

"Fire ruins of Floyd Co. Courthouse," Charles City (Floyd County), February 4, 1881. Taken by Harwood & Mooney, Charles City. Publisher: Harwood & Mooney. Cabinet mount; beige.

The telephone and the stereoscope are two instruments which stand alone, both with relation to the principles upon which they are founded and the experiences which people are able to gain from them. We get in connection with the telephone through the one sense of hearing an experience that is analogous to that gained in the stereoscope through the one sense of sight. . . . a person comes to the telephone, while we go to the place in the stereoscope.

 Albert E. Osborne, Why Man Has Used Pictures, and a Comparison Between the Telephone and the Stereoscope

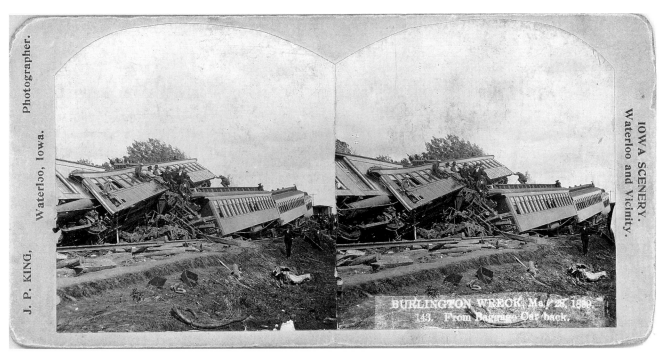

Photographer.

J. P. KING, Waterloo, Iowa.

IOWA SCENERY. Waterloo and Vicinity.

BURLINGTON WRECK, May 23, 1899. 143. From Baggage Car back.

"Burlington wreck May 23, 1899. 143. From baggage car back," Waterloo (Black Hawk County). Taken by J. P. King, Waterloo. Publisher: J. P. King, Iowa Scenery. Waterloo and Vicinity. Curved stereo mount; beige. Always a popular subject for photographers, a railroad wreck was a major event for small-town Iowans.

Priest and chapel at Festina
Sept. '94.

SERIES A.

1. 4th Street Bridge.
2. 5th Street Bridge.
3. 4th Street Bridge and dam.
4. East 4th Street from Bridge.
5. East 4th Street from Sycamore.
6. West 4th Street from R. R.
7. Commercial Street from 5th.
8. Old First M E Church.
9. First M E Church.
10. Congregational Church.
11. First Baptist Church.
12. Interior First Baptist Church.
13. Grace M E Church.
14. Interior Grace M E Church.
15. Episcopal Church East Side.
16. Universalist Church.
17. Waterloo College.
18. Presbyterian Church built of one Stone.
19. Church at Dinsdale.
20. Steam Grader, Dinsdale.
21. IC Train in Snow storm Ap 20 '93
22. Train in Winter, Fredricksburg
23. 15 Miles an hour, Lamont.
24. "And he spread his wings."
25. Dressing Poultry, Morrison.
26. Making the feathers fly.
27. Soldiers Home, Marshalltown.
28. Soldiers Hospital.
29. Where Anna Wiese was murdered, Marshall Co.
30. Watching for a ght blooming Cereus, flash light.
31. Night blooming Cereus, flash light.
32. Funeral Wreath, extra fine.
33. Funeral Flowers.
34. Double Calla, wonderful freak
35. Funeral Flowers, Winthrop.
36. Hail 15 days after the storm.
37. 32nd Iowa Battle flag.
38. Corpus christe, Gilbertville.
39. Inter Catholic Church.
40. Gilbertville Bridge, 1100 ft. long
41. Playing Mother.
42. 4 Paws Elephants.
43. A Happy Family.
44. Don't you smoke, Glen?
45. Cedar River Park, 3 Views.
46. Steamer "Scepta" at the Park.
47. Camp life at the Park.
48. Picknickng at the Park.
49. Bathing at the Park, 2 Views.
50. Fairview Cemetary May 30, '93 4 Views.
51. Rainbow on the Cedar.
52. A good Catch, fruit of the Cedar
53. View on the Cedar.
54. Cedar River Park, from Steamer
55. Jacob Binghams 60th Wedding Anniversary.
56. Clipper Wreck, Jan. 4. 1893.
57. Winthrop Schools, 1892.
58. Turkey River dam, Auburn.
59. The old Quaker meeting house "at Home."
60. View on Black Hawk, Hudson
61. Old mill, dam and bridge, "
62. Winter Sport, Waterloo, December 30. 1893.
63. Lutheran Church, House and School House
64. Decorations Y's Recception at Fullertons Jan. 1. 1894.

5 POMEROY CYCLONE VIEWS July 6 '93.

65. Mr. Lowry's House in ruins.
66. East from Mr. Lowry's House.
67. Mullans Cave where 29 were saved.
68. From the north, over Church ruins.
69. School House.

14 Views, Devils Back Bone, Deleware Co.

70. Top of Bridge.
71. Omnibus Gate.
72. Grand Stairway.
73. Hunters Retreat.
74. Well Tower.
75. Lovers Walk.
76. Maquoketa River.
77. Hunters Camp.
78. Bay Window.
79. West Lone Rock.
80. Eagle Eyrie.
81. Picturesque Rock.
82. Devils Hump, 95 feet high.
83. Pulpit Rock, 115 feet from River

Send 20 cents for 1; 50 cents for 3; $1. for 6; $2. for one dozen Views.

J. P. KING, WATERLOO, IOWA.

At the age of 17, [J. P. King] came to Black Hawk County, Iowa, and hired out as a farm hand. He helped break the virgin prairie north of Waterloo, Iowa. After a few years of farming, he took up the profession of photography and that remained his life long work. Later, he engaged in business for himself and built a complete studio on wheels, for many years visiting towns within a radius of 60 to 70 miles from Waterloo, for in the early days photographers were located only in a few of the larger centers. Mr. King would remain in a town two or three weeks, making his sittings and doing all of his developing and printing in his wagon studio. The car was hauled from place to place by horses. Mr. King would remain until the people at the locality were served and then move to a new location. He has taken tens of thousands of pictures of people in the scope of country extending from Calmar, 70 miles northeast to Marshalltown at the southwest.

Waterloo Evening Courier and Reporter, *ca. 1920*

THE GRINNELL TORNADO

After a muggy June afternoon in 1882, two swirling funnel clouds descended simultaneously on Grinnell at exactly sixteen minutes before nine in the evening. In just a few seconds, buildings and lives were torn apart and freight trains were lifted off their tracks. Grinnell College (then called Iowa College) was directly in the path of the tornado, which destroyed both of its main buildings. Pictures and papers from homes laid waste in the storm were later found as far away as Wisconsin. Frantic Grinnell citizens rushed to their storm cellars, but still the dead in the city and its immediate area numbered thirty-nine. Although not the worst tornado in Iowa's history (in fact, just twenty-two years earlier, forty-two persons in Camanche had been killed), it was the first major Iowa tornado to be recorded by photographers. June 17, 1882, would be a day remembered for generations because of the numerous stereographs that recorded the event.

By the morning after the storm, photographers from around the state had boarded trains or started pulling their photo wagons to Grinnell. D. H. Cross and James Everett, both of Des Moines, created the largest selection of views. Cross advertised on the front of the mounts that he had more than fifty stereo views for sale; his views actually numbered at least sixty. James Everett made forty views of the tornado and provided a backlist that clearly identifies each view and chronicles damage and those killed or injured. Both series show the destruction before anything had been cleaned up. Some of the stereographs show militia standing watch over the debris of homes to discourage looters. Several show a horse named Monarch, which was blown a thousand feet while tied to its manger; some show planks blown through the sides and floors of barns. The first in

the Everett series shows the two buildings of the college before the storm, looking peaceful with students on the lawns. It is in marked contrast to the views of destruction that follow.

Other Iowa photographers were also on the scene. Local Grinnell photographers Warner Babcock and Arthur Child each produced a series of ten or eleven views. These two photographers are not known to have produced any other stereographs. J. S. Lovell of Davenport photographed twenty-two different views and provided a backlist. He advertised: "Orders by mail from any part of the country promptly filled." H. B. Rice, from Lovilia, advertised on the back of his cards that he had views of the tornado for sale. A. W. Warrington of Oskaloosa put together a series of nine views. Charles Bierstadt of Niagara Falls, New York, a nationally known photographer, also issued a series of at least eleven views from negatives he may have purchased from local photographers. Views of the Grinnell disaster thus received national coverage.

With competition so keen during the day following the tornado, photographers even included other photographers in their views. Carefully using stripped trees, piles of debris, and exposed cellars as focal points, photographers exploited the three-dimensional effect of the stereoscope. The Grinnell tornado was talked about on front porches across Iowa that summer, and everyone wanted to witness the destructiveness of the event. Those who purchased views to add to their collections proudly showed their neighbors their latest acquisitions. People were awed by the power of the storm, as the stereoscope gave them the feeling of actually having been present. The *Spirit Lake Beacon* of August 25, 1882, reported that a Des Moines photographer had "already realized over $1,000 from sales of views of Grinnell after the June tornado, and the demand still continues."

Even today, more than a hundred years later, the Grinnell tornado views represent the pinnacle

of stereo photography in Iowa. These stereographs are the most common Iowa view to be found at estate auctions and in dusty attics. In viewing these stereographs, one can still sense the drama that the original purchasers must have felt when they viewed the images in the summer of 1882.

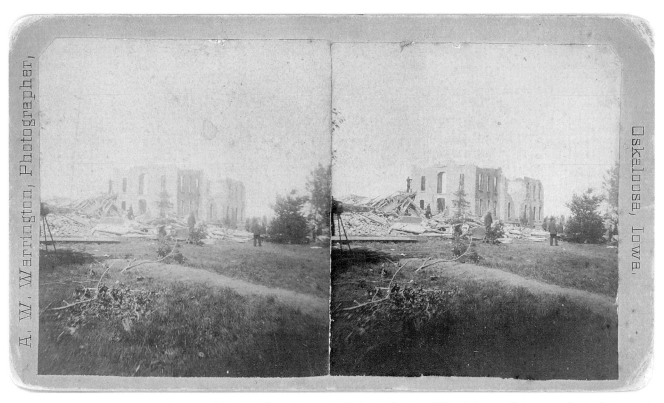

A. W. Warrington, Photographer,

Oskaloosa, Iowa,

"No. 3. Looking north of east, on right ruins of Central College, four stories high; on left ruins of West College, militia on top of ruins doing guard duty while excavations are going on,—four students taken out alive," Grinnell (Poweshiek County), June 17, 1882. Taken by A. W. Warrington, Oskaloosa. Publisher: A. W. Warrington, Grinnell Cyclone Views. Cabinet mount; gray. Note the tripod and camera of another photographer on the left.

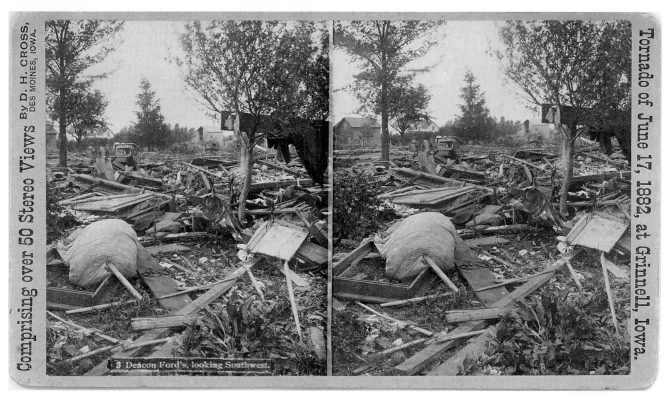

By D. H. CROSS, DES MOINES, IOWA.

Comprising over 50 Stereo Views

Tornado of June 17, 1882, at Grinnell, Iowa.

3 Deacon Ford's, looking Southwest.

"3. Deacon Ford's looking Southwest," Grinnell (Poweshiek County). Taken by D. H. Cross, Des Moines. Publisher: D. H. Cross, Tornado of June 17, 1882, at Grinnell, Iowa. Cabinet mount; pink, opp. orange.

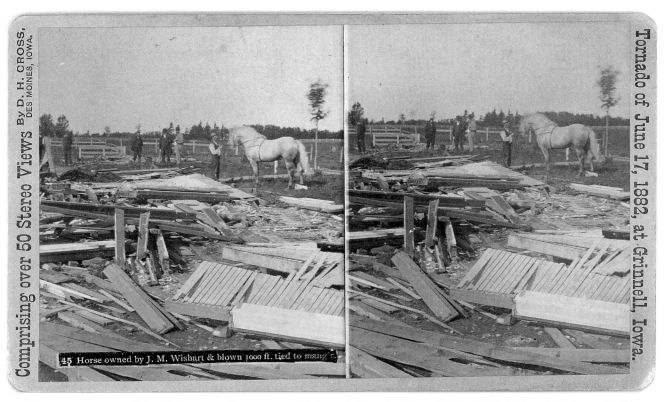

By D. H. CROSS, DES MOINES, IOWA.

Comprising over 50 Stereo Views

45 Horse owned by J. M. Wishart & blown 1000 ft. tied to mang'r.

"45. Horse owned by J. M. Wishart & blown 1000 ft. tied to mang'r," Grinnell (Poweshiek County). Taken by D. H. Cross, Des Moines. Publisher: D. H. Cross, Tornado of June 17, 1882 at Grinnell, Iowa. Cabinet mount; pink, opp. orange. The horse, named Monarch, became a local legend for surviving the tornado.

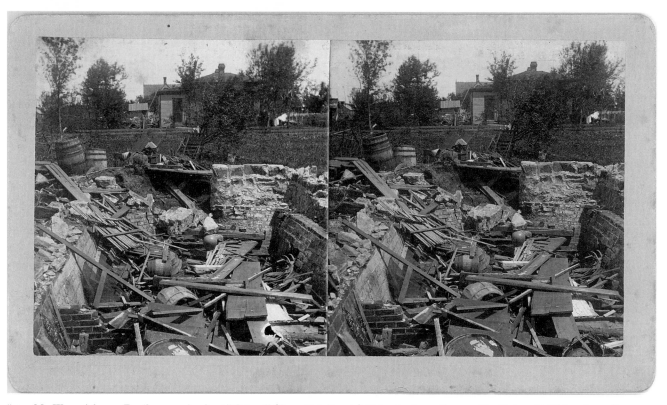

"12—Mr. Weaver's house. Family escaped unhurt," Grinnell (Poweshiek County). Taken by James Everett, Des Moines. Publisher: James Everett, Views of Grinnell after Tornado of June 17, 1882. Cabinet mount; lavender, opp. orange. In the third dimension, this image creates the impression of standing at the edge of the cellar.

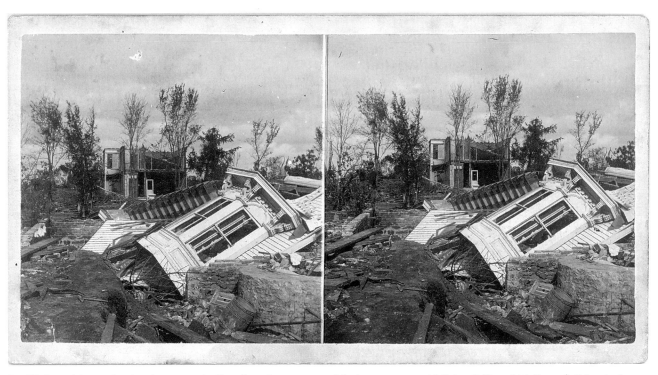

"5. C.P. Craver's house showing the corner of cellar where the occupants of the house were saved," Grinnell (Poweshiek County). Taken by Jas. Everett, Des Moines. Publisher: Jas. Everett, Views of Grinnell after Tornado of June 17, 1882. Stereo mount; cream. An entire staircase leans against the detached bay window.

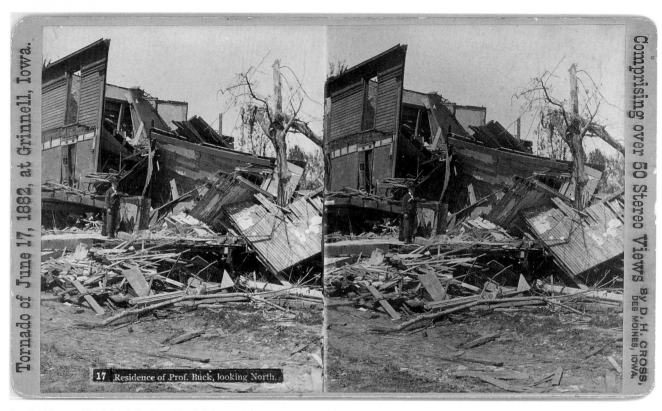

Tornado of June 17, 1882, at Grinnell, Iowa.

Comprising over 50 Stereo Views By D. H. Cross, DES MOINES, IOWA.

17 Residence of Prof. Buck, looking North.

"17. Residence of Prof. Buck, looking North," Grinnell (Poweshiek County). Taken by D. H. Cross, Des Moines. Publisher: D. H. Cross, Tornado of June 17, 1882, at Grinnell, Iowa. Cabinet mount; orange, opp. pink.

In 1855, [Daniel H. Cross] came to the village of Des Moines, where he learned the daguerreotype process of taking pictures and soon after took up ambrotyping, being one of the first in the state to practice that method. In 1857, he returned to Vermont where during the next few years he watched with growing interest affairs in the South. His zeal and anger were kindled by the hostility of the rebellious States and immediately after the firing against Ft. Sumter, he offered his services to the Government and became a member of the Second Vermont Regimental Band, in which he served until such bands were discharged as an unnecessary expense. From that time until the close of the war he continued with the army as a photographer. On the close of the hostilities he located in Bennington, Vermont, where he established and carried on a photograph gallery for six years. In 1871, Mr. Cross became a resident of Chicago, where he followed his profession for seven years. In 1879, he located in Indianola, Iowa, and in connection with the management of a gallery he engaged in the manufacture of dry gelatin plates until January 1880 when he removed to Des Moines and carried on both lines of business until 1886 since which time he has devoted himself exclusively to the later branch.

Portrait and Biographical Album of Polk County, *1890*

Grinnell Cyclone Views,

Representing a portion of Grinnell, Iowa, destroyed by the terrible cyclone of Saturday evening, June 17, 1882, in which some forty lives were lost in and near Grinnell.

Photographed and For Sale by A. W. WARRINGTON, Oskaloosa, Iowa.

DESCRIPTION BY NUMBERS.—View No. 3

No. 1. Congregational Church, Grinnell, where funeral services of the killed were held.

No. 2. Ruins of College Buildings, looking east. Total destruction of west building, three stories high. Six students in dormitories at the time; one killed in building, and one near Central College. Central College to left and farther east,—wrecked by the storm and caught fire from combustion in chemical department; contents destroyed.

No. 3. Looking north of east, on right ruins of Central College, four stories high: on left ruins of West College, militia on top of ruins doing guard duty while excavations are going on,—four students taken out alive.

No. 4. Ruins of College in distance, looking south-east: complete destruction of houses in the foreground.

No. 5. Residence of Rev Everest looking north-east, only building left standing for some distance.

No. 6. Residence of Mr. Phelps, Sr, in back ground looking north-east, surrounding buildings entirely swept away.

No. 7. Looking south-east, dwelling of Mr. Proctor, on right, Mr. Adams and Mr. Hanlin, on the left.

No. 8. Ruins of residence of Mrs. Gue, Mr. Dunn, Dr. C. B. Gruwell, S. Graham, and others. Several persons killed in this locality.

No. 9. Fragments of several houses in the foreground, residence of Mr. Hatch and Dr. Bodle, in the background.

It is the intention to rebuild the Colleges at once.

Backlist for Warrington.

DEMOCRACY PREVAILS

Having celebrated one hundred fifty years of statehood, Iowans have indicated that their faith in democracy has not wavered. Government has always worked for Iowans because of strong grassroots political forces, whether in the form of civic leaders, political parties, labor unions, or farm organizations. Democracy started at the local level and extended from the statehouse in Des Moines to the halls of Congress. Given the prominence of Iowans in the larger national political arena, people felt they had a voice and some clout in determining their future.

The results, even at this early stage of Iowa's growth, were some of the best schools in the world, a reliable system of roads and highways, railroad regulation, and a very effective system of county government. Imposing government buildings, erected as symbols of authority and as monuments to democracy, guaranteed stability for a community. The county courthouse served as a place to conduct official business, but it also became the centerpiece of a common heritage, a ceremonial place for some of life's necessary rituals. The crowning tribute came with the building of the state capitol in Des Moines, begun in 1871 and completed in 1886. Stereo photographers recognized the significance of the event and created almost enough views to rival the most-photographed Iowa event, the Grinnell tornado.

The grandeur of the capitol can best be understood in person. Architects spared no expense in designing this temple, and iridescent paints in the stencil work, colored marble, stained-glass windows, murals, and grillwork all added a fantastic effect to the structure. The photographers were challenged by the massive scale and magnitude of the building, and many shots emphasize how

new and empty the interior was. Construction materials lay about, and the surrounding neighborhood seems dwarfed by the towering building at the crest of the hill.

Des Moines leaders intended to dignify the state capitol by developing a well-planned city befitting a government center and reflecting a highly cultured society. Public buildings, ranging from the post office and federal building to the municipal waterworks and capitol heating plant, were designed in the latest architectural style. With a flourishing capitalist economy, the city expanded, and serious investors built sizable commercial structures and fashionable private residences. This pattern of growth among the wealthy elite was repeated throughout Iowa's towns, leaving impressive structures as a reminder that a prosperous society looks to the future while enjoying the fruits of democracy.

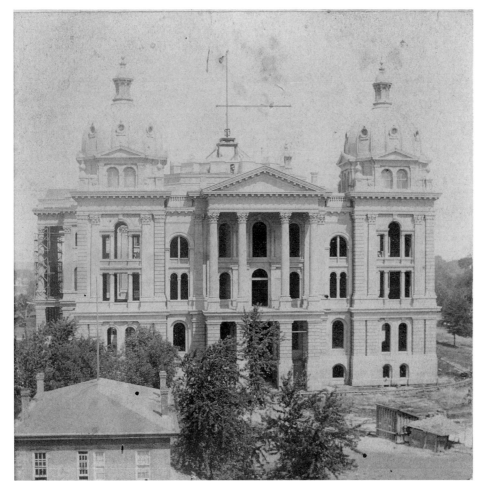

Partially completed
state capitol building
before the center
dome was built,
Des Moines (Polk
County), ca. 1881.
Taken by Horton.
Stereo mount; beige.

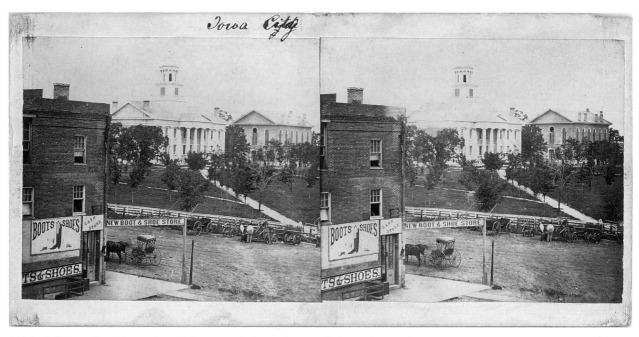

Old Capitol, Iowa City (Johnson County), late 1860s. Taken by Isaac A. Wetherby (probable), Iowa City. Publisher: Isaac A. Wetherby (probable). Stereo mount; yellow. As territorial and state capitol, the Old Capitol was an early symbol of democracy in Iowa. The capital was moved to Des Moines in 1857, and the University of Iowa inherited this golden-domed structure. Farm implements line the wooden fence surrounding the grounds.

Wetherby's gallery has the reputation, justly acquired, of being the best in the State. He is an artist of no mean powers, as the many works of his brush will testify, while as a photographer he has no superior in the west. His large photos colored in oil are positively matchless.

State Press *(Iowa City)*, *December 4, 1867*

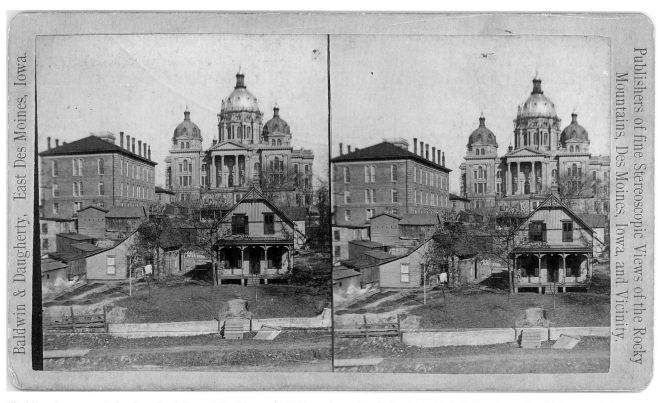

Baldwin & Daugherty, East Des Moines, Iowa.

Publishers of fine Stereoscopic Views of the Rocky Mountains, Des Moines, Iowa, and Vicinity.

"Building the new capitol—Iowa South Front," Des Moines (Polk County), ca. 1881. Taken by Baldwin & Daugherty, Des Moines. Publisher: Baldwin & Daugherty, East Des Moines, Iowa, Publishers of fine Stereoscopic Views of the Rocky Mountains, Des Moines, Iowa, and Vicinity. Cabinet mount; yellow. State government temporarily conducted business in the building with the numerous chimneys at the left. It was not until 1871 that construction of Iowa's grandest monument to democracy began.

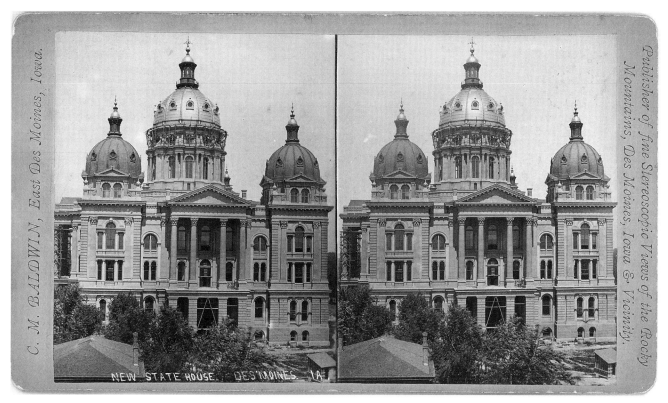

C. M. BALDWIN, East Des Moines, Iowa.

Publisher of fine Stereoscopic Views of the Rocky Mountains, Des Moines, Iowa & Vicinity.

NEW STATE HOUSE. DES MOINES. IA.

"New State House, Des Moines, Ia" (Polk County), ca. 1881. Taken by C. M. Baldwin, East Des Moines. Publisher: C. M. Baldwin, Publisher of fine Stereoscopic Views of the Rocky Mountains, Des Moines, Iowa & Vicinity. Cabinet mount; orange, opp. pink. The exact same view of scaffolding around the center dome was issued by two other publishers, J. Everett of Des Moines and the national distributor, Chas. Bierstadt. Cameras were positioned in the same spot, and the image was framed identically.

"4. Capitol, east steps,"
Des Moines (Polk County),
ca. 1881. Taken by E. G.
Everett, Des Moines.
Publisher: E. G. Everett,
Views of Des Moines.
Cabinet mount; orange,
opp. pink.

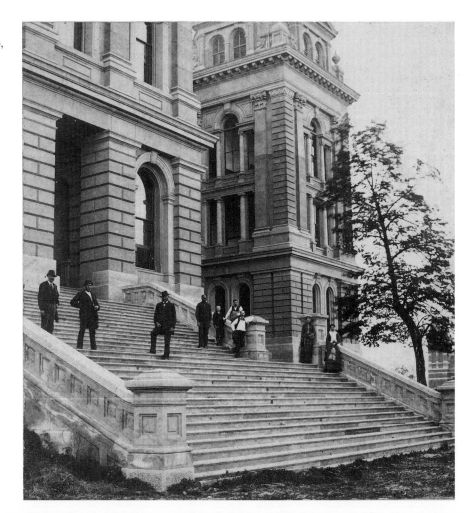

DIMENSIONS

Length of the structure from north to south is 365 feet, breadth from east to west 239 feet. The height from corner stone to cornice is 93 feet, and to the top of the central dome 275 feet, the latter point being 1,151 feet above the level of the sea. The exterior measurement of the wall is 1,464 feet. There are to be 29 rooms in the first story. The second story will contain the library and the two legislative halls, with a couple of dozen of smaller rooms. The edifice has cost just about $2,000,000 and will cost $500,000 more.

 Backlist of stereograph

"Governor's Rooms Iowa Capitol," Des Moines (Polk County), ca. 1881. Taken by C. M. Baldwin (probable), Des Moines. Publisher: C. M. Baldwin. Cabinet mount; orange, opp. pink. The huge mirrors create multiple reflections of the hanging chandelier.

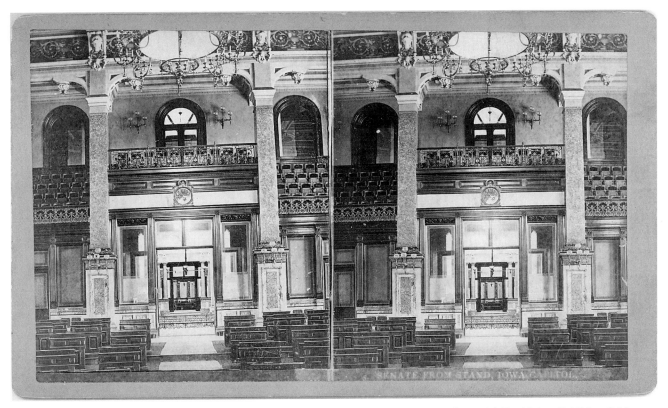

"5. Senate from Stand, Iowa Capitol," Des Moines (Polk County), ca. 1881. Taken by C. M. Baldwin (probable), Des Moines. Publisher: C. M. Baldwin. Cabinet mount; orange, opp. pink. The original gas lighting fixtures adorn the columns and walls.

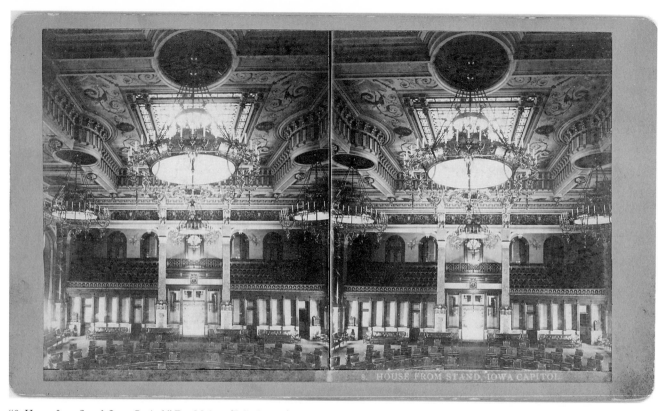

"8. House from Stand, Iowa Capitol," Des Moines (Polk County), 1880s. Taken by C. M. Baldwin (probable), Des Moines. Publisher: C. M. Baldwin. Cabinet mount; orange, opp. pink. Note the decorative stencil work on the high-vaulted ceiling and the stained-glass skylights.

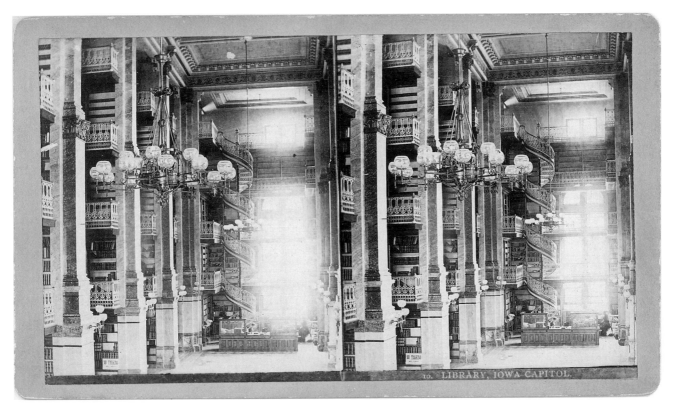

"10. Library, Iowa Capitol," Des Moines (Polk County), ca. 1881. Taken by C. M. Baldwin (probable), Des Moines. Publisher: C. M. Baldwin. Cabinet mount; orange, opp. pink. "No Talking" was permitted in the hallowed halls of the library, which featured a spiral staircase and abundant rows of shelving waiting to be filled.

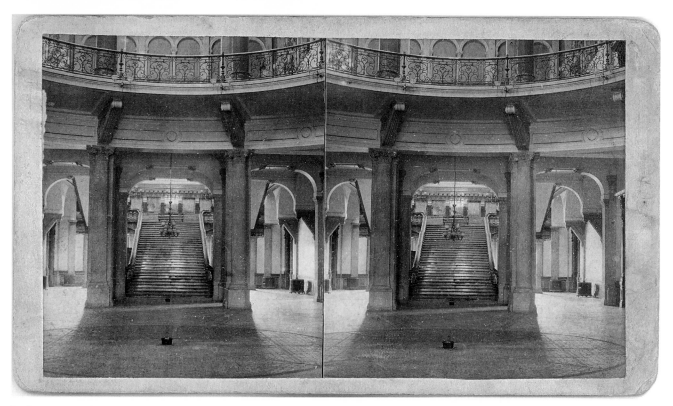

"5. Interior Iowa Capitol, Grand Stairway," Des Moines (Polk County), 1880s. Taken by C. M. Baldwin, Des Moines. Publisher: C. M. Baldwin. Cabinet mount; yellow. Spittoons are carefully placed along the corridor. The central rotunda is above the iron railing.

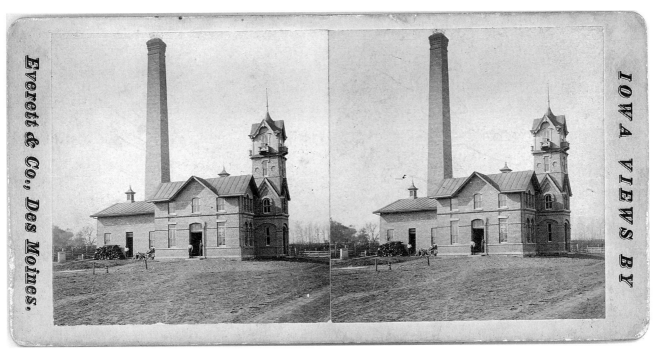

Everett & Co., Des Moines.

IOWA VIEWS BY

"Water Works," Des Moines (Polk County), 1870s. Taken by Everett, Des Moines. Publisher: Everett & Co., Iowa Views. Stereo mount; yellow. The stylistic design of the municipal waterworks reflected the desire of civic leaders to create substantial government buildings, emphasizing the worth of democratic efforts.

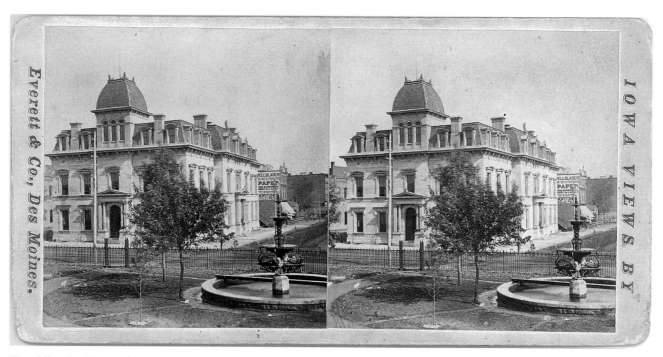

Everett & Co., Des Moines.

IOWA VIEWS BY

"Post Office, Des Moines" (Polk County), 1870s. Taken by Everett, Des Moines. Publisher: Everett & Co., Iowa Views. Stereo mount; yellow. As a capital city and the metropolitan center of Iowa, Des Moines had to fulfill expectations of grandeur with elegant government buildings to complement the style of the new state capitol. The fountain in the foreground is on the grounds of the courthouse, seen on page 173.

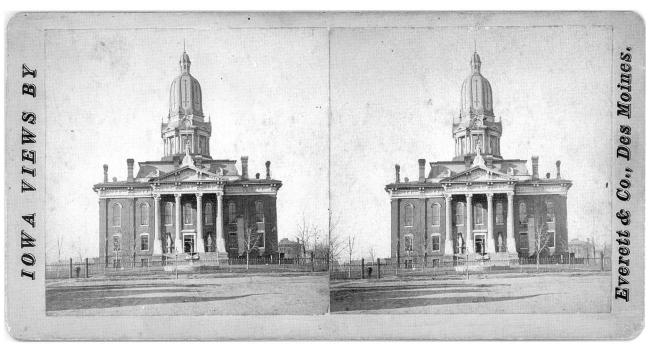

"Court House east entrance," Des Moines (Polk County), 1870s. Taken by Everett, Des Moines. Publisher: Everett & Co., Iowa Views. Stereo mount; yellow. Several bird's-eye views were photographed from the top of the building. The center statue is visible in the next view.

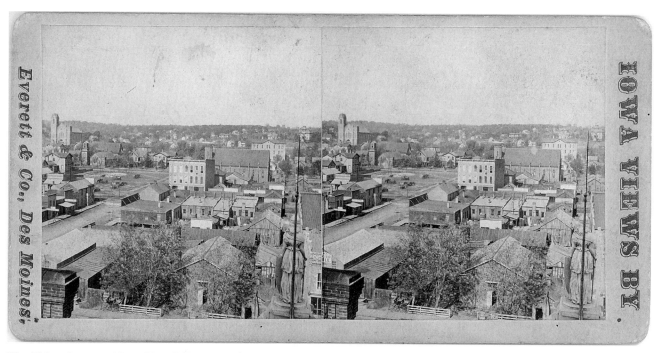

"Des Moines from top of Court House" (Polk County), 1870s. Taken by Everett, Des Moines. Publisher: Everett & Co. Stereo mount; yellow. State Historical Society of Iowa, Iowa City. Note the statue on the right. Often the grandeur of a building, in relation to the more commonplace surroundings of modest homes, is best revealed in a rooftop view of the neighborhood.

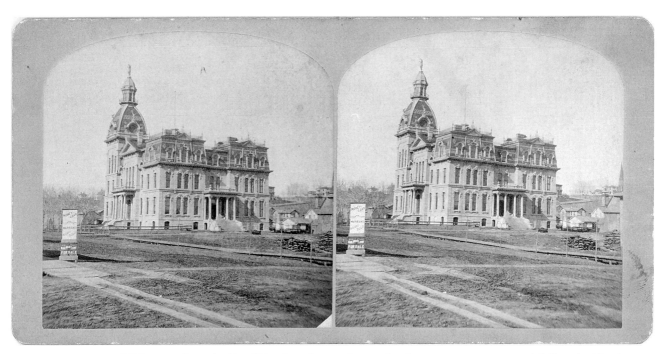

"Sioux City Court House" (Woodbury County), 1880s. Taken by unknown photographer. Stereo mount; orange, opp. pink. In each of Iowa's ninety-nine counties, the courthouse became the focal point of government.

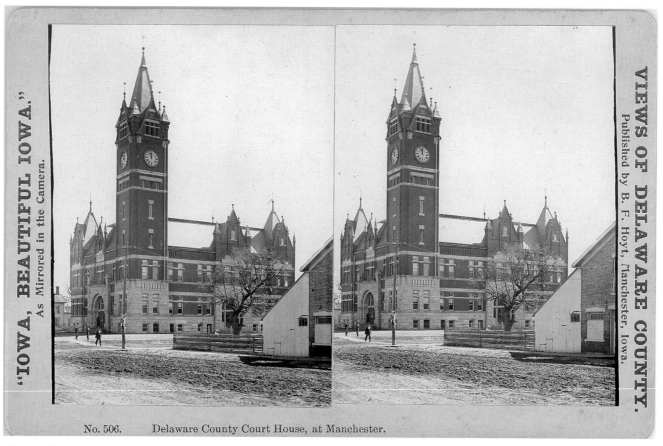

"IOWA, BEAUTIFUL IOWA."
As Mirrored in the Camera.

VIEWS OF DELAWARE COUNTY.
Published by B. F. Hoyt, Manchester, Iowa.

No. 506. Delaware County Court House, at Manchester.

"No. 506. Delaware County Court House, at Manchester," (Delaware County), 1890s. Taken by B. F. Hoyt, Manchester. Publisher: B. F. Hoyt, Views of Delaware County—"Iowa, Beautiful Iowa." Cabinet mount; beige. The courthouse was often the most extravagant public architecture in a community.

A flourishing democratic society, even at its earliest stages, used public funds and private capital to create cultural institutions to educate the young, protect citizens, and meet special needs. Iowa government followed established systems of law and order to secure and protect the rights of citizens, and building elaborate structures to house and control prisoners and social misfits became a concern of state leaders. The earliest prison, in Fort Madison, was extensively photographed by J. R. Tewksbury. Stereographs show the dining room, cells, chapel, and even the prisoners marching to dinner. The new stone prison constructed at Anamosa beginning in 1873 was an architectural marvel, photographed by both C. E. Littlefield and M. M. Mott of Anamosa.

State government also provided hospitals and schools for persons who were blind, deaf, mentally ill, or without a home and family. Having a state-run institution conveyed a permanent status symbol that helped ensure the stability of a community while benefiting the local economy. Public institutions were frequently built on a grand scale and became landmarks, important to communal identity. Stereo photographers were attracted to these structures, hoping that a market could be found among those who visited the various institutions.

Knowing that Iowans were proud of their local schools, stereo photographers created a market for photographs of schools and their students and faculty. Many rural schools began as small, one-room structures. By the 1870s and 1880s, however, impressive brick buildings were being built in larger towns, reflecting the belief in education as a means to improve one's life. The exteriors of

monumental school buildings were documented by early stereo photographers, but seldom the interiors. Some views portray schools even before building materials were removed from the scene. Others show students and teachers gathered in front of the building. As communities prospered, institutions of higher education were established. Often, churches or religious groups sponsored private colleges or seminaries. A large student body was sure to purchase souvenir stereographs for family and friends.

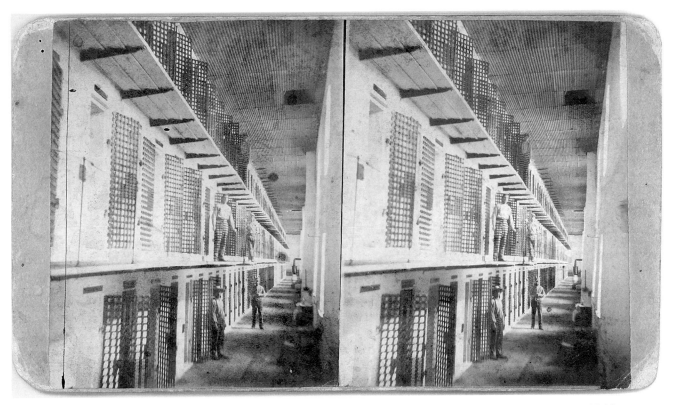

Corridor in prison with prisoners along their cells, Anamosa (Jones County), 1880s. Taken by M. M. Mott, Anamosa. Publisher: M. M. Mott. Cabinet mount; orange, opp. pink.

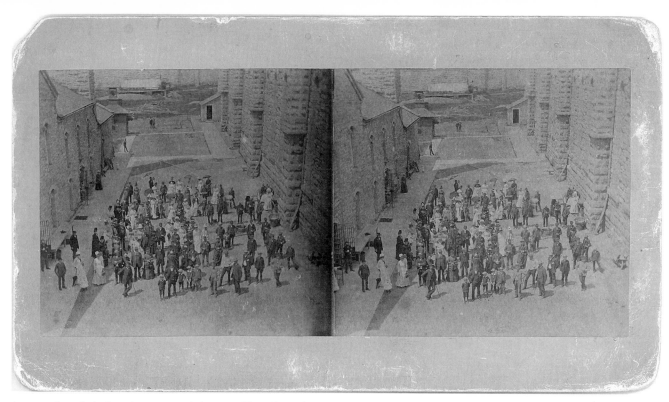

A group of people in the prison courtyard, Anamosa (Jones County), 1880s. Taken by M. M. Mott, Anamosa. Publisher: M. M. Mott's New Excelsior Gallery. Cabinet mount; orange, opp. pink.

Merritt Morgan Mott came to Iowa a few years before his parents, and established himself in the town of Fairview in 1862. There he followed the blacksmith's trade, which he had learned in the East, but, being of an artistic temperament, gave it up to pursue the photographic art, which was at that time just beginning to come into the prominence it enjoys at present. As progress has been made in the business it has advanced until he is now able to produce work which may well stand beside that turned out in other and larger cities. His success is in part due to the fact that he is his own most severe critic, for with the true instinct of an artist he is satisfied with the best only. On many an occasion, it is related of him, he has refused to let work leave his shop because it did not satisfy his exacting taste, although his customer found in it nothing to criticise. Endowed with a keen love of art, and a discrimination in the choice and posing of subjects, he has won a success that equals that attained by prominent men in other parts of the country. His reputation as well as the long period of his residence here, amounting to more than forty-seven years, entitle him to the fair name he enjoys as a workman and the respect in which he is held by all those who have come in contact with him, for a high code of honor has guided him in his business dealings as a high grade of achievements in his art had been his ambition.

History of Jones County, *1910*

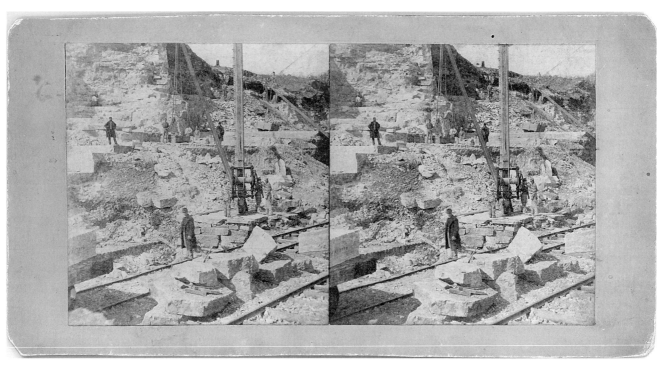

Prison stone quarry near Stone City, Anamosa (Stone City) (Jones County), 1880s. Taken by M. M. Mott, Anamosa. Publisher: M. M. Mott's New Excelsior Gallery. Stereo mount; orange, opp. pink.

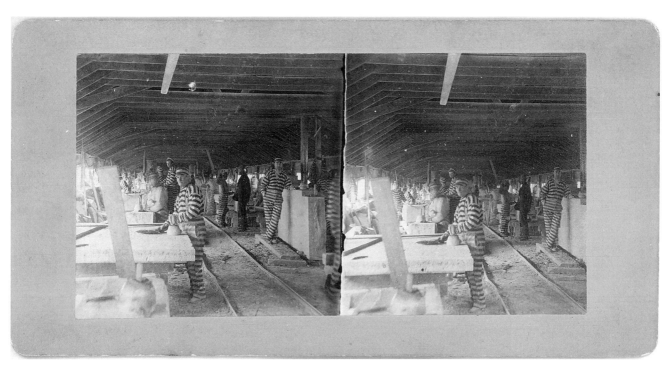

Prisoners cutting stone, Anamosa (Jones County), 1880s. Taken by M. M. Mott, Anamosa. Publisher: M. M. Mott's New Excelsior Gallery. Stereo mount; orange, opp. pink.

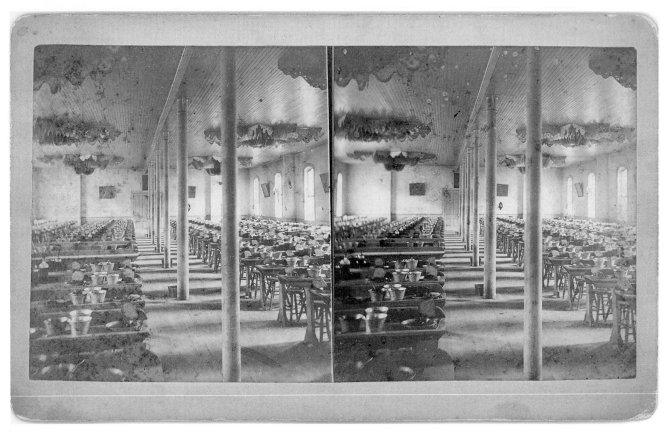

"Dining Room, Iowa State Penitentiary," Fort Madison (Lee County), 1880s. Taken by J. R. Tewksbury, Fort Madison. Publisher: J. R. Tewksbury, Iowa State Penitentiary. Cabinet mount; beige. "General number of prisoners about 400." Note the bread loaves at each setting.

As my residence and gallery join, I am always ready for work, and owning them pay no rent; with all the instruments and stock that plenty of means and fifteen years' experience can provide. I am well prepared to serve an appreciative public with all the various styles of pictures at the lowest possible rates. Call and See Samples.

Views (all styles) of this city, Nauvoo and Bluff Park camp ground, at 25 cents each. $2.00 per dozen, postpaid. All the late improvements in taking children, single or in groups.

Fort Madison Illustrated, *in reference to J. R. Tewksbury*

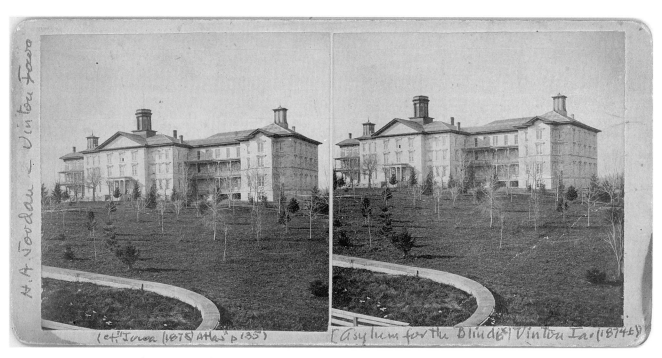

Asylum for the Blind, Vinton (Benton County), 1870s. Taken by H. A. Jordan, Vinton. Publisher: H. A. Jordan. Stereo mount; yellow. "Stereoscopic and large views of public buildings and private residences a specialty."

H. A. Jordan, the photographer, on the southeast corner of Main and Eighth streets, has uniquely decorated one of his outdoor sample show cases. The embellishment consists of a background of deep yellow Silk disposed in plaits, waives, and folds. Within the frame the specimen photos are variously placed and arranged, the whole constituting a decided attraction.

Dubuque Trade Journal, *January 1890*

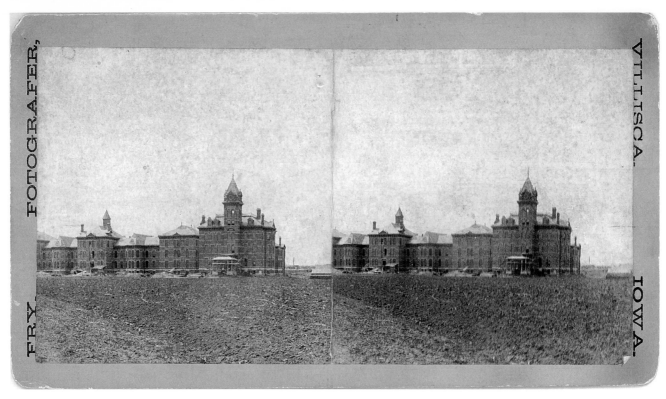

State hospital at Glenwood (Mills County), 1880s. Taken by Fry, Villisca. Publisher: Fry. Cabinet mount; orange, opp. lavender. State institutions brought a symbol of permanence and prestige to small towns across Iowa. This complex of buildings featured monumental architecture spread over a large parcel of land. The "Institution for Feeble Minded Children" at Glenwood had seven hundred pupils in 1897.

Views of Iowa City and Vicinity.

By T. W. TOWNSEND.

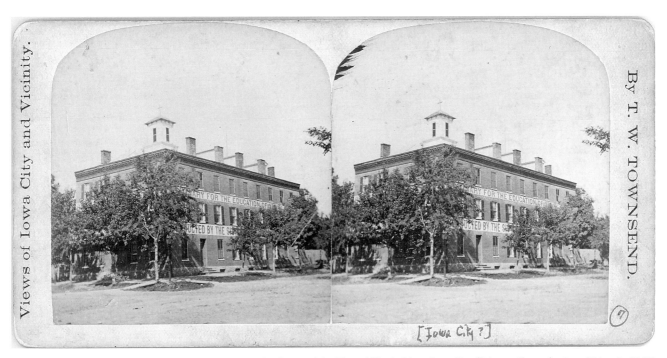

[Iowa City ?]

Seminary for the education of young girls conducted by the Sisters of the Blessed Virgin Mary, Iowa City (Johnson County), 1870s. Taken by T. W. Townsend, Iowa City. Publisher: T. W. Townsend, Views of Iowa City and Vicinity. Stereo mount; yellow. Religious orders were among the first to establish schools. This structure has been modified with a fourth story and a mansard roof, but it still stands on the northwest corner of Dubuque and Jefferson Streets.

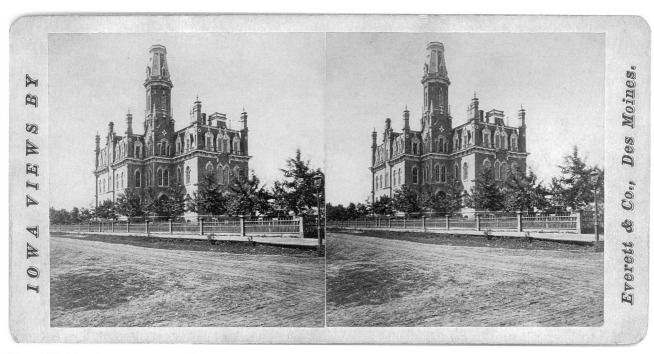

IOWA VIEWS BY

Everett & Co., Des Moines.

"Second Ward School House Des Moines" (Polk County), 1870s. Taken by Everett, Des Moines. Publisher: Everett & Co., Iowa Views. Stereo mount; yellow. The public school served a fundamental role in a democratic society, and Des Moines spared no expense when building this schoolhouse. A bird's-eye view taken from the roof of this building appears on page 78.

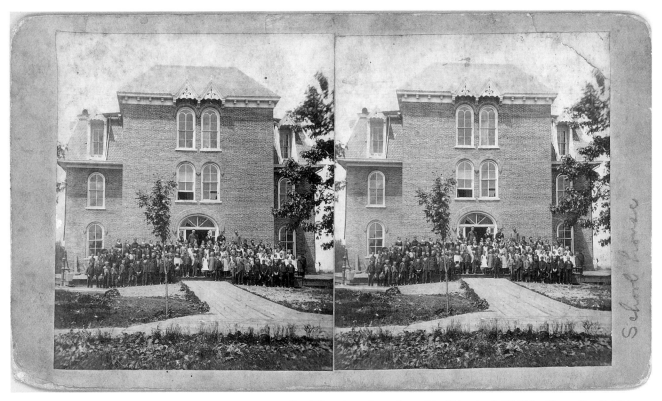

Students standing in front of a three-story schoolhouse, Forest City (Winnebago County), ca. 1880. Taken by G. W. Elder, Forest City. Publisher: G. W. Elder. Cabinet mount; beige. A number of children appear to be barefoot. Note the pump and bucket at the left.

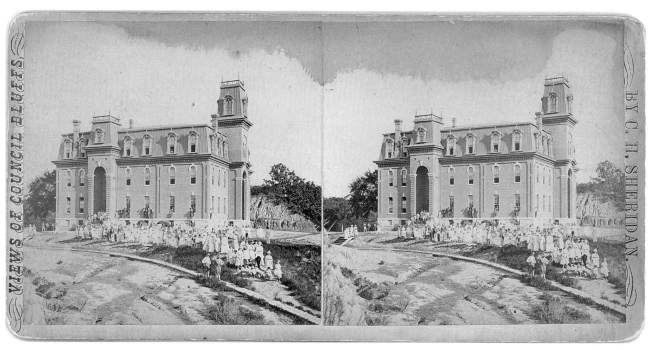

"High School," Council Bluffs (Pottawattamie County), 1870s. Taken by C. H. Sheridan, Council Bluffs. Publisher: C. H. Sheridan, Views of Council Bluffs. Stereo mount; pink. The erosion of the clay bluffs of the Loess Hills can be seen in the foreground and to the far right, behind the school. Notice the children hanging out the windows and standing on the foundation ledge.

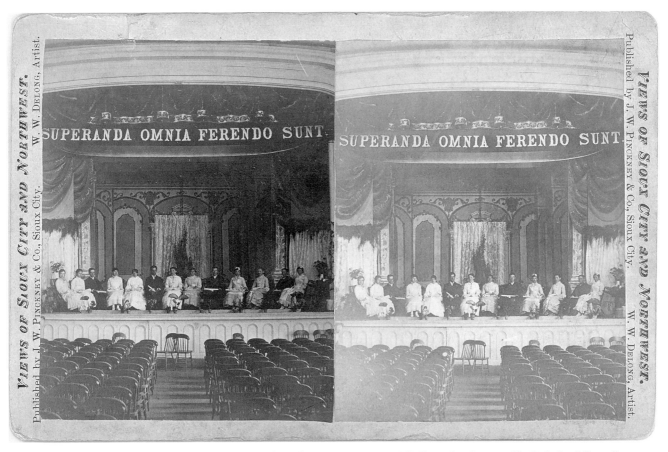

VIEWS OF SIOUX CITY AND NORTHWEST.

W. W. Delong, Artist.

Published by J. W. Pinckney & Co., Sioux City.

Published by J. W. Pinckney & Co., Sioux City.

VIEWS OF SIOUX CITY AND NORTHWEST.

W. W. Delong, Artist.

SUPERANDA OMNIA FERENDO SUNT.

SUPERANDA OMNIA FERENDO SUNT.

Graduating students in an auditorium with a Latin banner (above), which translates as "All Things Are Conquered by Enduring," Sioux City (Woodbury County), 1881. Taken by W. W. Delong, Sioux City. Publisher: J. W. Pinckney and Co., Sioux City, Views of Sioux City and Northwest. Cabinet mount; yellow, opp. pink.

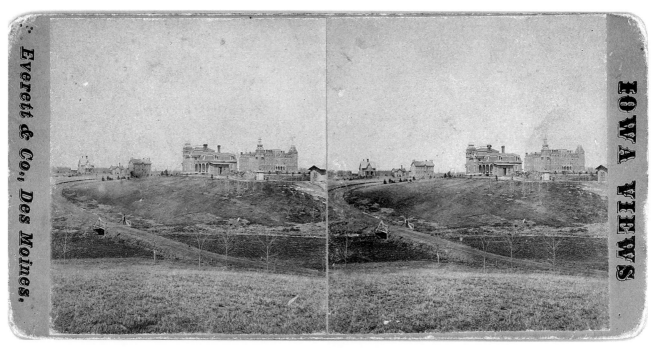

"Ag. College Ames, Iowa" (Story County), 1870s. Taken by Everett, Des Moines. Publisher: Everett & Co., Iowa Views. Stereo mount; green, opp. beige. Iowa State University's original campus buildings appear in this view.

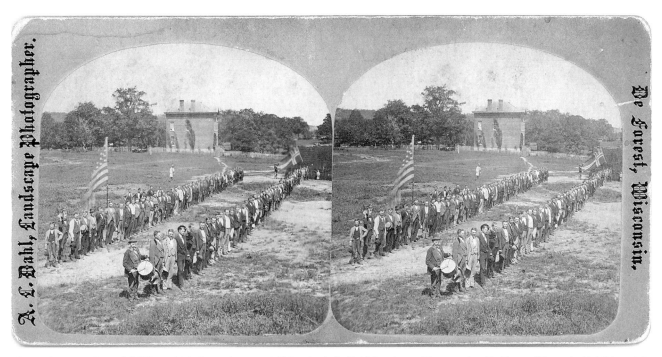

"Student's Parade Decorah" (Winneshiek County), ca. 1876. Taken by A. L. Dahl, Landscape Photographer, De Forest, Wisconsin. Publisher: A. L. Dahl. Stereo mount; green. Both an American and a Norwegian flag are used in the parade. The photographer could find a ready market for his stereographs among the students who appear in the photo and might purchase a copy to send to family or friends.

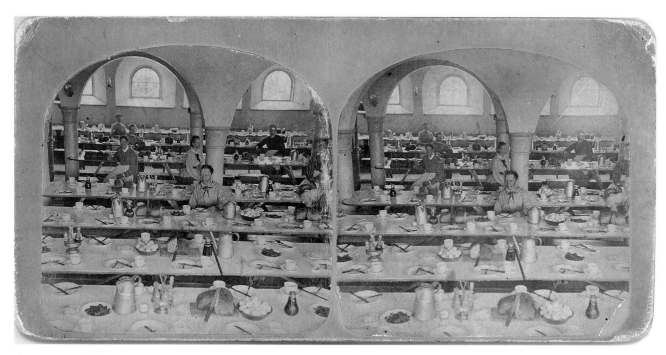

Dining room at Luther College, with food on tables, ready to be served, Decorah (Winneshiek County), ca. 1876. Taken by A. L. Dahl (probable), De Forest, Wisconsin. Publisher: A. L. Dahl. Stereo mount; orange, opp. pink. Large loaves of bread, hard-boiled eggs, and neatly set tables have been prepared by the women in the photo, awaiting the hungry hordes of students who appear in the next image.

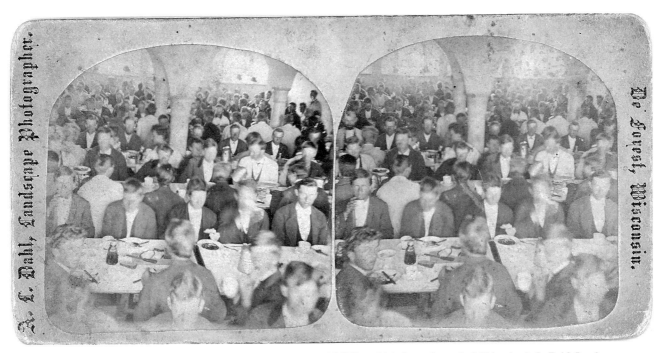

"Decorah College dining hall—students to dinner Proff Larson, Decorah" (Winneshiek County), ca. 1876. Taken by A. L. Dahl, Landscape Photographer, De Forest, Wisconsin. Publisher: A. L. Dahl. Stereo mount; yellow.

Prof. Trueblood in private office. Principal of School of Shorthand and Typewriting. Simpson College, Indianola, Iowa.

"Prof. Trueblood in private office. Principal of School of Shorthand and Typewriting. Simpson College, Indianola, Iowa" (Warren County), 1904. Taken by unknown photographer, "The Art Nouveau (Platino) Stereograph." Publisher: Universal Photo Art Co., C. H. Graves. Curved stereo mount; gray.

Religious beliefs and traditional customs defined the social conventions in many Iowa communities. The countryside was dotted with churches, and even the smallest town might have several houses of worship, usually based on ethnic origin and a common language. The church stood as a symbol of stability and social harmony, and congregations were proud of the structures they built.

The dominance of the Protestant and Catholic religions in Iowa resulted in a certain uniformity in church architectural style, but building materials varied from wood to stone and brick. High towers and steeples were common, and parsonages were often placed next door to the churches. Among the most prominent landmarks in a town, the churches portrayed in stereograph views are relatively new buildings. Many may have replaced more primitive structures from the pioneer period of settlement. As they accumulated wealth, congregations wanted to build on a grander scale, repeating patterns of design they knew from life in the East or in Europe.

The remnants of past traditions can be seen in the stained-glass windows, pump organs, decorative stenciling, and carved woodwork. Expansive windows and kerosene lanterns provided light, while stoves and fireplaces offered heat. Special decorations installed for holiday celebrations like Christmas and Easter provided fresh subject matter for the stereo photographer. Harvest celebrations also brought a display of bounty to symbolize the many rewards of living on the land.

Many Iowans lived more secular lives, outside the bounds of formal church membership, but the emphasis on church architecture among landscape photographers indicates how important re-

ligious life was to certain segments of the community. Determined to capitalize on the discretionary income of these middle-class citizens, stereo photographers were sure to gain respectability and money from associating with churchgoers.

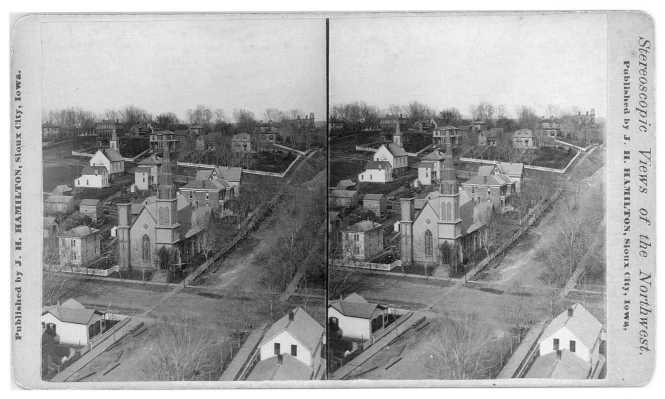

Published by J. H. HAMILTON, Sioux City, Iowa.

Stereoscopic Views of the Northwest. Published by J. H. HAMILTON, Sioux City, Iowa,

Presbyterian Church on the corner of 6th & Nebraska, Sioux City (Woodbury County), ca. 1880. Taken by J. H. Hamilton, Sioux City. Publisher: J. H. Hamilton, Stereoscopic Views of the Northwest. Cabinet mount; pink, opp. yellow. Another church stands behind. A string of posts has been laid in the street next to the sidewalks, perhaps to be used for a series of lampposts.

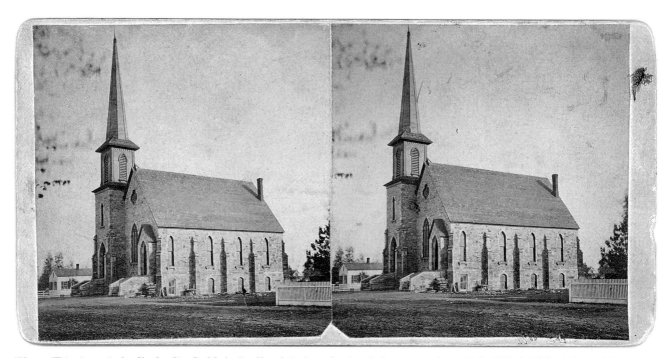

"No. 24. This picture is the Charles City, Ia, Methodist Church in the early 1870s before our moving to Cedar Falls, Ia" (Floyd County). Taken by Gilbert & Wilkin, Nashua. Publisher: Gilbert & Wilkin. Stereo mount; yellow.

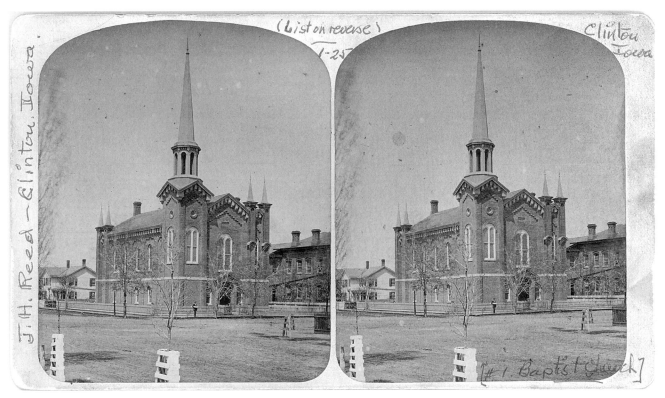

"No. 1. Baptist Church," Clinton (Clinton County), ca. 1875. Taken by J. H. Reed, Clinton. Publisher: J. H. Reed, Views of Clinton and Vicinity. Cabinet mount; yellow. The young trees in the foreground have protective supports around them.

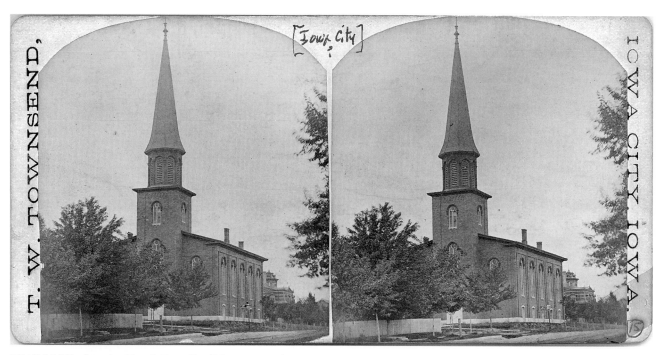

T. W. TOWNSEND,

[Iowa City]

IOWA CITY, IOWA.

"Old Brick," Presbyterian Church, Iowa City (Johnson County), ca. 1875. Taken by T. W. Townsend, Iowa City. Publisher: T. W. Townsend. Stereo mount; yellow. This rare view shows a steeple on top of the tower of this familiar Iowa City landmark. The house with the striped mansard roof in the right background can be seen on page 226.

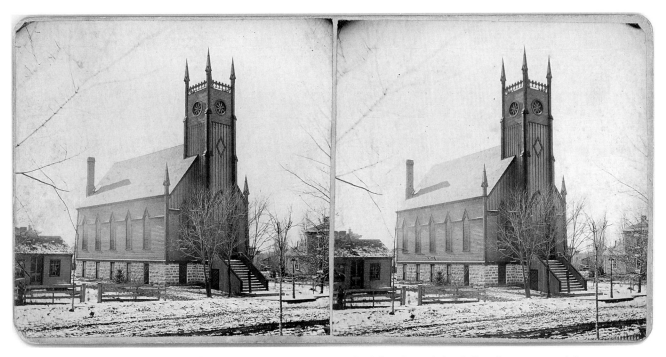

Church in winter, Osage (Mitchell County), 1870s. Taken by Samson, Osage. Publisher: Samson's Art Gallery. Stereo mount; pink, opp. orange.

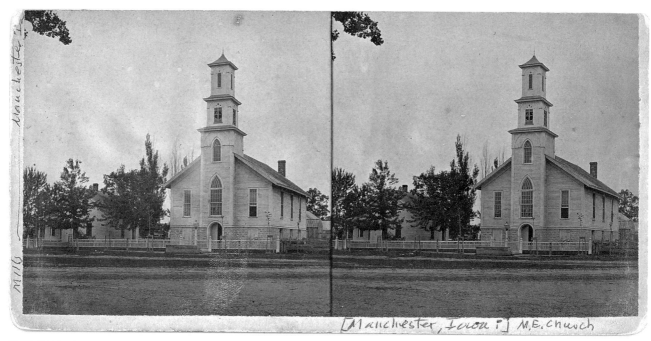

Handwritten on image: *Manchester I* / *Mills* / *[Manchester, Iowa ?] M.E. Church*

"M.E. [Methodist Episcopal] Church Manchester, Iowa" (Delaware County), 1880s. Taken by C. B. Mills, Manchester. Publisher: Mills' Premium Photograph Gallery. Stereo mount; pink. "Photographs of all sizes and kinds in the latest styles of Art."

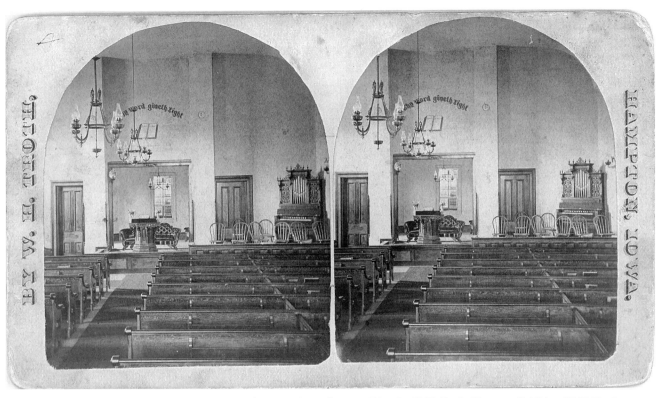

"First Congregational Church" interior view, Hampton (Franklin County), 1880s. Taken by W. H. Troth, Hampton. Publisher: W. H. Troth. Cabinet mount; yellow. The doors to anterooms on either side of the altar are closed, unlike the way they appear in the next image.

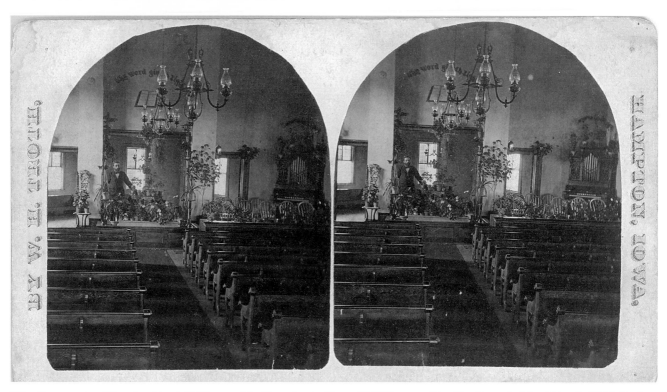

"First Congregational Church—Rev. A.D. Kinzer—A.L. Kinzer baptised here 1886," Hampton (Franklin County), 1880s. Taken by W. H. Troth, Hampton. Publisher: W. H. Troth. Cabinet mount; yellow. The doors have been opened to reveal the interiors of the anterooms, and the church has been profusely decorated with plants.

Silas T. Wiggins was a youth of fourteen years when he accompanied his parents to Wisconsin. He completed his education in the schools of that state and afterward took up the study of photography, going to Chicago when about twenty-one years of age in order to acquaint himself with that art. When he had become familiar with the modern methods of photography, he returned to Fall City where he opened a studio and began business on his own account. Later he removed to Winona, Minnesota, where he remained for about ten years, and was there accorded a very liberal patronage, meeting with gratifying success. On the expiration of that period he came to Cedar Rapids, arriving in the year 1876, after which he remained for a number of years as the leading photographer of this city. He always kept abreast with modern ideas and improvements in the art, had the keenest appreciation for the effects of light, shade, and pose, and the life-like results which he obtained made his work highly satisfactory to his patrons. He continued in the business until the time of his death and his ability was widely recognized and constituted the basis of a pleasing success.

History of Linn County, *1911*

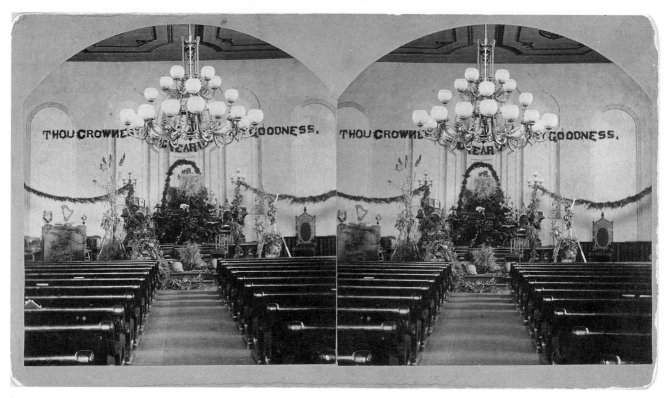

Interior of a church at harvest time, Cedar Rapids (Linn County), 1880s. Taken by Wiggins, Cedar Rapids. Publisher: Wiggins' Fine Art Parlors, Views of Cedar Rapids and Vicinity. Cabinet mount; green. Harvest celebrations took on a religious tone in the midst of farming communities.

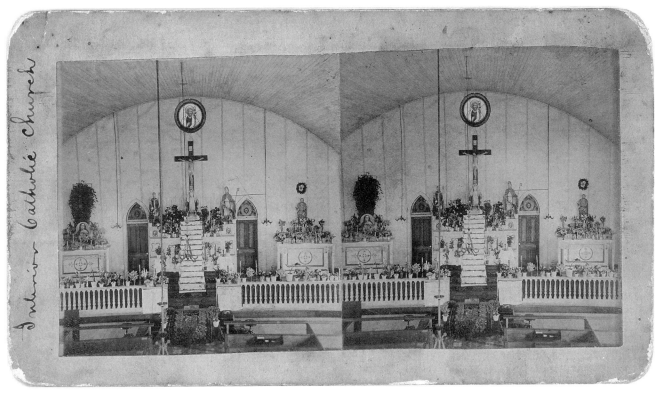

Interior of Catholic church, Waterloo (Black Hawk County), 1880s. Taken by J. P. King, Waterloo. Publisher: J. P. King. Cabinet mount; green. The use of a stairway to heaven in the center of the altar is a symbolic reference to Easter, as are all the spring bouquets. Note the arched wooden ceiling. The photographer may be in a loft, as the camera is higher than the two hanging chandeliers in the foreground. The entire effect of a three-dimensional view is apparent when seen through a stereoscope.

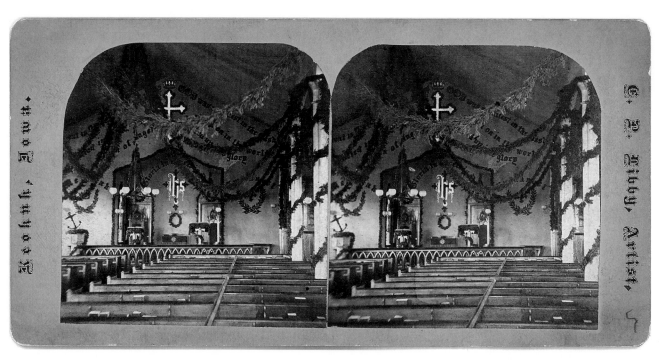

"St. John's Church, Keokuk, Ia, Xmas 1874" (Lee County), December 25, 1874. Taken by E. P. Libby, Keokuk. Publisher: E. P. Libby. Stereo mount; orange, opp. pink. Elaborate lettering adorns the wall, while evergreen boughs are draped everywhere.

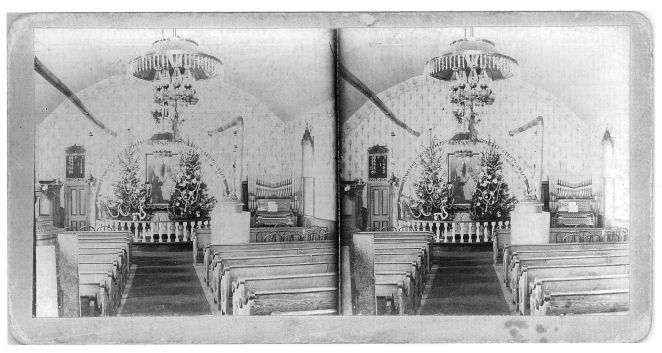

"Albert City Lutheran Church" (Buena Vista County), December 1901. Taken by Elving, Albert City. Publisher: Elving. Curved mount; beige. Note the stovepipes that extend along the ceiling, helping to heat the entire sanctuary in the wintertime. The board at the left displays the hymn numbers. The motto in the arch may be in Norwegian.

Duplicates of this picture always on hand and for sale at 25 cents. Orders by mail promptly filled. Particular attention given to making views of all sizes, of Residences, Machinery, animals, etc., A large stock of Frames, Albums, Stereoscopes and Stereoscopic and Large Views, for sale at LOW PRICES. All work first-class.

Backlist, Wiggins' Fine Art Parlors, Cedar Rapids

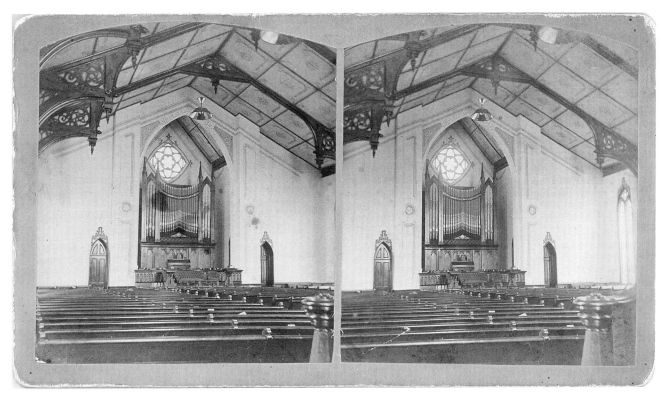

Interior view of M.E. [Methodist Episcopal] Church, Cedar Rapids (Linn County), 1880s. Taken by Wiggins, Cedar Rapids. Publisher: Wiggins' Fine Art Parlors, Views of Cedar Rapids and Vicinity. Cabinet mount; green. A detail of the ceiling follows.

"M.E. Church, 60 thousand," Cedar Rapids (Linn County), 1880s. Taken by Wiggins, Cedar Rapids. Publisher: Wiggins' Fine Art Parlors, Views of Cedar Rapids and Vicinity. Cabinet mount; gray. The stenciled ceiling and wooden carvings show the fine artisanship of this church, built for $60,000.

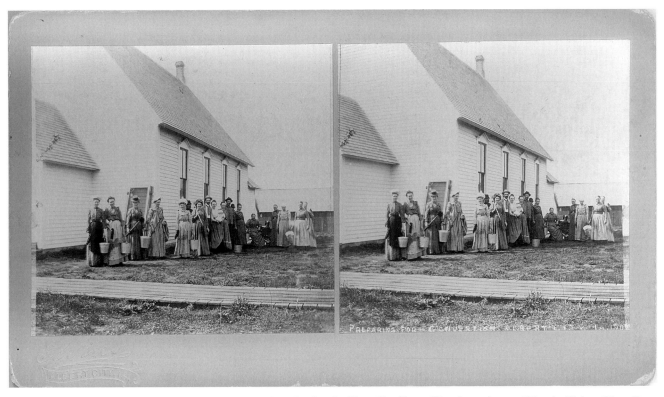

"Preparing for Convention." View of women preparing to clean the church, Albert City (Buena Vista County), 1909. Taken by Elving, Albert City. Publisher: Elving. Curved cabinet mount; orange, opp. pink. This image is a prize because it shows women in ordinary work clothes, wearing smocks, aprons, and duster caps.

"Baptising Scene in Coon River, Jefferson, Iowa—Pastor J. C. Hart administrator in 1886" (Greene County), 1886. Taken by unknown photographer. Cabinet mount; pink. A rare shot of outdoor church activity.

A HOME OF OUR OWN

It was a dream of every family to make a comfortable home. Many had left homes in the East, coming to Iowa with the intention of bettering their lives. Some dreamed of a prominent mansion in the midst of a city; others, with more modest aims, sought the quiet of a tidy farmhouse. Regardless, they hoped to establish a home of their own. Every aspect of their new home — the porch or balcony, the fence rows, the back orchard — conveyed personal meanings to the individuals who lived there.

Pride in their accomplishments motivated them to have a stereo photograph made, often with the entire family gathered in the front yard for the event. Stereographers responded to this desire for a personal record, and many advertised that making home pictures was their specialty. S. T. Wiggins of Cedar Rapids printed on the back of his stereographs: "particular attention given to making views of all sizes of residences, machinery, animals, etc." H. N. Twining of Burlington advertised that he "makes all kinds of out-door views such as houses or barns." The photographer likely encouraged his subjects to strike a pose or display a prized possession. This could include anything from a rifle or favorite horse to a new parlor piano or doll buggy. Although not as common because of the lighting difficulties, interior views of the fanciest rooms, the parlor or the dining room, were sometimes taken.

Homes were photographed from a variety of angles — front views from street level or bird's-eye views from above. Rural views were sometimes taken from a distance to show farm buildings and fields. Multiple copies were ordered so that stereographs could be sent to distant relatives.

Martin Morrison in Ames, for instance, made views of the farmsteads near the Norwegian settlement of Story City, probably to be sent to family back in Norway. His images include a small display easel with the name of the family and date of the photograph.

Stereographs of residential architecture served as tangible reminders of the rewards of domestic life, and also as statements of individual character.

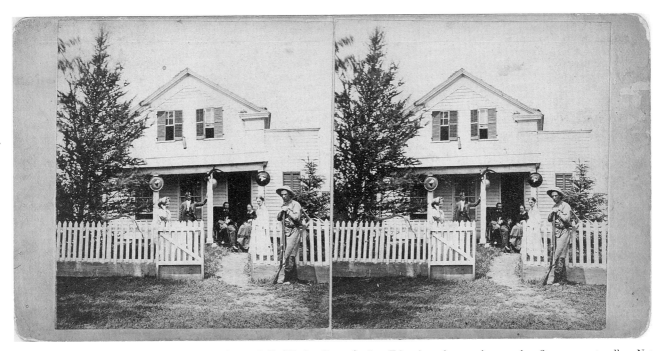

Group including a man with a gun in front of a home, Pella (Marion County), 1875. Taken by unknown photographer. Stereo mount; yellow. Note the racks of antlers and the family cat perched on the seated man's lap.

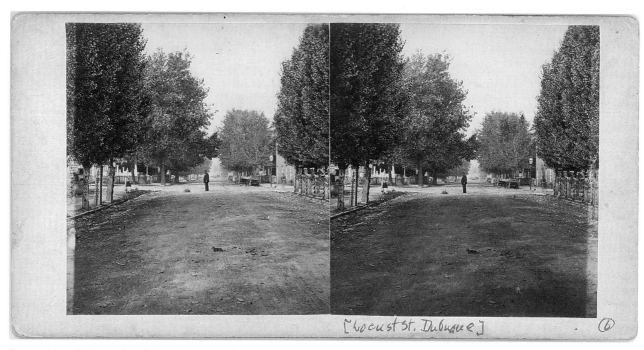

[Locust St. Dubuque] ⑥

"Locust Street, Dubuque, Iowa" (Dubuque County), 1870s. Taken by unknown photographer. Stereo mount; yellow. Old World craft can be seen in the stenciled wooden tree protectors lining the street.

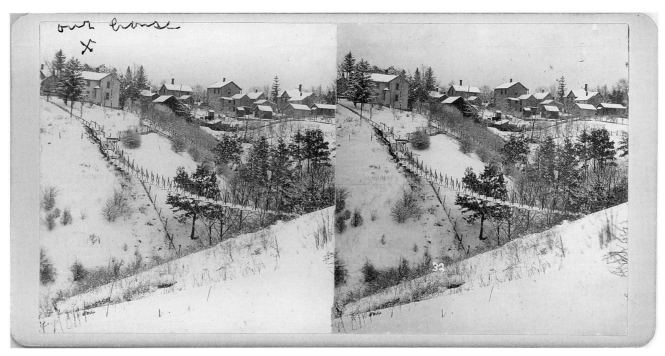

"32. Our house." View of swinging bridge of Columbus Junction (Louisa County), 1900s. Taken by J. G. Baker, Columbus Junction. Publisher: J. G. Baker. Stereo mount; beige. The ravine looks very deep in the third dimension.

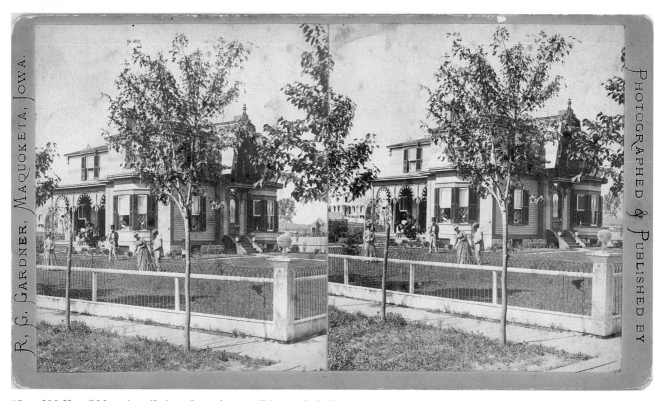

R. G. GARDNER, MAQUOKETA, IOWA.

PHOTOGRAPHED & PUBLISHED BY

"Capt. J.M. Hoag," Maquoketa (Jackson County), 1880s. Taken by R. G. Gardner, Maquoketa. Publisher: R. G. Gardner. Cabinet mount; orange, opp. pink. An active game of croquet is under way.

Iowa City, the "Athens of Iowa," situated on the Iowa River, was the former capital of the State. It is noted for its fine buildings, residences, and its broad streets, which are paved throughout the business portion of the city, and, among the residences, lined with every variety of trees. The Iowa River has, along its banks, high bluffs, beautiful groves and woodlands, boat-houses, and picnic grounds. The State University is located here. T. W. Townsend has the leading Photograph and View Gallery in the city.

Backlist, T. W. Townsend

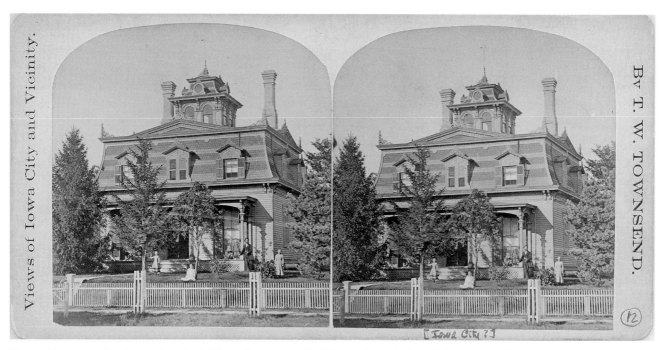

Views of Iowa City and Vicinity.

By T. W. TOWNSEND.

Home with a mansard roof, located on North Clinton Street, Iowa City (Johnson County), 1870s. Taken by T. W. Townsend, Iowa City. Publisher: T. W. Townsend, Views of Iowa City and Vicinity. Stereo mount; yellow. This house appears in the background of Townsend's view of "Old Brick" Presbyterian Church, on page 204.

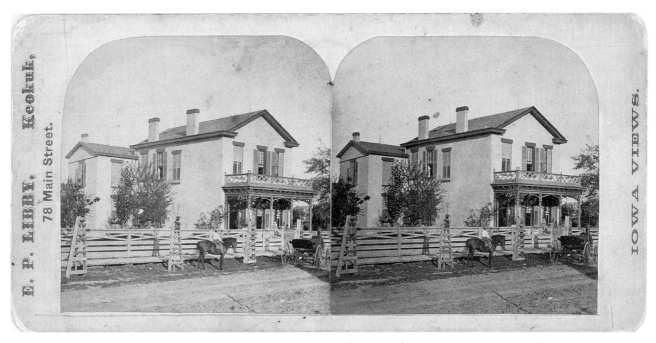

"Newton Edwards." View of house with tree protectors and a fence, Keokuk (Lee County), 1870s. Taken by E. P. Libby, Keokuk. Publisher: E. P. Libby, Iowa Views. Stereo mount; yellow.

$3 for an 8 x 10 photograph in a good frame at Ensminger's.

$5 will get an 8 x 10 ink picture at Ensminger's.

$10 will get a life-size 22 x 27 photograph at Ensminger's.

Buchanan County Bulletin *(Independence), June 9, 1876*

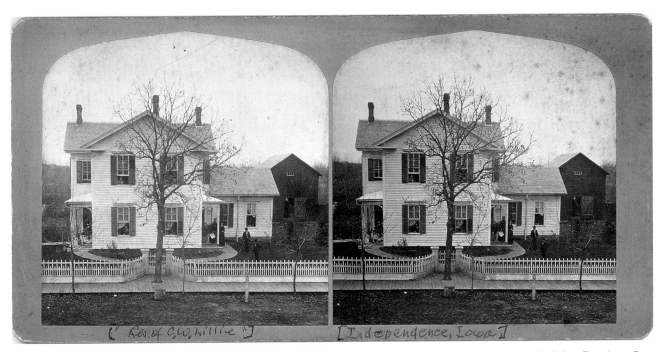

"Res. of C. W. Lillie" [Independence, Iowa]

"Residence of C. W. Lillie, Independence, Iowa" (Buchanan County), 1870s. Taken by Ensminger Bros., Independence. Publisher: Ensminger Bros. Stereo mount; orange, opp. pink. People took great care to design fences and sidewalks as orderly as this one. Note the barn at the right, an essential structure when horse-drawn vehicles were the primary mode of travel.

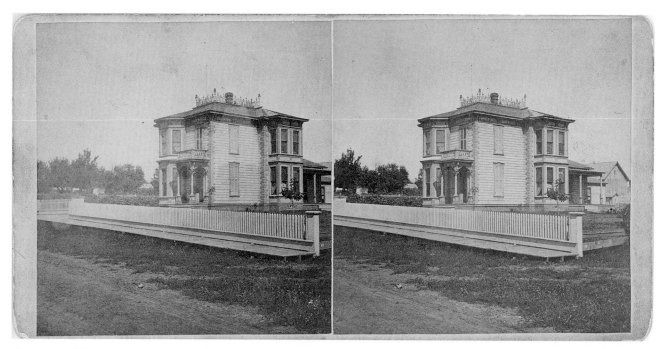

"Residence of W.L. Ramey, Clarinda, Iowa" (Page County), 1870s. Taken by unknown photographer. Stereo mount; pink. Skilled stonemasons were needed to build this large home. A long fence, the grillwork on the crest of the roof, and a barn for horses complete the picture of prosperity.

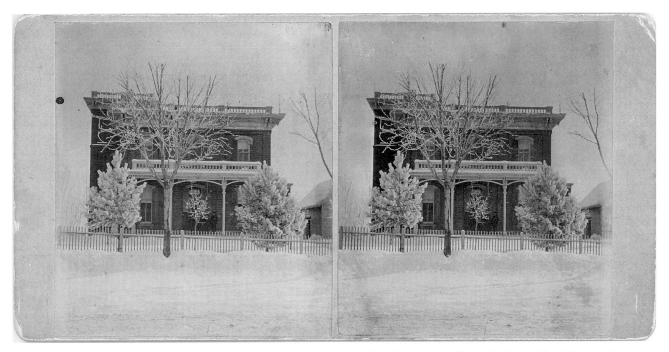

"Boardman Residence Marshalltown" (Marshall County), 1870s. Taken by Manville & Jarvis, Marshalltown. Publisher: Manville & Jarvis. Stereo mount; green. A heavy snow may enhance the beauty of this scene, but stereo photographers seldom ventured out in winter.

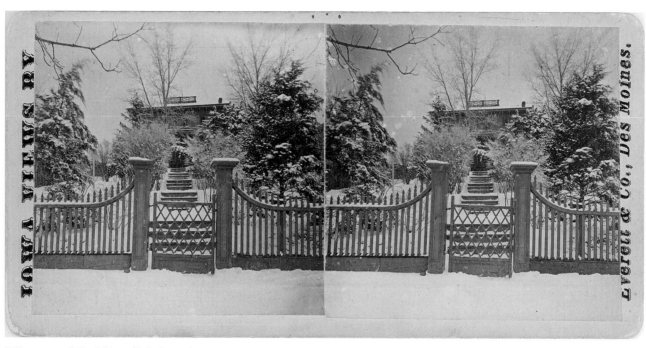

"Winter scene," Des Moines (Polk County), 1870s. Taken by Everett, Des Moines. Publisher: Everett & Co., Iowa Views. Stereo mount; yellow. Viewed through a stereoscope, the fence and gate stand out in relief against the house.

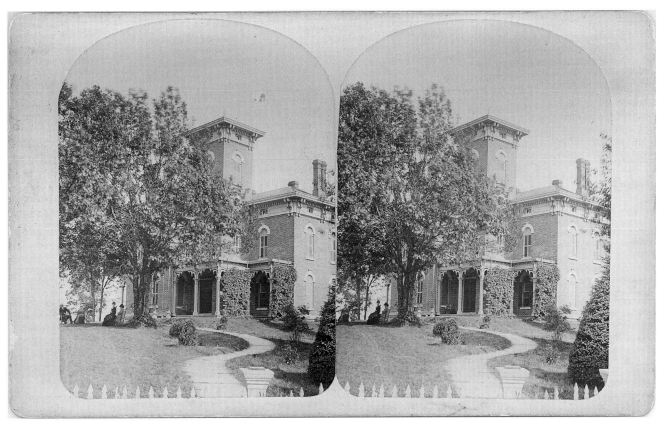

William Tuckerman Shaw's home, Anamosa (Jones County), 1880s. Taken by unknown photographer. Cabinet mount; pink. A view of a hilltop mansion on the eastern edge of Anamosa.

View of yard at William Tuckerman Shaw's home, Anamosa (Jones County), 1880s. Taken by unknown photographer. Cabinet mount; pink. The palatial estates of Iowa's wealthier elite were primary targets for photographers making their rounds of the neighborhood canvasing for customers.

At the age of nineteen [Samuel H. Coon] removed to the vicinity of Austin, Minnesota, where he became engaged in farming, which business he followed until 1869 when he came to Iowa and learned the business of a photographer, at Charles City, Floyd County, which business he followed in numerous towns in this state. Mr. Coon is one of the finest artists in this part of the country and is fully prepared to take any kind of a picture that may be desired.

History of Iowa County, Iowa, *1881*

"Home of E.P. Hall, Victor, Iowa." View of home with picket fence and baby stroller in front (Iowa County), 1880s. Taken by S. H. Coon, Malcom. Publisher: S. H. Coon. Stereo mount; pink.

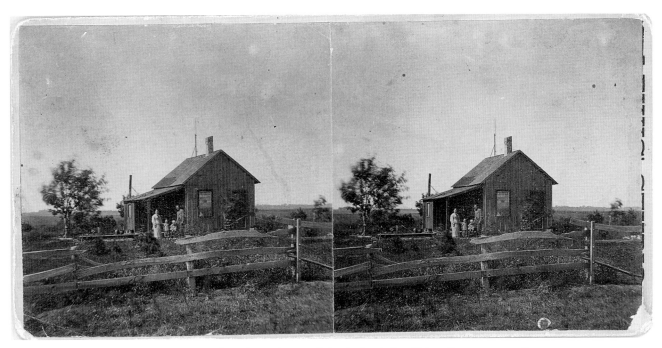

Front of a farmhouse with family, Des Moines (Polk County), 1870s. Taken by Lewis, Des Moines. Stereo mount; yellow.

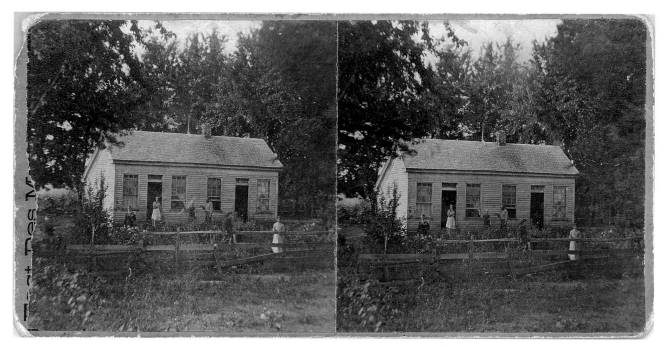

A small farmhouse with people in front, Des Moines (Polk County), 1870s. Taken by Lewis, Des Moines. Stereo mount; green.

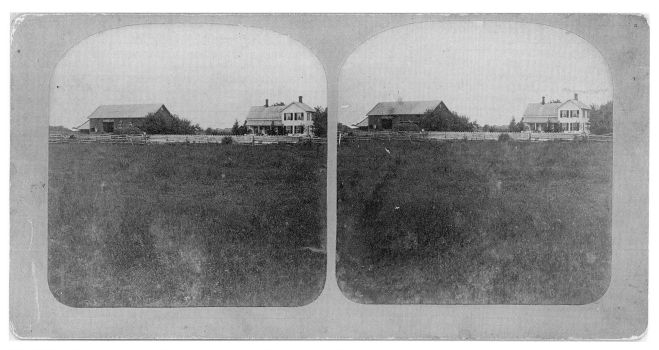

"The William Dean farm 3 1/2 miles east of Nora Springs" (Floyd County), 1870s. Taken by Holbrook & Slocum, Nora Springs. Publisher: Holbrook & Slocum. Stereo mount; green.

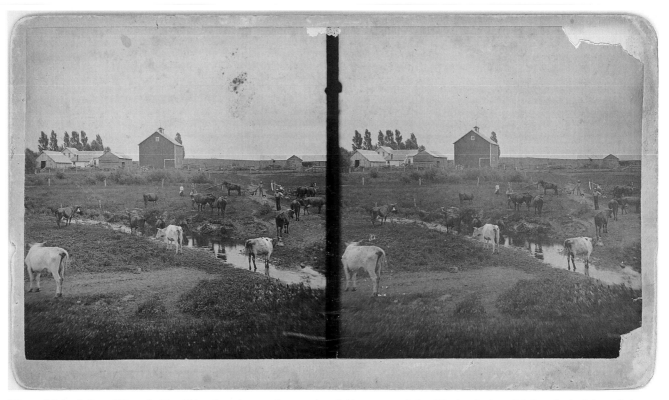

"Farm of Orlando Russell Iowa," 1880s. Taken by unknown photographer. Cabinet mount; beige. The handwritten label on the back is confusing, as it is unclear whether the view was taken near Russell, in Lucas County, or if Orlando Russell was the owner of the farm.

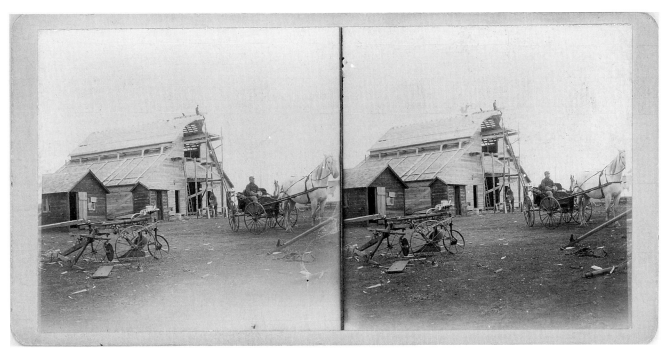

Scene of barn raising, Albert City (Buena Vista County), 1900s. Taken by Elving, Albert City. Publisher: Elving. Curved stereo mount; beige.

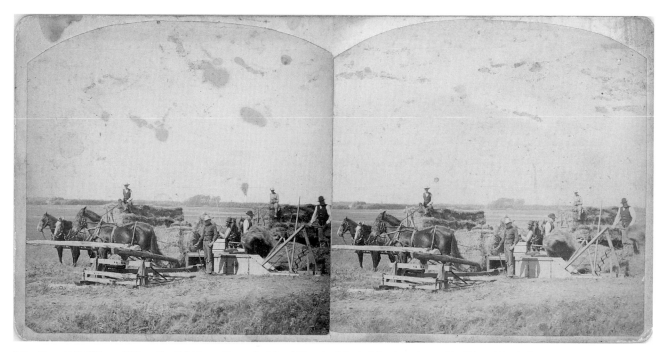

"Hay Press F. T. Wilson, Gilbert Sta. Ia" (Story County), 1880s. Taken by Martin Morrison, Ames. Publisher: Martin Morrison. Stereo mount; beige.

It cannot be said just when or by whom the first photograph was taken in Clarksville, as for several years every now and then an artist would come along with his gallery mounted on wheels, stop a few days, and go on his way. But in January, 1873, George Fisher located here, and has since continued the business with increasing patronage, and he is therefore the first permanent artist of Clarksville. In 1858 he commenced his present vocation, and he is therefore one of the few artists whose experience dates back to the days of daguerreotypes. In 1865, he came to Iowa, and has since been engaged in his present business being first located at Waterloo, subsequently at Vinton before coming to Clarksville.

History of Butler and Bremer Counties, *1883*

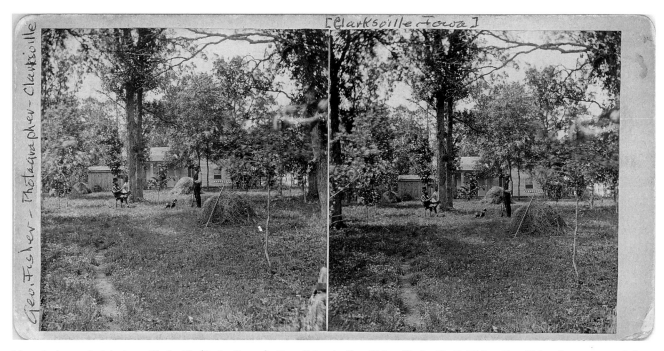

Geo. Fisher – Photographer – Clarksville

[Clarksville Iowa]

Men who have raked the lawn, Clarksville (Butler County), 1870s. Taken by Geo. Fisher, Clarksville. Publisher: Geo. Fisher. Stereo mount; beige.

HAMPTON & GAMBLE
WHITTIER, IOWA

LOCAL VIEWS

DAKOTA GROVE YRS OLD

"Dakota Grove 3 years old, an ave. in the grove, eleven rows, 880 trees, South Carolina poplars on Strother farm," Whittier (Linn County), 1900s. Taken by Hampton & Gamble, Whittier. Publisher: Hampton & Gamble. Stereo mount; gray.

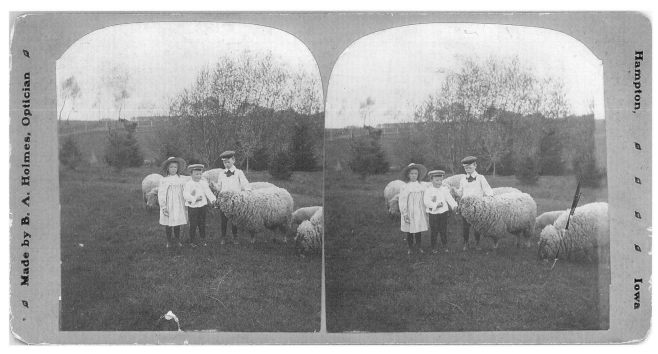

Children posing with sheep, Hampton (Franklin County), 1890s. Taken by B. A. Holmes, Hampton. Publisher: B. A. Holmes, Optician. Stereo mount; orange, opp. gray.

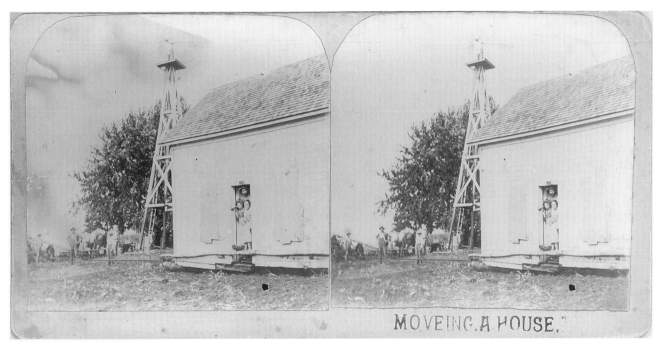

"Moveing a House." View of team of horses moving a house with people in the doorway, probably near Williamsburg (Iowa County), 1900s. Taken by unknown photographer. Stereo mount; beige. Tenant farmers sometimes moved from property to property each year.

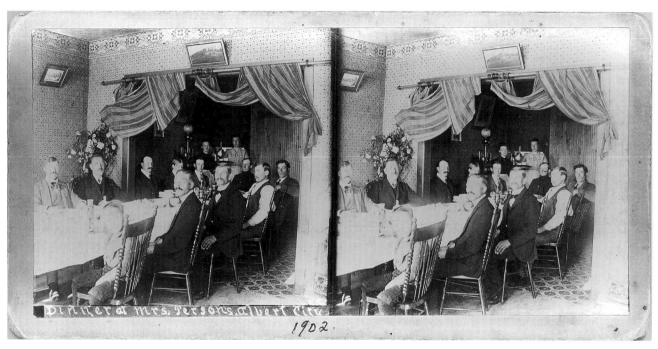

1902.

"Dinner at Mrs. Person's," Albert City (Buena Vista County), 1901. Taken by Elving, Albert City. Publisher: Elving. Curved stereo mount; beige. Boardinghouses could be found throughout Iowa, offering a temporary residence for single people and travelers.

The Stereoscopic picture is much more esteemed in America than in Europe: I think there is no parlor in America where there is not a stereoscope.

 Dr. Herman Vogel, on his third trip to America, Photographic Times, *August 1883*

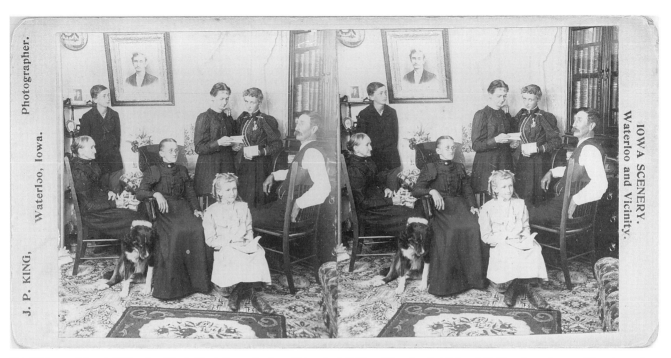

J. P. KING, Waterloo, Iowa. Photographer.

IOWA SCENERY. Waterloo and Vicinity.

"M. Wilbur and family," Waterloo (Black Hawk County), 1890s. Taken by J. P. King, Waterloo. Publisher: J. P. King, Iowa Scenery Waterloo and Vicinity. Stereo mount; beige. Even the dog held its pose for the photographer's camera and flash.

Grandpa Beebee's house had a formal parlor, and a library table in there held a stereopticon viewer and many of its double-faced cards. For us kids a great reward was to be allowed to hold it and see the marvels it displayed in three dimensions.

Beebee, The Farmer's Daughter

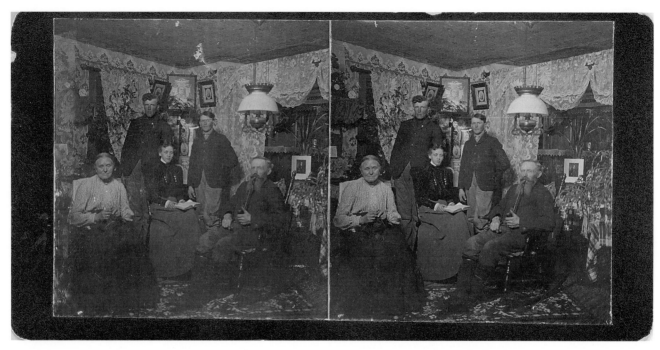

Group portrait of a family in their living room, Dike (Grundy County), 1900s. Taken by N. A. Nelson, Dike. Publisher: N. A. Nelson. Curved stereo mount; dark gray. Note the long-stemmed pipe held by the older man and the knitting in the hands of the older woman.

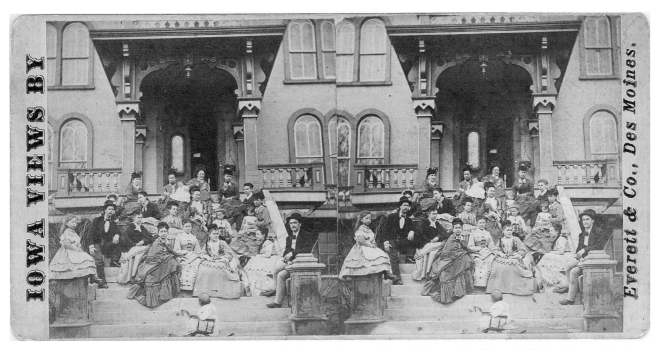

Large group of people seated in front of a home, Des Moines (Polk County), 1870s. Taken by Everett, Des Moines. Publisher: Everett & Co., Iowa Views. Stereo mount; yellow.

Interior view of a home with a covered heating stove, Albert City (Buena Vista County), 1900s. Taken by Elving, Albert City. Publisher: Elving. Curved mount; beige. During the summer months, heating stoves were often moved out of the way and covered to keep the polished chrome clean.

"Grandma and Grandpa Johanson's living room in back of shoe store building where Grandpa and Victor operated a shoe store. Ida and Victor lived upstairs. Vernon was born here 1903." Albert City (Buena Vista County), 1901. Taken by Elving, Albert City. Publisher: Elving. Curved stereo mount; beige. The upper floors of Main Street businesses often served as homes for the merchants. Photographs are on display everywhere, and paper hearts hang from the centerpiece as decorations for a wedding reception.

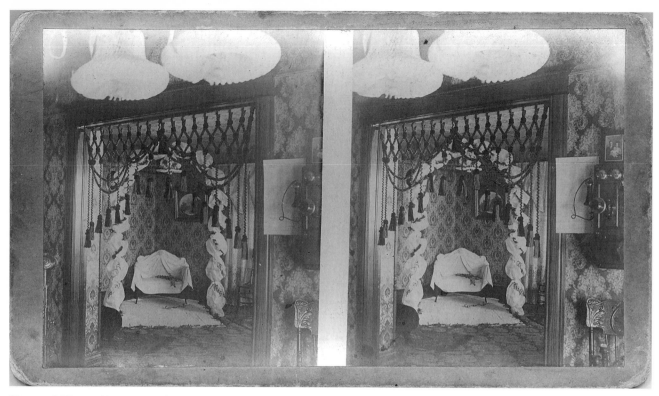

"Oscar and Ellen wedding corner where they were married," Albert City (Buena Vista County), 1900s. Taken by Elving, Albert City. Publisher: Elving. Curved cabinet mount; beige. Though constrained in a tight place, the photographer composed this shot to maximize the three-dimensional effect. Notice the telephone at the left and the paper bells overhead.

Summer was so hot we sometimes entertained at a breakfast party instead of afternoons. If one set entertained, another would pay it back and I have gone to partys at Breakfast time, afternoon and evening all in one day. We had stereopticon views and I think we Deans had the first phonograph with wax cylindar records, and a big Morning Glory horn.

 Carrie Dean Pruyn, "Out of the Dusk Memories of a Girl of the Gay Nineties," reminiscences about life in Tipton, Pruyn Collection, State Historical Society of Iowa, Iowa City

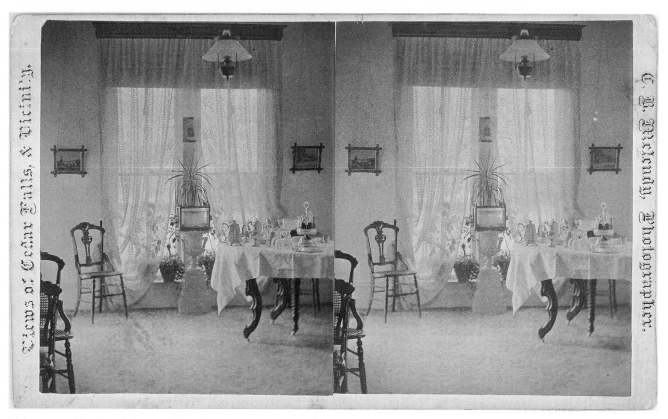

Living room with a bay window and the table set for tea, Cedar Falls (Black Hawk County), 1880s. Taken by C. B. Melendy, Cedar Falls. Publisher: C. B. Melendy, Views of Cedar Falls & Vicinity. Curved cabinet mount; beige. Silver and crystal adorn the linen-covered table.

Those who lived in or near Iowa's modest-sized towns participated in or were entertained by a variety of amusements, even if only on a seasonal basis. Town life offered the warmth of humanity to individuals and families living in rural areas and a place to enjoy relief from their daily labors. Community life revolved around traditional institutions like schools, churches, and workplaces, but it also included a wide array of public and private social gatherings. Whether engaged in open-air pastimes like picnics or sports, or visiting an opera house, a band concert, or a theatrical performance, people took their leisure time seriously. Stereo photographers capitalized on the desire to commemorate an occasion or secure a keepsake to help preserve memories of these happy, relaxing times.

Holidays became the focal point for celebrations, and towns sponsored festivals, fairs, street carnivals, parades, political rallies, and special ceremonies. For many citizens, the town symbolized a link to the rest of civilization, serving not merely as a center of commerce but also as the cultural vortex of life. Pioneer clubs, fraternal orders, veterans' groups, booster clubs, women's groups, and other grassroots organizations helped bind the community together while providing recreational pleasure and intellectual stimulation.

Expanding economic and educational opportunities led to a quest for status and the public display of one's affluence and culture. With the rise of middle-class society, people had more discretionary income and were able to spend more on leisure activities and the decorative arts. People were obsessed with current fads and newly affordable luxuries, but they were also keen on self-

improvement and looked to community activities for involvement in intellectual pursuits and celebrations of achievement. The Chautauqua circuits — with speakers of the day, musical performers, theatrical groups, and children's programs — fulfilled some of this need for cultural enlightenment and exposed people to mainstream national culture.

The naturalistic outlook dominated American thought after the Civil War, partly in response to industrialization and urbanization, and in the 1890s, a revived interest in environmentalism spawned a "back-to-nature" movement. People took an avid interest in parks, gardens, and scenic areas, many still in pristine condition. Stereo photographers, obviously attracted to the outdoors as much as their customers were, made regular trips to popular boathouses and swimming areas, hiked along the same trails in wooded areas, and traveled to local resorts and health spas. Society was undergoing a profound change in moral climate, which meant that women in the leisure classes could now engage in physical activity to a greater degree without appearing disrespectable or indecent. Unlike the landscape views so predominant in stereo photography, here the focus was on people, revealing some of the more private moments in their lives.

The sentimental and romanticized stereographs disguise the fact that many Iowans were not as economically advantaged as these views suggest and that, indeed, their energies were absorbed by simply making a living. Still, even though farm life brought strenuous labors and small-town life was sometimes described as boring, stereo photographers recorded middle-class Iowans at play and their enduring interest in developing a strong cultural identity based on involvement in a larger social arena.

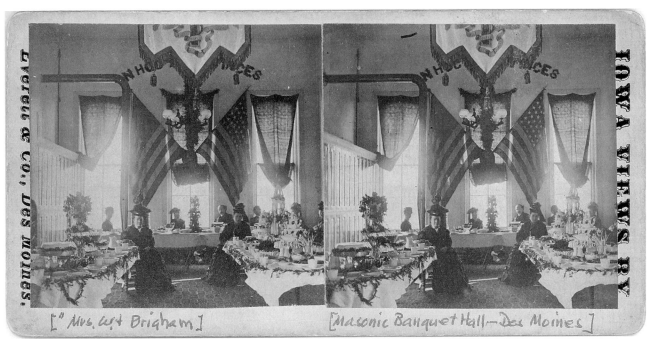

["Mrs. West Brigham] [Masonic Banquet Hall—Des Moines]

"Masonic Banquet Hall Des Moines" (Polk County), 1870s. Taken by Everett, Des Moines. Publisher: Everett & Co., Iowa Views. Stereo mount; yellow. A real feast has been laid out on the tables, and participants want the memorable occasion documented by the photographer.

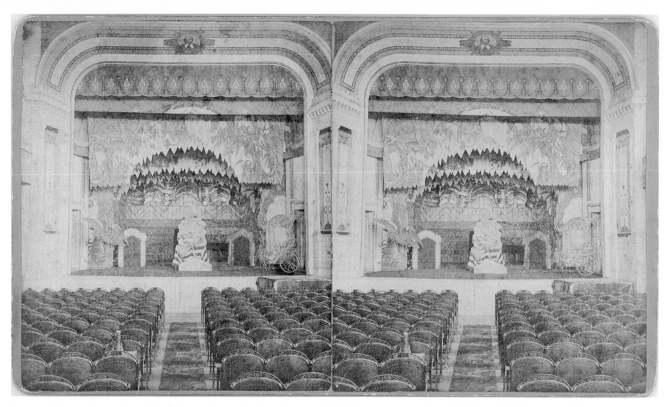

Interior of Opera House, Iowa City (Johnson County), 1880s. Taken by T. W. Townsend, Iowa City. Publisher: T. W. Townsend. Cabinet mount; orange, opp. pink. Note the portrait of Shakespeare at the top of the arch over the stage. The theater backdrops stand out in stark relief when viewed through a stereoscope.

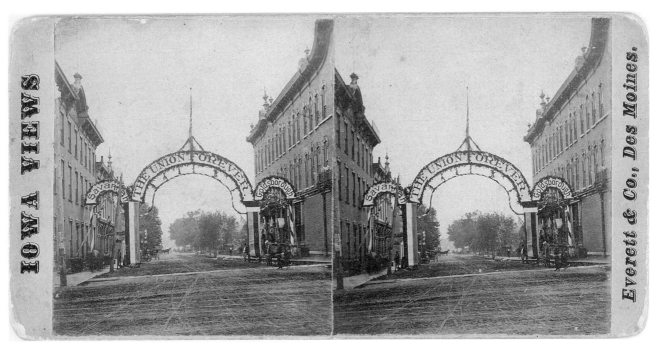

Banner for the visit of President Grant, Des Moines (Polk County), 1875. Taken by Everett, Des Moines. Publisher: Everett & Co., Iowa Views. Stereo mount; yellow, opp. gray. Banners recall military campaigns Iowa soldiers fought during the Civil War.

Holiday arch with patriotic bunting and a band posed in front, Manchester (Delaware County), 1870s. Taken by Mills, Manchester. Publisher: Mills' Premium Photograph Gallery. Stereo mount; pink.

"9. Pared at Dayten the 4 July 1898," Dayton (Webster County), July 4, 1898. Taken by A. L. Walline, Gowrie. Publisher: A. L. Walline. Stereo mount; beige.

Hickox and Co. claimed to be only company making stereo views in the west.

Waterloo Courier, *July 1871*

Circus tent, Waterloo (Black Hawk County), 1870s. Taken by Hickox, Waterloo. Publisher: Hickox & Co. Stereo mount; orange, opp. pink.

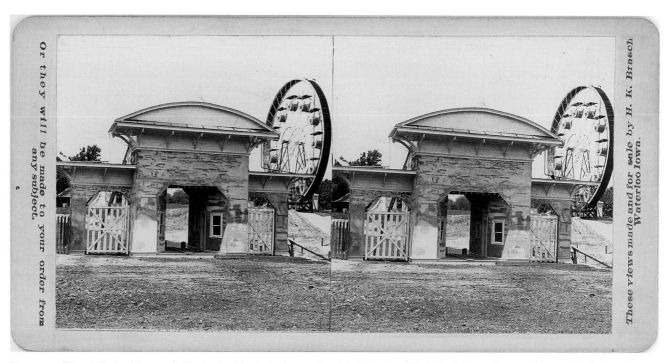

Entrance to Electric Park with an early Ferris wheel in the background at right, Waterloo (Black Hawk County), 1910. Taken by H. K. Brasch, Waterloo. Publisher: H. K. Brasch. Stereo mount; cream.

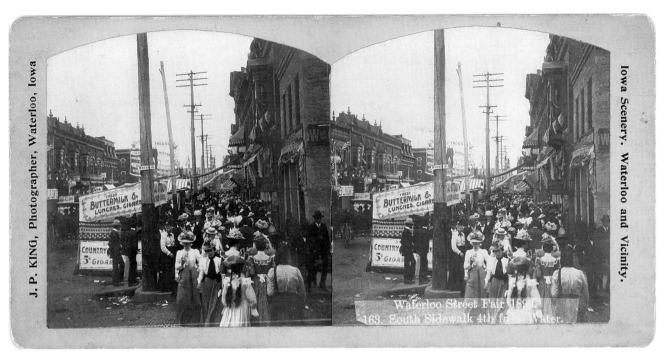

J. P. KING, Photographer, Waterloo, Iowa.

Iowa Scenery. Waterloo and Vicinity.

"Waterloo Street Fair 1899 163. South Sidewalk 4th from Water" (Black Hawk County), 1899. Taken by J. P. King, Waterloo. Publisher: J. P. King, Iowa Scenery, Waterloo and Vicinity. Curved stereo mount; orange, opp. bluish. This view offers quite a spectacle of advertising signs and women with elaborate flowers on their hats.

People in a tent selling pictures, Clinton (Clinton County), 1880s. Taken by Morlan & Nichols, "Artists and Photographers," Clinton. Publisher: Morlan & Nichols. Cabinet mount; orange, opp. pink.

Banquet tables set up outdoors with paper lanterns overhead, Iowa City (Johnson County), 1880s. Taken by T. W. Townsend, Iowa City. Publisher: Iowa View Company, Iowa City and Vicinity. Cabinet mount; pink, opp. orange. The following view was taken after the fifty or so guests had arrived at the party.

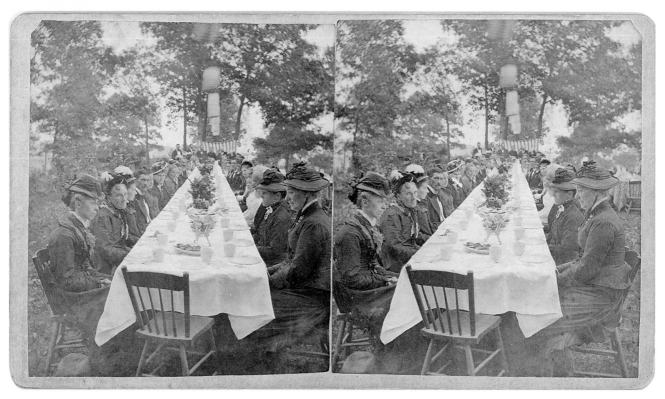

People seated at an outdoor table, Iowa City (Johnson County), 1880s. Taken by T. W. Townsend, Iowa City. Publisher: T. W. Townsend. Cabinet mount; pink, opp. orange.

Mrs. F. S. Dunham started on Monday last, for Philadelphia, to be present with her Department at the opening of the great Centennial Exposition. Mrs. Dunham has charge of the Centennial Department of photographs of Iowa scenery and eminent men and women. Her collection is creditable to her taste and judgment, and a splendid addition to Iowa's contribution to the display. Mrs. Dunham has spent much time and untiring effort in her work, and we are glad to know that she will be rewarded by the consciousness that her department is among the most attractive and valuable of Iowa's display.

Monticello Express, *as quoted in* Anamosa Eureka, *May 4, 1876*

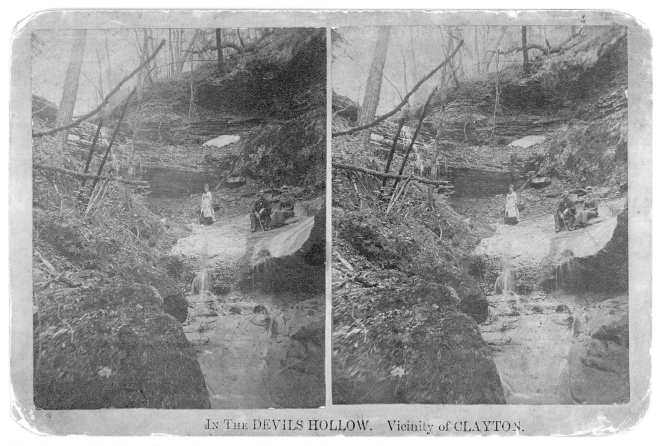

IN THE DEVILS HOLLOW. Vicinity of CLAYTON.

"No. 1. The three falls," Clayton (Clayton County), 1870s. Taken by G. M. Dempsie, Clayton. Publisher: G. M. Dempsie, Beauties of Clayton County. Series No. 4. In the Devil's Hollow. Cabinet mount; beige. When viewed through a stereoscope, each ledge stands out in bold perspective.

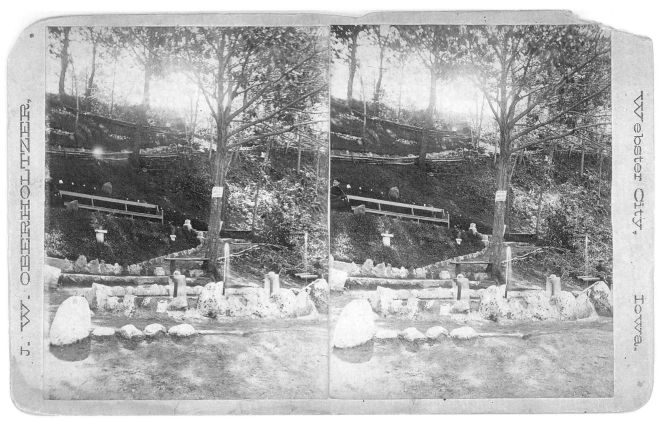

Rosenkran's park and fountains, Webster City (Hamilton County), 1880s. Taken by J. W. Oberholtzer, Webster City. Publisher: J. W. Oberholtzer. Cabinet mount; yellow. The stereoscope accentuates the terraces and height of the bluff.

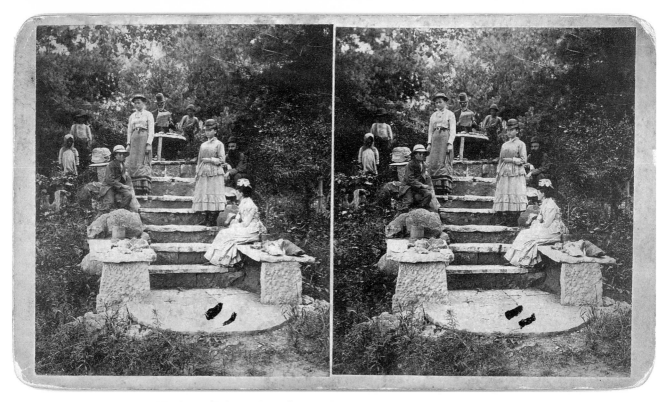

Women and men on stone steps, Manchester (Delaware County), 1880s. Taken by C. B. Mills, Manchester. Publisher: C. B. Mills. Cabinet mount; beige. The subjects at different elevations draw the focal point to the elderly man with glasses at the top.

Mr. Rich was the pioneer photographer of Charles City, in fact, took pictures here before photography had reached any considerable proficiency and when tin-types and ambrotypes were the best pictures known to the camera manipulator. Many here still possess pictures taken in that first picture gallery in this place which consisted of a car on wheels and was moved around the county as the interests of the picture man dictated. It was quite an event to the towns in this and adjoining counties when the Rich's picture car arrived and the maidens especially fixed themselves up for the purpose of having a "picture took." To this day a good ambrotype in a case looks to us to be about the best thing there is in pictures, and the ones we have of those early days are the ones most cherished.

Floyd County Advocate, *November 19, 1901*

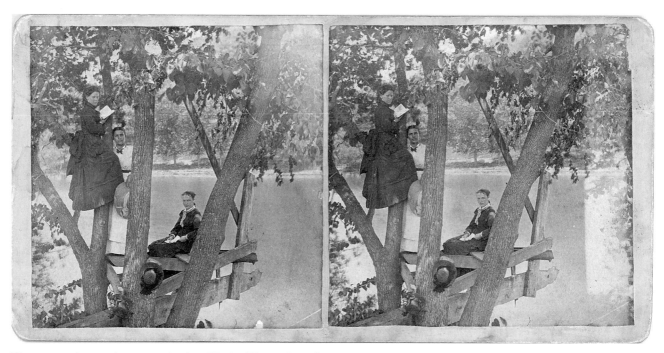

Three women in a tree house near the river, Elkader (Clayton County), 1880s. Taken by G. M. Dempsie, Elkader. Publisher: G. M. Dempsie, Stereo Views of Elkader and Vicinity. Stereo mount; yellow.

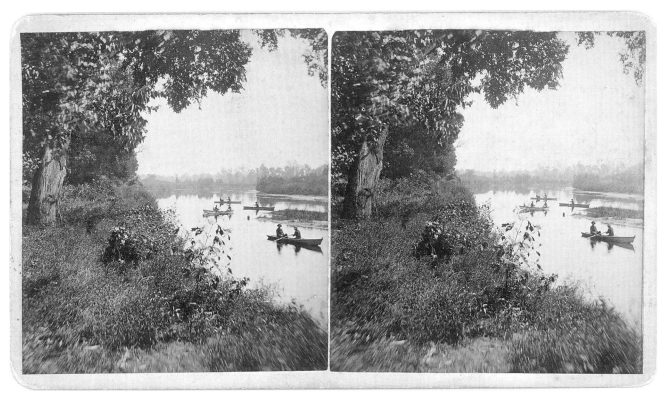

"5. The Fleet Afloat," Charles City (Floyd County), 1880s. Taken by Harwood & Mooney, Charles City. Publisher: Harwood & Mooney, Camp Wildwood: Home of the Fresh Water Marines, Cedar River, Floyd County, Iowa. Cabinet mount; beige.

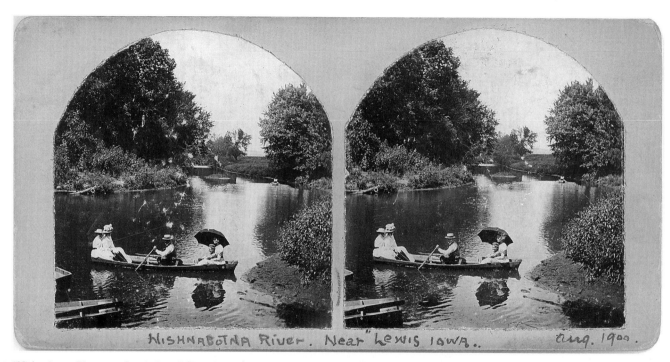

Handwritten on mount: NISHNABOTNA RIVER. Near "LEWIS IOWA.. aug. 1900.

"Nishnabotna River near Lewis, Iowa" (Cass County), August 1900. Taken by unknown photographer. Curved mount; beige.

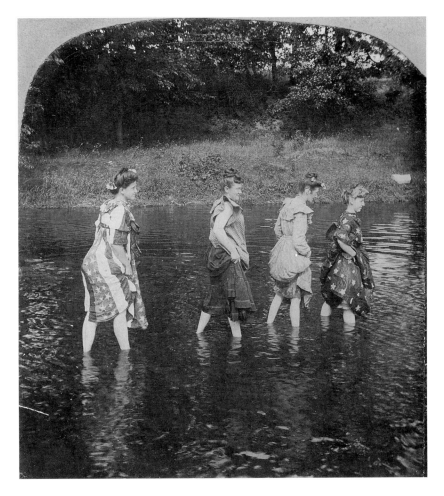

Four women in patriotic dress, Waterloo (Black Hawk County), 1890s. Taken by J. P. King, Waterloo. Publisher: J. P. King, Views of Waterloo and Vicinity. Stereo mount; beige. These women, draped in parade finery, sought relief from the heat by walking in the water. King created at least four distinct views in this series, including two of women playing with a dog.

"Jim (girl) Patterson at Alpha," Alpha (Fayette County), 1880s. Taken by J. P. King, Waterloo. Publisher: J. P. King. Cabinet mount; yellow. The man appears to be lying in a bed of pansies.

When [J. S. Buser] was a small boy the family removed to Warren, Illinois, where he attended the public schools, and on completing his education was granted a teacher's certificate. After teaching for a few terms he took up photography and traveled over a greater part of the United States taking views. He finally located in Lansing, Iowa, where he spent one year, and then removed to Monroe, Wisconsin, where the following two years were passed. Subsequently he was a resident of Waterloo, Iowa, for five years, and at the end of that time removed to Cedar Rapids. From there he traveled over the state in the interests of his profession and made many thousand stereoptican views. About 1885, he came to Mt. Vernon, and at this place he now has one of the best galleries in Iowa. It being built purposely for his business. He also has a branch studio in Mechanicsville and another in Lisbon. He is recognized as one of the best and most artistic photographers in this section of the state, and is a member of the National Photographers Association of America.

Biographical Record of Linn County, *1901*

IOWA SERIES.

Photographed by J. S. BUSER, Waterloo, Ia.

HOME SCENERY.

Residences, Groups, City Views, &c.

Three small children playing croquet, Waterloo (Black Hawk County), 1870s. Taken by J. S. Buser, Waterloo. Publisher: J. S. Buser, Iowa Series Home Scenery. Stereo mount; orange, opp. pink.

At the close of hostilities, [Henry R.] Buser was mustered out and returned to Warren [Illinois], where he entered the employ of a sash and door manufacturing concern. In 1868, however, he took up the study of photography and removed to Cedar Rapids to become a permanent resident of this city. Here he opened the first studio and for a long period conducted a prosperous business, keeping in touch with the advancement made in the methods of photography. He devoted nearly a quarter of a century to the profession and about 1898 retired from the business, after which he devoted his attention to his real estate interests, having in the meantime made extensive and judicious investments in property. When he arrived here the city contained a population of about five thousand but he was pleased with its conditions and its prospects and took great pride in promoting its interests and upbuilding. He was always active in support of any project or movement to promote its welfare and his labors were efficient and far-reaching.

History of Linn County, *1911*

J. P. KING, Photographer, Waterloo, Iowa

Iowa Scenery. Waterloo and Vicinity.

Six children on a donkey, Waterloo (Black Hawk County), 1890s. Taken by J. P. King, Waterloo. Publisher: J. P. King, Iowa Scenery. Stereo mount; orange opp. gray.

They aught to be happy

"They ought to be happy but they hain't." View of two hunters with prairie chickens, Center Point (Linn County), 1880s. Taken by J. A. Fairbanks, Center Point. Publisher: J. A. Fairbanks Art Gallery, Views of Center Point and Vicinity. Stereo mount; yellow.

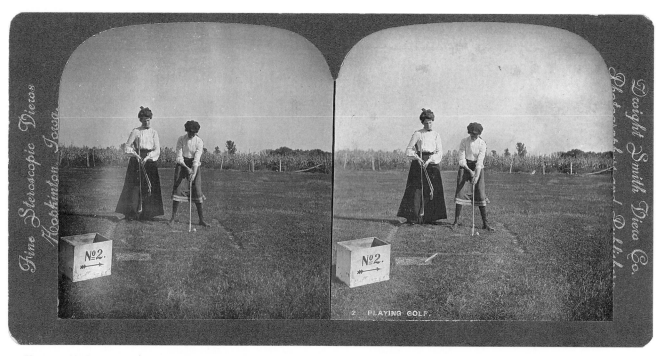

"2. Playing golf," Hopkinton (Delaware County), 1900s. Taken by Dwight Smith, Hopkinton. Publisher: Dwight Smith View Co., Fine Stereoscopic Views. Curved stereo mount; dark gray.

Mr. Baker, of this review, possessed advantages of education in the district schools until he was fourteen years of age. Not being attracted to farming, he learned the printer's trade, which he followed for fifteen years. In the meantime his natural artistic talents began to manifest themselves and he took up the study of photography to which he has given his attention for the last fourteen years. He has had an extensive experience and has attained high proficiency in the art, being now the owner of the leading photograph gallery of Columbus Junction, where he has been located since 1907. The success of Mr. Baker in his business has been due to natural talents, and an ambition to excel which has not permitted him to rest satisfied with an ordinary measure of proficiency. He has made a close study of his art from every practical standpoint and his work attracts favorable comment wherever it is shown, his patrons being among the best people in this part of the state.

Springer, History of Louisa County, *1912*

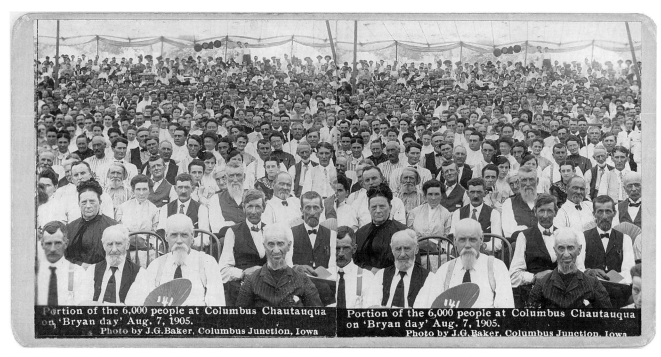

Portion of the 6,000 people at Columbus Chautauqua
on 'Bryan day' Aug. 7, 1905.
Photo by J.G. Baker, Columbus Junction, Iowa

Portion of the 6,000 people at Columbus Chautauqua
on 'Bryan day' Aug. 7, 1905.
Photo by J.G. Baker, Columbus Junction, Iowa

"141. Portion of the 6,000 people at Columbus Chautauqua on 'Bryan day' Aug. 7, 1905," Columbus Junction (Louisa County). Taken by J. G. Baker, Columbus Junction. Publisher: J. G. Baker. Curved stereo mount; beige. William Jennings Bryan, popular orator and politician, drew large crowds on this special day at the Chautauqua.

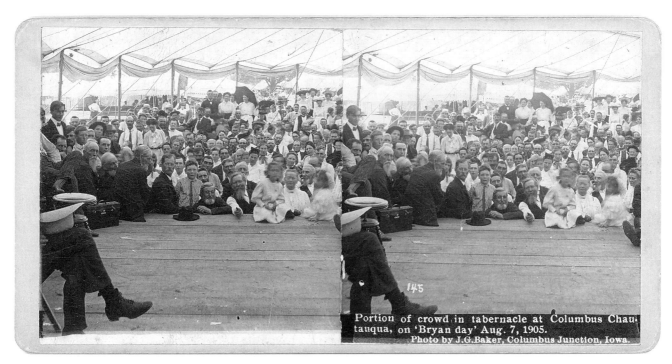

Portion of crowd in tabernacle at Columbus Chautauqua, on 'Bryan day' Aug. 7, 1905.
Photo by J. G. Baker, Columbus Junction, Iowa.

"145. Portion of crowd in tabernacle at Columbus Chautauqua, on 'Bryan day' Aug. 7, 1905," Columbus Junction (Louisa County). Taken by J. G. Baker, Columbus Junction. Publisher: J. G. Baker. Curved stereo mount; beige.

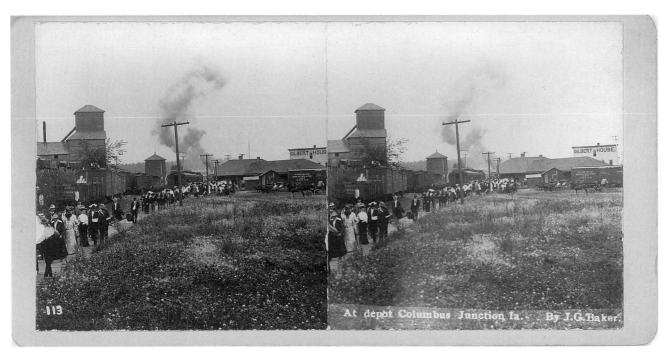

"113. At depot Columbus Junction, Ia. Coming to Chautauqua" (Louisa County), ca. 1905. Taken by J. G. Baker, Columbus Junction. Publisher: J. G. Baker. Curved stereo mount; beige.

TRAVEL SOUVENIRS

The desire to preserve memories of trips away from home spawned another steady market for stereo photographers. This was never more apparent than in the numerous views created of Clear Lake, Iowa's Great Lakes, and the Sioux City Corn Palace. Iowans enjoyed traveling to nearby towns for summer vacations and holiday retreats. Hotels and resorts were established near mineral springs and scenic lakeside areas, offering healthful relief from the labors of everyday life. Stereo photographers hoped to capture memorable events by taking pictures of groups at a railroad station or in front of a favorite spot. Visitors wanted a keepsake reminder of the sites they saw, the places where they stayed, and the leisurely activities they enjoyed.

The advertising on the backs of stereo cards was used to lure visitors, as exemplified by the inscription on the back of T. W. Townsend's stereographs of Clear Lake: "The Great Summer Resort of the Northwest." Townsend added: "It is a very beautiful sheet of water, clear as crystal, being fed entirely by springs. It affords facilities for boating, bathing, and fishing, surpassed by no sheet of water on the continent, and only equaled by a few."

Clear Lake attracted many tourists who felt that one could attain a more spiritual mood when relaxing in the natural beauty surrounding the lake. Some Clear Lake stereographs show members of various religious groups convening at the lake, while others show boaters and swimmers. Several of the earliest views of Clear Lake were produced by Orville Slocum. In the late 1870s, T. W. Townsend of Iowa City also published, under the auspices of the Iowa View Company, a series

titled "Gems of Clear Lake," with at least twenty-seven views. George Fisher, from Clarksville, also had a lengthy Clear Lake series. H. S. Mather, however, became the resident photographer of Clear Lake, operating throughout the 1880s. His studio, at the corner of Third and State Streets, was directly across from the city park in the center of town. Mather's wife was possibly related to Slocum, the earliest photographer in Clear Lake.

Iowans in the northwest part of the state were fortunate in having lakes that provided a retreat from the sultry days of summer. Stereo photographers in Spirit Lake and Storm Lake centered their businesses on the seasonal visitors to the lakes.

Spirit Lake, with an area of twelve miles, is the largest lake in Iowa. The resident stereo photographer in Spirit Lake, Frank F. Roblin, was responsible for a series of views, "Views of Spirit Lake and Vicinity." Taken in 1883, these show fifty-three different scenes of the region. Although some distance away, two Charles City photographic firms were also responsible for many views of Okoboji and Spirit Lake. J. E. Rich probably made these views and created the series titled "Views on and About the West and East Okoboji and Spirit Lakes," with backlists of up to thirty-six views. His studio was later sold to the firm of Harwood & Mooney, who continued to issue stereographs of the same views using an identical backlist. Not far from Spirit Lake, Gerrit Coman became the principal stereo photographer for the Buena Vista County town of Storm Lake. Storm Lake is situated on the great watershed in the county and covers an area of four or five square miles. Although his lake views are rare, Coman probably also used the lake to his advantage in marketing his town's stereographs.

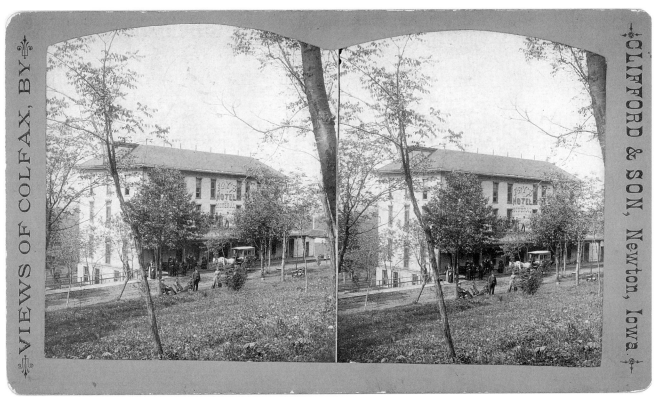

Fry's Hotel and Mineral Spring, Colfax (Jasper County), 1880s. Taken by Clifford & Son, Newton. Publisher: Clifford & Son, Views of Colfax. Cabinet mount; orange, opp. pink.

I. L. Townsend, the Iowa Falls photographer, is a native of Knox County, Ohio, born July 19, 1839. He came to Iowa in 1853 and first lived in Cedar County. In 1860 he engaged in a photograph business and in 1861 located at Iowa City but he has since continued the business in several different places at different intervals. He came to Iowa Falls in September, 1880.

History of Hardin County, *1883*

IOWA FALLS AND VICINITY.

IOWA FALLS is situated 142 miles west of Dubuque. The Illinois Central Railroad, and the Burlington, Cedar Rapids and Northern Railroad cross at this point. The Town is located among the most romantic scenes of diversified beauty to be found in the West. The IOWA RIVER flows past the town, the level of the water being nearly seventy-five feet below the level of the principal business street. MINERAL SPRINGS of rare quality are being developed, and IOWA FALLS is destined to be a great Summer resort, second to none in the West. The following are the principal places of interest:

No. 156, Rock Run Bridge, Rock Run.
" 157, Fair View Ledge, " "
" 158, Twin Rocks, " "
" 159, Cedar Cliffs, " "
" 160, Shady Dell, " "
" 161, Rocky Ford, " "
" 162, Shelving Rocks, " "
" 163, Sunny Dell, " "
" 164, Railroad Cliffs, " "
" 165, Silver Ripples, " "
" 166, Dry Cascade, Wild Cat Glen.
" 167, Echo Cave, " " "
" 168, Sunny Point, " " "
" 169, Viney Cliffs, " " "

No. 170, Elk Run Retreat, Elk Run.
" 171, Dam and Grand View Cliffs.
" 172, Mill and Dam.
" 173, Mill, from Grand View Cliffs.
" 174, Wagon Bridge.
" 175, Grand View Cliffs.
" 176, Village, from Grand View Cliffs
" 177, Kelly's Dam.
" 178, Misquaka Bluffs.
" 179, Sulphur Spring Cliff.
" 180, Ammonite Cliff.
" 181, "Sulphur Springs at Kelley's Creamery."
" 182, "Off for a Pic-Nic."

No. 183, Wood's Hotel.
" 184, Carlton's Perpetual Lime Kiln.
" 185, Under R. R. Bridge, looking E.
" 816, Up the River from R. R. Bridge.
" 187, R. R. Bridge, with Train.
" 191, Washington Avenue, looking East, Iowa Falls.
" 195, Entrance to Cemetery, " "
" 204, General View in Cemetery. "
" 207, Lover's Retreat, Rock Run.
" 208, "Lover's Promenade."
" 209, "Artist's Delight."
" 210, "Behind the Rocks."

Duplicates of this View always on hand.
Orders by Mail Promptly Filled.

Published by I. L. TOWNSEND, Artist
Iowa Falls, Iowa.

Backlist for I. L. Townsend.

"Pool of Silvani" [Siloam Springs],
Iowa Falls (Hardin County),
1880s. Taken by I. L. Townsend.
Publisher: I. L. Townsend, Iowa
Falls and Vicinity. Cabinet mount;
orange, opp. pink.

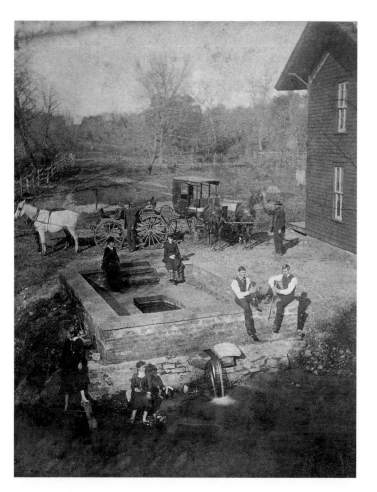

Gems of Clear Lake,

THE GREAT SUMMER RESORT OF THE NORTHWEST.

Clear Lake is in Cerro Gordo County, Iowa. It is about midway of the State east and west, and about thirty miles south of Minnesota State line. The lake is said to be seven miles long and three miles wide. It is a very beautiful sheet of water, clear as crystal, being fed entirely by springs. It affords facilities for boating, bathing and fishing, surpassed by no sheet of water on the continent, and only equaled by a few. Green Brothers and the Camp Meeting Association each have a fleet of boats on the lake and ample appliances to supply every demand of Pleasure Seekers.

The principle places of interest are as follows:

(The pen mark indicates the view on this card.)

No 1 Looking across Lake.
" 6 Pavilion, Clear Lake Camp Ground.
" 11 Observatory from Prospect House.
" 13 Pavilion and Group.
" 14 Asbury Avenue, looking north.
" 15 Andrews Avenue looking west.
" 16 Camp Ground Pier looking west.
 Canopy and Headquarters, with Group.
" 19 Camp Ground beach from pier looking east.
" 7 Commercial Row Clear Lake Camp Ground.
" 69 Group at Woodford cottage.
" 94 Camp Ground R. R. Landing,
" 88 Bishop Peck, J. S. Inskip and other Eminent Ministers at Clear Lake National Camp Meeting of '78.

X " 61

No 20 Bathing party in Clear Lake.
" 23 Looking down the Lake.
" 24 Looking up the Lake.
" 31 Fleet on Clear Lake.
" 38 Island from reef of rocks.
" 40 Island from main land.
" 41 Island from Saxby's Point.
" 56 Childrens Meeting at Bethany.
" 59 Interior of Pavilion.
" 68 Prospect Avenue from "Lozier Court."
" 85 From Dome of Pavilion,
 Group on Beach,

Duplicates of this Picture always on hand.
Orders by Mail Promptly filled.

Published by "IOWA VIEW Co.,"
T. W. TOWNSEND, Manager.
Corner Clinton and Washington Streets, IOWA CITY, Iowa.

Backlist for T. W. Townsend.

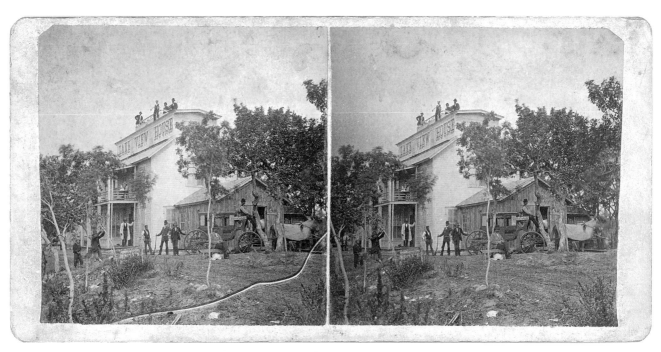

"No. 80." View of Lake View House, Clear Lake (Cerro Gordo County), 1870s. Taken by T. W. Townsend, Iowa City. Publisher: Iowa View Company, Stereoscopic Views of Clear Lake and Vicinity. Stereo mount; pink, opp. orange. Note the stagecoach parked at the right. A view taken from the top of this hotel appears next.

This is a new house, elegantly furnished with all the comforts and luxuries of a summer resort hotel, and calculated to be first-class in every respect. It is located on the lake shore, convenient to both park and town, and provided with a fine dock where all boats land.

Iowa State Gazetteer and Business Directory, *1880 −81*

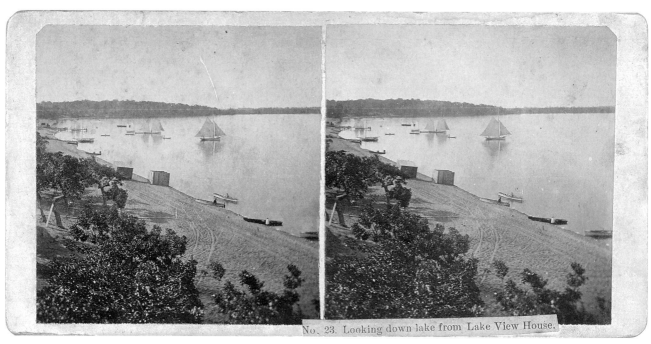

No. 23. Looking down lake from Lake View House.

"No. 23. Looking down lake from Lake View House," Clear Lake (Cerro Gordo County), 1870s. Taken by T. W. Townsend, Iowa City. Publisher: Iowa View Company, Stereoscopic Views of Clear Lake and Vicinity. Stereo mount; pink, opp. orange.

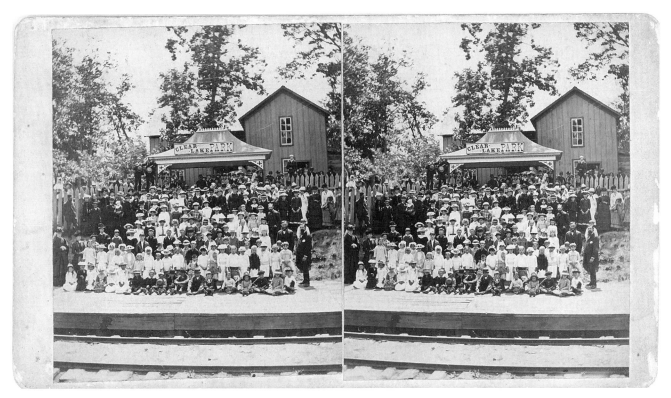

People posing at a train stop for Clear Lake Park, Clear Lake (Cerro Gordo County), 1880s. Taken by H. S. Mather, Clear Lake. Publisher: H. S. Mather, Views in and around Clear Lake, the Greatest Summer Resort of the Northwest. Cabinet mount; pink.

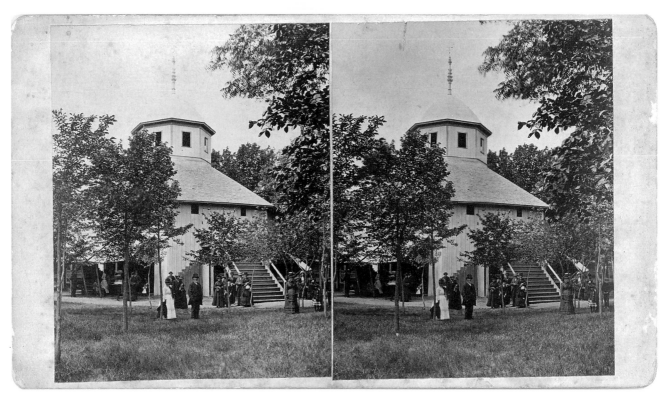

The Pavilion, an octagon-shaped meeting house on Clear Lake (Cerro Gordo County), 1880s. Taken by H. S. Mather, Clear Lake. Publisher: H. S. Mather, Views in and around Clear Lake, the Greatest Summer Resort of the Northwest. Cabinet mount; pink. An interior view follows.

"No. 59." Interior of Pavilion, Clear Lake (Cerro Gordo County), 1870s. Taken by T. W. Townsend, Iowa City. Publisher: Iowa View Company, Stereoscopic Views of Clear Lake and Vicinity. Stereo mount; pink, opp. orange. The arch reads: "For God so loved the world that He gave His only begotten Son that whosoever believeth in Him should not perish but have everlasting life" and "Those who educate the nation's children shape its destiny."

H. S. Mather, photographer, established his business here in 1881 and is the only representative of his art in the city. He is a good artist and thoroughly competent to excel in all branches of his business. He has recently erected a new building with excellent arrangements for first class work. He makes a specialty of stereoscopic views of Clear Lake and vicinity and has constantly on hand an assortment of views of the Lake, village and camping ground. Mr. Mather is a native of Cazenovia, New York, and was born in 1836. He studied the technique of his art at Morrisville, New York, and has pursued his present calling since 1865. His wife, Jennie (Slocum) Mather is also a native of Cazenovia.

History of Franklin and Cerro Gordo Counties, *1883*

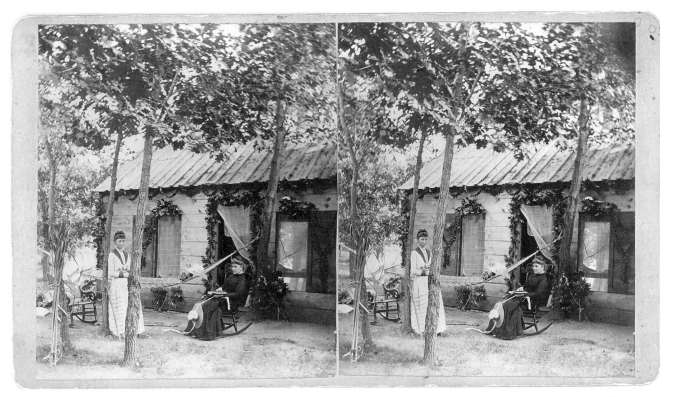

Summer cottage by the lake with gauze cloth on windows and doors, Clear Lake (Cerro Gordo County), 1880s. Taken by H. S. Mather, Clear Lake. Publisher: H. S. Mather, Views In and Around Clear Lake. Cabinet mount; green, opp. beige. These women have embellished their little cottage with boughs of oak leaves around the doorway, windows, and roofline.

Boats with sails drying, Clear Lake (Cerro Gordo County), 1880s. Taken by H. S. Mather, Clear Lake. Publisher: H. S. Mather, Views in and around Clear Lake, the Greatest Summer Resort of the Northwest. Cabinet mount; pink. Two steam-driven excursion boats also appear in the background.

"No. 6. Headquarters Concord Union S. S. School," Clear Lake (Cerro Gordo County), 1870s. Taken by T. W. Townsend, Iowa City. Publisher: Iowa View Company, Stereoscopic Views of Clear Lake and Vicinity. Stereo mount; pink, opp. orange. Various household goods and furniture were brought for the extended stay at the campground.

Boat on its side and its mast leaning on the dock, Clear Lake (Cerro Gordo County), 1880s. Taken by H. S. Mather, Clear Lake. Publisher: H. S. Mather, News In and Around Clear Lake, the Great Summer Resort of the Northwest. Stereo mount; green.

No. 20. Bathing party in Clear Lake.

"No. 20. Bathing party in Clear Lake," Clear Lake (Cerro Gordo County), 1870s. Taken by Gould, Clear Lake. Publisher: Iowa View Co. Stereo mount; pink, opp. yellow.

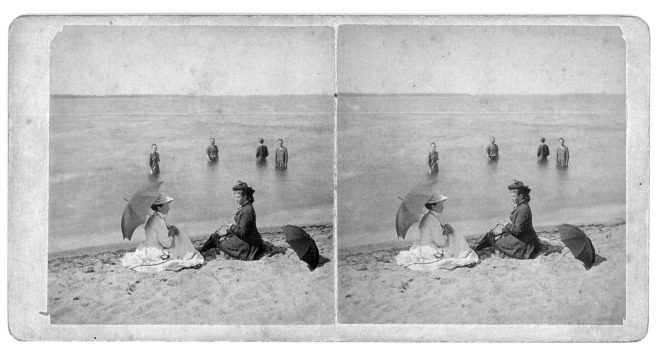

"No. 57." View of two ladies on beach and swimmers in the water, Clear Lake (Cerro Gordo County), 1870s. Taken by T. W. Townsend, Iowa City. Publisher: Iowa View Company, Stereoscopic Views of Clear Lake and Vicinity. Stereo mount; pink, opp. orange.

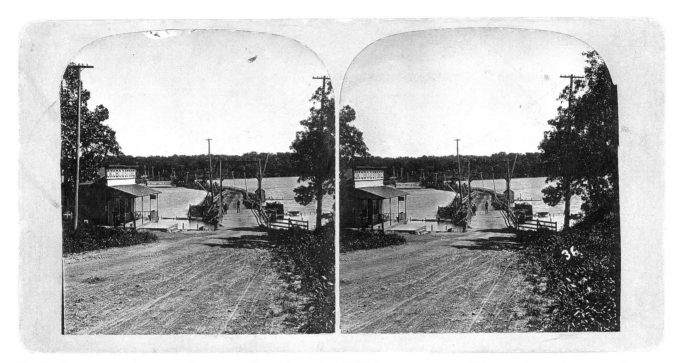

The "Okoboji Store" and the causeway between the Okoboji Lakes, Okoboji (Dickinson County), 1900. Taken by unknown photographer. Stereo mount; gray.

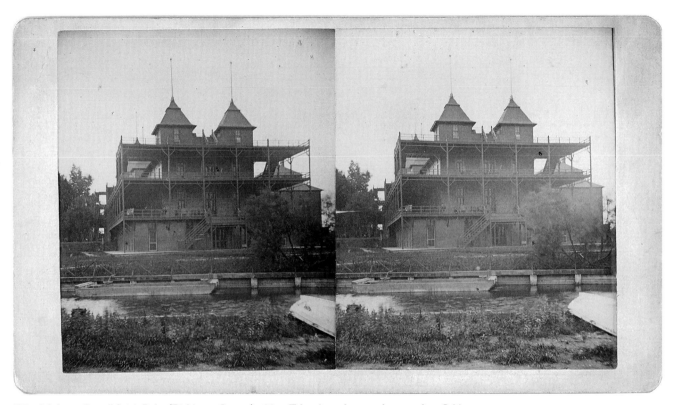

"Hotel Orleans, Iowa," Spirit Lake (Dickinson County), 1880s. Taken by unknown photographer. Cabinet mount; gray.

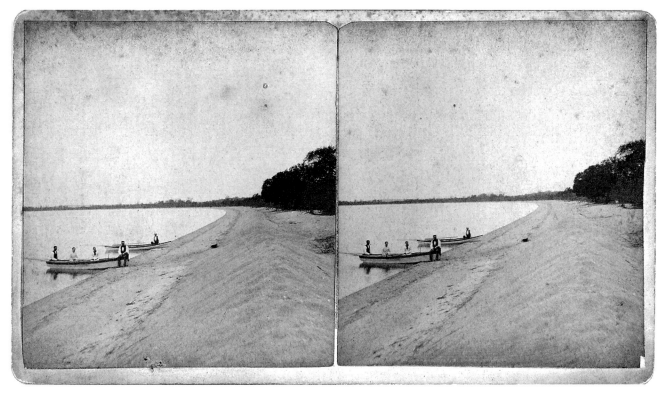

"23. Hunter's Lodge, Spirit Lake—looking South West," Spirit Lake (Dickinson County), 1880s. Taken by Harwood & Mooney, Charles City. Publisher: Harwood & Mooney, Views on and about the West and East Okoboji and Spirit Lakes, Dickinson County, Iowa. Cabinet mount; beige.

~Views of Spirit Lake~

AND VICINITY.

DICKINSON COUNTY, IOWA,

TAKEN IN 1883.

1. Dixon's Beach.
2. Dixon's Point.
3. Foliage on Dixon's Beach.
4. Log House on West Okoboji Lake that people were massacred in in 1857.
5. C. M. & St. P. Bridge and Wagon Crossing at Okoboji.
6. The Steamer "Favorite" up for repairs at Okoboji.
7. Pilsbury's Point, East Side.
8. Beach at Arnold's Park, looking east.
9. Beach at Arnold's Park, looking west.
10. Pilsbury's Point, from Arnold's Park.
11. Middle Gar Lake.
12. Henderson's Boats on Middle Gar Lake.
13. Lake Park House, Spirit Lake, Iowa.
14. Hotel Orleans, west end, and Bridge.
15. Hotel Orleans, south side.
16. M. E. Church, Spirit Lake, Iowa.
17. Cutting Ice on East Okoboji Lake.
18. East end of Lake Street, in the winter of '82.-83.
19. Snow Drift on Lake Street.
20. A Pair of Setter Dogs.
21. Looking We t. up Lake St. in Winter.
22. Cattle Drinking from East Okoboji Lake in Winter.
23. Just before Launching the "Queen" on Spirit Lake.
24. Hotel Orleans, half of north side.
25. The Arrival of the "Alpha" at Spirit Lake.
26. The Grade at foot of Lake St.
27. A Fishing Party at Stony Point.
28. Lake Street, looking west from Hill Street.
29. Lake Street, looking east

from Hill Street.
30. Whole of Hill Street from the north.
31. A View of the Isthmus from town.
32. View of the Isthmus from the west.
33. View of the Hotel Orleans from Lilywhite Lodge.
34. Sunken Lake.
35. Li tle Spirit Lake, and where it empties into Spirit Lake.
36. The Old Tree, near where Marble was shot by the Indians.
37. A House now used for a stable.
38. Narrow Strip of Ground dividing Little Spirit Lake from Spirit Lake.
39. Beach on Spirit Lake, west of Crandall's Lodge.
40. Beach on West Shore of Spirit Lake.
41. The Beach on Spirit Lake dotted with Tents.
42. A Dog in a Tree up from the Lake Shore.
43. View of Lilywhite Lodge.
44. Beach on Spirit Lake at the Isthmus.
45. Beach in front of Hotel Orleans.
46. The Steamer "Queen" at the Orleans Landing.
47. Crandall's Lodge.
48. Crandall's Lodge, from the Landing.
49. Looking east from Crandall's Lodge.
50. Looking west from Crandall's Lodge.
51. North End of Spirit Lake, looking towards Sampson's Lodge.
52. McClellan's Beach, on Spirit Lake, looking east.
53. Sampson's Lodge, from the Boat Landing.

FRANK F. ROBLIN, PHOTOGRAPHER,

SPIRIT LAKE, IOWA.

There is nothing more beautiful than a good stereoscopic picture, and yet stereoscopic work is in its infancy. It had one great whooping-up soon after it arrived, and grew wonderfully; then it lighted on evil days, and for years has been in abeyance—a sport of optical measles or teeth-cutting. There are signs that now this stage is over and we are to see a revival.

Edward Gill, "Stereoscopic Work," Photographic Mosaics, *1900*

"When the ice goes out of West Okoboji Lake, Ia. Pillsbury's Point" (Dickinson County), 1900. Taken by unknown photographer. Stereo mount; gray. This late image capturing an impression of clouds in the sky was possible because film speeds had become faster than in the earlier years of stereo photography.

Sioux City was proud to host the honeymoon visit of President Grover Cleveland to the inaugural Corn Palace in 1887. Cleveland heralded the fantastic building as the first new thing he had seen on his trip across America that year. The Corn Palace opened on October 3, 1887, designed as a promotional gimmick by city leaders who wanted to showcase the regional economy using corn and farm produce as a theme. Trainloads of midwesterners attended the event, and the celebration lasted for a week. Sioux City built Corn Palaces for five consecutive years, with the final one constructed in 1891. Souvenir stereographs from all five Corn Palaces were published in great numbers.

Each Corn Palace was unique, though all featured a decorative facade of corn. The 1888 palace used 30,000 bushels of corn. Combining corn, grain, grasses, and straw, the temporary structure featured high towers, domes, turrets, and balconies. Some were of Moorish design or included interior grottos, Grecian temples, barnyard scenes, and spectacular colors to illustrate the seasons of the year. The 1890 palace even had a river running through it.

Accompanying the palaces were parades, fireworks, dancing by Native Americans, speeches, and band concerts. Sioux City photography firms vied for the chance to be designated the official photographer of the Corn Palace, an honor given to James Hamilton in 1888 and to the partnership of Brown & Wait in 1890. The studios for the competing photographic companies were on Fourth Street in Sioux City, only a few doors apart. Both the 1888 and the 1889 Corn Palaces are known to have had interior views taken. Exterior views exist of all of the Corn Palaces; some show

parades passing by. Local photographers, such as Gerrit Coman from Storm Lake, also came to Sioux City to earn profits from stereographs of the spectacular Corn Palaces.

Other Iowa towns used such palaces to celebrate the harmony between the farm and business communities, but none could rival the fame and popularity of the Sioux City Corn Palaces among stereo photographers.

"Corn Palace at Sioux City, IA, 1888" (Woodbury County). Taken by Coman, Storm Lake. Publisher: Coman. Cabinet mount; orange, opp. pink. Although the men in the foreground are looking up, a parade is marching down the street.

HAMILTON, Publisher, 407 Fourth St.

(Official Photographer for Corn Palace Association.)

HAMILTON, Publisher, 407 Fourth St.

(Official Photographer for Corn Palace Association.)

CORN PALACE, 1888.

"Corn Palace, 1888." View of state motto of Iowa, "Our Liberties We Prize and Our Rights We Will Maintain," Sioux City (Woodbury County), 1888. Taken by Hamilton, Sioux City. Publisher: Hamilton. Cabinet mount; beige. When viewed through a stereoscope, this series of stereographs allows the viewer to vicariously visit the interior space of the Corn Palace.

HAMILTON, Publisher, 407 Fourth St.
(Official Photographer for Corn Palace Association.)

HAMILTON, Publisher, 407 Fourth St.
(Official Photographer for Corn Palace Association.)

CORN PALACE, 1888.

"Corn Palace, 1888." View of several arches, Sioux City (Woodbury County), 1888. Taken by Hamilton, Sioux City. Publisher: Hamilton. Cabinet mount; beige. A sense of depth is created by the layers of woven grains hanging in each archway.

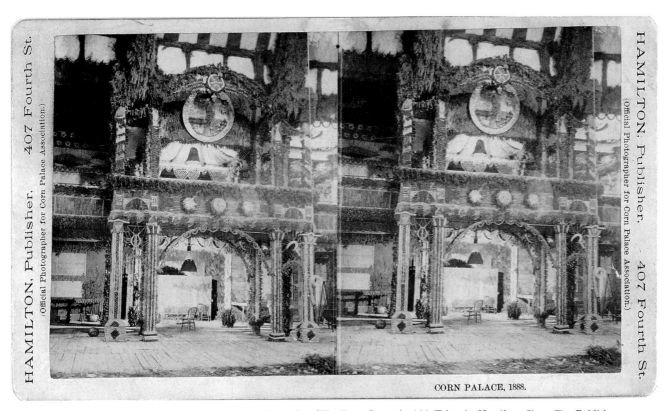

HAMILTON, Publisher, 407 Fourth St.

(Official Photographer for Corn Palace Association.)

HAMILTON, Publisher, 407 Fourth St.

(Official Photographer for Corn Palace Association.)

CORN PALACE, 1888.

"Corn Palace, 1888." Grand arch with State Seal of Iowa, Sioux City (Woodbury County), 1888. Taken by Hamilton, Sioux City. Publisher: Hamilton. Cabinet mount; beige.

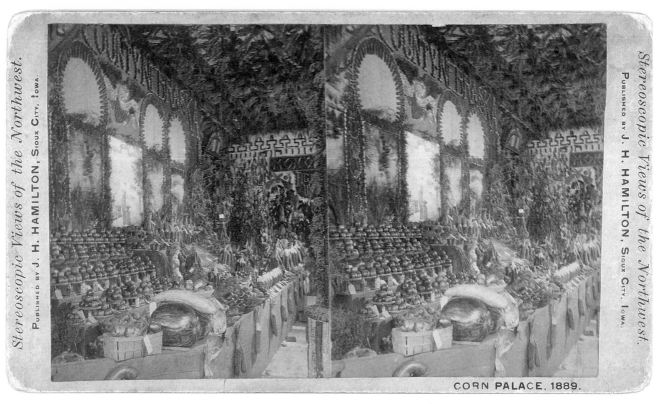

Stereoscopic Views of the Northwest. PUBLISHED BY J. H. HAMILTON, SIOUX CITY, IOWA.

Stereoscopic Views of the Northwest. PUBLISHED BY J. H. HAMILTON, SIOUX CITY, IOWA.

CORN PALACE, 1889.

"Corn Palace, 1889." Interior view with County Nebraska along wall, Sioux City (Woodbury County), 1889. Taken by J. H. Hamilton, Sioux City. Publisher: J. H. Hamilton, Stereoscopic Views of the Northwest. Cabinet mount; beige. The purpose of the Corn Palace was to promote the regional agriculture and commerce. Each vegetable stands out clearly when the image is viewed through a stereoscope.

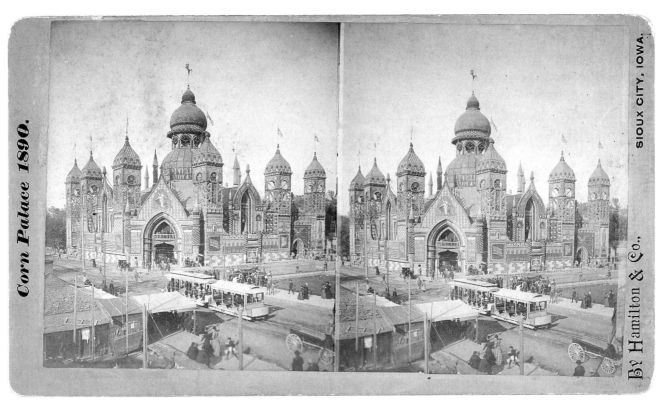

Corn Palace 1890.

By Hamilton & Co., SIOUX CITY, IOWA.

"Corn Palace, 1890," Sioux City (Woodbury County). Taken by J. H. Hamilton, Sioux City. Publisher: Hamilton & Co. Cabinet mount; orange, opp. gray. Note the excursion trolley for visitors. Each palace presented a different architectural style, usually built as a façade.

EPILOGUE

The inspiration and starting point for any book on stereographs come from the work of William C. Darrah, author of *The World of Stereographs*, among other works on historical photography. In the 1970s the field of photo history enjoyed a revival in scholarship and public appreciation, resulting in genre-specific texts focusing attention on all sorts of historical imagery, especially daguerreotypes and the work of fine art photographers. Darrah was among the first to explore the popularity of stereo photography as a worldwide phenomenon. He concentrated primarily on photographers from America, Great Britain, and continental Europe. Given the broad scope of his study, it is no surprise that his information on local photographers in states like Iowa was incomplete. One feature of his book was a listing of known stereo photographers, the first attempt to identify the whereabouts of this group of professionals.

Building on Darrah's scant list of Iowans was our first challenge, and slowly we uncovered evidence of more than 350 photographers or partnerships operating as stereo photographers in Iowa between 1865 and 1900. The surviving record of their work seems relatively small given the information gathered in this study. We have direct evidence of more than two thousand one-of-a-kind stereographs; thousands more must exist. Imprints on many of the stereographs provide details and descriptions that are unavailable in any other photographic medium. The authoritative information accompanying each image permits us to track the body of work of individual photographers as well as the marketing and distribution patterns they employed.

Using Iowa stereo photographers as a microcosm, we can learn a great deal about photo history in America, such as the nature of the profession and how successful these people were at both mastering their craft and creating artistic expressions. Although numerous directories of photographers have been generated at the state and local levels, few have investigated the story behind the individuals who created this marvelous imagery. Even though some art historians dismiss this vernacular form of photography, the sheer number of quality stereo images demands our attention. Acknowledging the contributions of these photographers and elevating some of their work to the realm of fine art is the purpose of this book.

Several patterns emerge in an examination of the lives of Iowa's stereo photographers. The first wave of pioneer photographers consisted generally of those born in the 1830s and 1840s. Caught up in the romance of the West, they were lured to Iowa for many reasons — often to join family or to search for economic success. Some, with poetic and artistic spirits, kept on the move in order to make a living as photographers. One obvious parallel among the lives of the photographers is that many were just coming of age at the time of the California gold rush and, later, the Civil War. More than a dozen stereo photographers were veterans of the war, including D. H. Cross, who had served in a photographic unit. While some were born in Iowa, more came from the East right after the war, no doubt following the railroad. Recent immigrants from places like Denmark and Nova Scotia settled in Iowa as well, bringing their photography skills with them.

Photographers were transient, constantly searching for new and larger markets. Day-to-day travel was limited to horse-drawn vehicles, but rail transportation was opening up new possibilities for travel and trade. Stereo photographers depended on the railroad to deliver supplies and pho-

tographic chemicals from larger urban areas, often supply houses in Chicago or farther east. The railroad also allowed the photographer to move from one village to another, hauling trunks of photo equipment or actually pulling a photo car along the tracks. Photographers searched for new territory by following the railroad to smaller communities, often located at the end of a spur line.

Even within the state, the movement westward was common among photographers. Isaac Wetherby, for instance, moved from Iowa City to Rock Valley in northwest Iowa, and later to Kansas; Alonzo G. Rifenburg went from Cedar Rapids to Hamburg in southwest Iowa. Some nomadic photographers continued farther west, ending up in Idaho or California, where they established studios and took stereo views.

Typically, photographers learned the trade as young people in their teens and twenties, sometimes starting their careers as apprentices. Family connections were important, and it was common to practice photography alongside a parent or sibling. Husband-and-wife teams like Theodore and Elizabeth Farrington of McGregor, Mr. and Mrs. L. W. Schoonover of Vinton, or Perrin C. and Chasta Huffman of Waukon worked together in the studio and the darkroom. Merritt M. Mott of Anamosa was assisted by his daughter Catherine, who was also a photographer.

In a profession clearly dominated by men, women were nonetheless able to make their own mark, without the support of male family members. Lydia A. Schooley, who operated a gallery in Indianola, raised five children. She was also known to have taught photography to others. Another notable exception to the preponderance of males was Lucelia Carpenter of Parkersburg, though her surviving work is elusive. Carpenter was part of the later wave of stereo photographers, born in the 1850s and 1860s, who began their careers after the vanguard had paved the way. By 1880,

5.7 percent of Iowa's 420 known photographers were women, though far fewer were stereo photographers. Regardless, even Darrah noted that women in the Midwest joined the professional ranks by practicing in smaller communities.

Photographers who persisted over two or three decades in one community can be identified, but it was as common for them to branch out or move on. Successful partnerships existed between brothers like the Ensmingers of Independence, the Leisenrings of Mount Pleasant, or the Reynoldses, who worked at several locales. Henry R. and Joseph S. Buser both prospered with studios in eastern Iowa towns. Sharing expenses in formal business partnerships, even without familial ties, was one way a photographer could get started without taking sole risk for the venture. More than forty such partnerships existed among the known stereo photographers.

An economic profile has not yet been formulated, but longevity in the profession may have been difficult unless a photographer was versatile. Though many belonged to professional organizations or tried to gain recognition through prizes like state fair premiums, a reliable income required hard work and constant canvasing for customers. Even with steady customers, photographers had competitors in the trade. A small town could not support more than one studio, but larger urban areas attracted many photographers. Even after cultivating an eight-year relationship with one patron, for example, Isaac A. Wetherby earned only a total of $51.25, or a few dollars a year from that customer. Census records from the 1870s indicate the average photographer's personal estate to be around $800 or $1,000, although some evidence points to more successful photographers with personal estates valued at twice as much. When Orison Byerly's Parkersburg gal-

lery burned in 1893, he lost "his entire photographic outfit" and stock valued at $800. Generally, few struck it rich in the business, and all had to contend with the usual market for portrait photographers. The specialists in stereo photography were but one segment of a larger group of professional photographers.

The rise and fall in popularity of local stereographs in Iowa can be clearly traced by comparing the numbers of photographers working in the decades covered by this study. Although figures may vary, fewer than 20 stereo photographers appear in the 1860s, and only about 6 of these persist into the 1880s. By the 1870s, with the boom in stereo photography, the numbers rise to nearly 175, and more than half of these survived long-term. Numbers diminish slightly, to approximately 155, in the 1880s but then drop dramatically to only 16 or so in the 1890s, a decrease attributable to dry plate photography and the growth of amateur photography. Only a handful of Iowa stereo photographers existed in the 1900s, and for the most part they may have been amateurs, since professionals seem to have ceased to produce stereographs.

By the time the latecomers started practice in the stereo view trade, photographers were on the verge of adopting dry gelatin plates, which revolutionized picture taking. Again, D. H. Cross emerges as a major figure. He gained national fame as an early innovator in creating premanufactured negatives to replace the time-consuming wet plate photography. The later stages of Iowa stereo photography, beginning in the 1890s, also brought the abandonment of the older albumen prints in favor of modern developing-out papers. The result was a change in tonal quality, as the image shifted from the familiar muted brown and sepia tones to the harsher black-and-white

image. Part of the distinctive character of local views seems lost when they match the look commonly found on mass-produced stereographs like those issued by the Keystone or Underwood & Underwood companies.

Stereo photography started out as a noble endeavor, but eventually the local practitioner who made images by hand was undermined by the more cheaply priced stereographs produced by large publishing and distribution houses, which used mass marketing. The demise of the stereograph was also triggered by the advent of the picture postcard, which flourished after an 1898 law permitted postcards to be sent in the mail for only a penny. Ironically, Queen Victoria, who had earlier championed the age of stereo photography, was among the first to adopt and praise the picture postcard. Superseded by technological improvements in photography that allowed amateurs to take their own photos, local stereo views began to go out of fashion. It was just a matter of time before the printing and publishing industry mastered new ways of presenting photographic imagery in the press, literary magazines, and books.

Although its value diminished in many areas, in others stereo photography served as the main tool for educating people about the world's geography and culture. Three-dimensional images also remained of critical importance in the scientific field. As late as the mid-1920s, Fred W. Kent found that stereo imagery offered great research potential for medical specialists at the University of Iowa. Microscopic stereo photography was even better, as it extended the vision of the researcher into areas never before imagined.

Kent's humorous side led him to create loving stereographs of his family, along with beautifully composed views of Iowa's natural landscape that harked back fifty years to a time when

stereo photography was at its peak. Using a somewhat nostalgic medium, Kent helped perpetuate a tradition that was almost obsolete. By the 1950s, serious amateur and professional photographers were using Stereo Realist cameras to capture dual images for 35mm color slides. Special viewers illuminated the three-dimensional views.

One of the last bridges to the past can perhaps be found in the popular Viewmaster stereographs, a series of tiny color transparencies mounted on circular cards. Children of the 1950s and 1960s can remember the surprise of seeing each image pop out as the lever of the Viewmaster was clicked. This generation of children was also among the last to be entertained by vintage stereographs owned by older relatives. Visiting a grandmother or great aunt could mean an adventurous trip to the attic to hunt for these old treasures to play with.

The significance of the stereograph should not escape us: It presents an insider's view of nineteenth-century America. Our sense of history will be greatly enhanced by reexamining this nearly passé genre of photography, more seriously this time and in combination with other sources. Not merely decorative accents to enliven texts and films, stereographs deserve to be considered works of art and valuable documents of the past, revealing many secrets of an age gone by.

IOWA

DIRECTORY OF IOWA STEREO PHOTOGRAPHERS

This directory of Iowa stereo photographers is based on extensive research over many years, a process that is ongoing and never-ending. More complete biographical information, evidence of expanded activities and studio locations, and more precise dates for these photographers are documented elsewhere. While thousands of photographers operated studios in Iowa, the information in this directory focuses only on those who practiced stereo photography.

The dates, and even the names, of the photographers are taken from various sources, and these sources may contradict each other. Many photographers spent a few years in one town and moved on, a phenomenon almost impossible to fully document. A photographer may have visited several towns within one decade.

Likewise, partnerships may have lasted only a few years, and an individual might form a joint venture more than once. In some instances, images were created by the individual photographer even if distributed under the name of a partnership. The directory attempts to identify those professionals who actually set up studios or announced their services in city directories or advertisements. It does not include all of the photographers' assistants, whether family members or hired help.

By nature, the directory is selective, partly because of the scarcity of historical records. Attempts were made to authenticate information or reconcile variances by identifying multiple sources to confirm or verify facts. Nonetheless, the spelling of the photographers' names on the stereographs themselves varied. The company that made the mounts or the local printer who hand-set type often made errors in the spelling of the photographer's name or even that of the town itself. The inconsistencies in style and presentation between photographers, or even within one photographer's career, mean many cards lack any imprints or labeling.

Photographers sometimes identified the town in which they worked on the side or back of the stereograph, while others used their imprint to advertise series of stereo views for sale. They ventured far from the studio, as indicated by the backlists and hand-labeling of images. Some may have set up branch studios that they visited only on certain days or,

This map, based on an 1875 map of Iowa, identifies towns where stereo photographers were located and indicates the relative number of photographers throughout the state. Eager to find viable commercial markets, those who practiced the trade of photography settled in towns with larger populations, usually situated near a waterway or linked by the railroad to other towns. Map by Pat Conrad.

less frequently, brought their photo wagon or temporary studio to town. The towns and dates listed in the directory are based more on printed sources than on information from the stereographs themselves.

Without specifically citing all of the sources used in compiling this list, basic research for this directory relied upon county histories, newspapers, advertisements, city directory listings, atlases, census records, and biographical files. Confirmations came through additional research conducted by JoAnn Burgess and direct examination of the Juhl collection of Iowa stereographs. Members of the National Stereoscopic Association constantly report "sightings" and research findings, which has resulted in the national directory of stereo photographers created by Darrah and Treadwell.

Although at present our knowledge is primarily limited to nineteenth-century photographers, research into the lives of Iowa photographers continues. JoAnn Burgess is compiling a directory of Iowa photographers that will reach beyond the scope of this directory of Iowa stereo photographers.

PHOTOGRAPHER	TOWN	STUDIO EXISTED
Adams, Asa W. (1842−1915)	Decorah	1865−1873+
	Waterloo	1889−1900
	McGregor	1863−1865
Adams, George H.	Walnut	1880s
	Avoca	1880
	Lewis	1883
	Griswold	1883−87
Adams, W. G.	Waterloo	1880s
Addis, Alfred S.	Dubuque	1860s?
Allen (Chatfield & Allen)	Keokuk	1870s?
Anschutz, Herman M. (1869−?)	Keokuk	1890s−1910s
Araah, Antheonia (Prof.)	Oxford Junction	1876−1904
	Onslow	1880−1882
	Maquoketa	1882
	Garfield	1884
	Monticello	1887
Armstrong, C. M.	Leon	1870s?
Armstrong, Samuel McDowel (1849−1923)	Fairfield	1877
	Washington	1880s-1890s
Atherton, Albert Carl	Charles City	1890s
	Cedar Falls	1891−92
Atkinson, Charles A.	Davenport	1870s
Babcock, Warner D.	Grinnell	1880s
	Union	1880
	Marengo	1884

| --- | --- | --- |
| Bacon, George | Chariton | 1870s |
| Baker, James Geddes (1868?) | Columbus Junction | 1900s |
| Baker, W. | Marshalltown | 1870s |
| Baldwin, Cassius M. (1848–?) (Baldwin & Daugherty) | East Des Moines | 1870s–1880s |
| Barber, Earl (1852–1896) | Waterloo | 1870s |
| Barke, J. F. | Council Bluffs | 1880s |
| Barnard, Alonzo A. (Huffman & Barnard) | Waukon | 1880s-1890s |
| Barnes, Harvey C. (Jacoby & Barnes) | West Liberty | 1870s–1890s |
| Barnes & Kennedy | Newton | 1870s |
| Barnett, L. M. G. | Davenport | 1860s–1870s |
| | Des Moines | 1870s |
| Beatty, William (1844–1913) | Sigourney | 1870s–1890s |
| Bell, Isaac A. | Donnellson | 1890s |
| | Fort Madison | |
| | Farmington | |
| Belveal, E. S. | Ottumwa | 1880s |
| Benton, W. E. | Missouri Valley | 1880s? |
| Bernard, A. L. | Avoca | 1870s–1880s |
| Bertrand, Edison E. | Cresco | 1870s–1880s |
| | Independence | 1880s |
| Beverage, Maurice C. (Beverage & Jessup) | Marshalltown | 1870s–1890s |
| Bilbrough, John E. (1840–?) | Dubuque | 1864–1899 |
| Bingham, F. V. | Clermont | 1880s |
| Bittenbender, Levi C. | Knoxville | 1870s–1880s |
| Blackhall, John | Clinton | 1860s–1870s |

PHOTOGRAPHER	TOWN	STUDIO EXISTED
Blair, Lyman G.	Ida Grove	1870s–1880s
	Odebolt	
Blair, Robert H.	Keokuk	1860s
Blair, William E.	Sac City	1870s–1880s
	Rock Rapids	1889–1895
	Belle Plaine	1897–1899
Borloug, Ole E. (1856–1894)	Decorah	1880s
Bowen, R. Judson (Haddock & Bowen)	Waterloo	1890s
Boyd, William F.	Des Moines	1870s–1890s
Brandt Brothers (Fred, Henry, William F.)	Avoca	1880s–1890s
	Walnut	
Brasch, H. K.	Waterloo	1900s
Brewer, Mary Ann Proctor	Shenandoah	1874–1890s
Brewer, William Henry (1838–?)	Shenandoah	1874–1890s
Briggs, J. P.	Mitchell	1870s?
Brown, Henry R. (Brown & Wait)	Sioux City	1880s–1890s
Bryan, Sylvester T.	Burlington	1874–1880s
Buser, Henry R. (1840–1903)	Cedar Rapids	1870s–1890s
Buser, Joseph S. (1845–?) (Buser's Gallery)	Lansing	1870
	Waterloo	1870s
	Cedar Rapids	1870s–1880s
	Mount Vernon	1885–1880s
	Mechanicsville	1880s
	Lisbon	1880s

PHOTOGRAPHER	TOWN	STUDIO EXISTED
Byerly, Orison (1836–?)	Parkersburg	1880s–1890s
	Dubuque	1870s
	Farley	
	Jesup	
Cammack, Walter R. (Stubbs & Cammack)	Marshalltown	1880s
Card, B. F.	Leon	1870s?
Carpenter, Lucelia (1854–1921)	Parkersburg	1880s
Carter	Hampton	1880s
Chapman, A.	Adel	1870s–1880s
Chase, C. B.	Davenport	1870s
Chatfield (Chatfield & Allen)	Keokuk	1870s?
Chatterton, H. D.	Villisca	1880s
	Centerville	1880s
Child, Arthur Leon (?–1938?)	Grinnell	1880s–1890s
Clark, Lyman	Webster City	1880s–1890s
	Albion	1860s
Clausen, Axel J. (1864?–?)	St. Ansgar	1880s
Clausen, Christian M. (1833–1923?)	St. Ansgar	1880s
Clement, Eben	Marshalltown	1870s–1880s
Clifford, Charles (Clifford & Son)	Newton	1880s–1890s
Clifford, Frederick (Clifford & Son)	Newton	1880s
	Muscatine	1880s
Clough, J. F.	Audubon	1880s
Clutter, D. (Clutter & Daft)	Newton	1870s

PHOTOGRAPHER	TOWN	STUDIO EXISTED
Collins, Cephas H.	Wyoming	1870s–1880s
Coman, Gerret S. (1849–1913?)	Storm Lake	1870s–1890s
Conners, W. J.	Clarinda	1860s–1870s
Cook (Cornell & Cook)	West Union	1870s?
Cook, Isaac N.	Davenport	1860s–1870s
Cook, John C.	Webster City	1880s
Cook, Joseph	Waterloo	1880s
Cook, Newton Gaston	Ames	1880s
Coon, Samuel H. (1844–?)	Malcom	1880s–1890s
	Victor	1880s–1890s
	Charles City	
Cope Bros. (Thomas & Joseph A.)	Lyons	1870s–1890s
	Clinton	1890s
Cornell (Cornell & Cook)	West Union	1870s?
Corning, Nathan A.	Osage	1880s
Cottrell	Dunlap	1870s?
Couvens, J. W.	Waverly	1870s–1880s
Coyle, Frank A.	Monticello	1870s–1890s
Cross, Daniel H. (1836–?)	Indianola	1879–1890s
	Des Moines	1880s
Cutler, Schuyler	Mount Pleasant	1880s–1890s
Cutter, Ephraim (1823–1886)	Dubuque	1860s–1880s
Dabb, R. I.	Le Mars	1880s–1900
Daft, Charles E. (Clutter & Daft)	Newton	1870s

PHOTOGRAPHER	TOWN	STUDIO EXISTED
Dammand, Robert Peterson (1855–?)	East Des Moines	1880s
(Daugherty & Dammand)	Harlan	1880s–1890s
Datesman, Peter	Eldora	1870s–1880s
	Burlington	1860s
	Marshalltown	1870s
Daugherty, C. J. (Baldwin & Daugherty)	East Des Moines	1880s
(Daugherty & Dammand)		
Delong, W. W. (1858–?)	Sioux City	1870s–1880s
Dempsie, George M.	Elkader	1870s–1880s
	Clayton	1880
	Strawberry Point	1899
	Garnavillo	
Dennis, E. G.	Waverly	1880s
Ditts	Eagle Grove	1880s
Dolen, John O.	Lake Mills	1880s
Doolittle, Alonzo P.	Columbus Junction	1880s
Dougherty, H.	Waterloo	1870s
Douglass	Waverly	1880s
Dunlap, Thomas A.	Bloomfield	1870s–1890s
Eberhart, H. C.	Springville	1880s
Eberhart, Manoah H.	Cedar Rapids	1865–1880s
	Mount Vernon	
	Preston	
	Wyoming	

PHOTOGRAPHER	TOWN	STUDIO EXISTED
Egbert, William P. (1831–1904)	Davenport	1852–1904
	Atlantic	
Egnes, John	Story City	1870s
Elder, George W.	Forest City	1870s–1890s
Elite Studio	Morning Sun	1900s
Elliott, Herbert I. (Jones & Elliott)	Davenport	1870s
	Marion	1870s–1890s
Elliott, William H.	Marshalltown	1870s
Ellis, Azro D.	Waterloo	1880s
Elving, Lars Erick (1862–1918)	Albert City	1900s
Emerson, James H.	Keokuk	1870s
Emery, J. F.	Northwood	1870s–1880s
Ensminger, Jefferson C. (1845–?) (Ensminger Bros.)	Independence	1860s–1880s
Ensminger, J. Madison (Ensminger Bros.)	Independence	1860s–1880s
Esmay, John (1834–1911?)	Sabula	1860s–1880s
Evans, James G.	Muscatine	1860s–1870s
Evans, T. E.	Muscatine	?
Everett, E. G.	Des Moines	?
Everett, James E. (Jas.) (1834–?)	Indianola	1870s–1880s
	Des Moines	1870s–1880s
Fairbanks, James A. (1849–1910)	Center Point	1880s–1890s
	Walker	
Farr, H. R.	Dubuque	1870s
Farrington, Elizabeth Peavy (1847–?)	McGregor	1860s–1870s

PHOTOGRAPHER	TOWN	STUDIO EXISTED
Farrington, Theodore (1844–?)	McGregor	1860s–1890s
Favorite	What Cheer	1870s–1880s?
Fellows, Eliha G. (1846–?)	Vinton	1870s–1890s
Fields, Mr. & Mrs. William B. (Margaret J.)	Lyons	1870s–1880s
	Burlington	1850s
Fisher, George C. (1823–?)	Clarksville	1870s–1880s
	Waterloo	1860s
	Vinton	1870s
Flanders, Charles M.	Glenwood	1880s–1890s
	Humeston	
	Corydon	
Fosnot, Lewis C. (1847–1930) (Fosnot & Hunter)	Keosauqua	1870s–1890s
Fox, George W. (Fox & Wiltse)	Osage	1880s
	Mitchell	
	Mason City	
Franklin, E. S.	Montour	1870s
Freeborn, Lee H.	Des Moines	1860s–1890s
Fritz, John S. (1821?–1891?)	Waverly	1880s
	Guttenberg	
Fry, William D.	Villisca	1880s
	Hopkinton	1880s
	Clarinda	1880s
Gamble (Hampton & Gamble)	Whittier	1890s–1900s
Gardner, Richard G. (1837–?)	Maquoketa	1860s–1880s

PHOTOGRAPHER	TOWN	STUDIO EXISTED
Garrison Bros. (Charles F., Frederick A., C. C.)	Fort Dodge	1870s–1890s
	Ruthven	
	Rolfe	
	Marathon	
	Laurens	
Gay, W. D.	Essex	?
Gilbert (Gilbert & Wilkin)	Nashua	1880s
Gilbert, Calvin Hubert	Independence	1890s
Gilchrest, Geo. K.	Cedar Falls	1880s
	Fairfield	
Goldsberry, Benjamin E.	Bedford	1870s–1880s
	Red Oak	
Gould	Clear Lake	?
Graack, Nicholas P.	Davenport	1874–1884?
Green, Benjamin F. (Green & Smith)	Ottumwa	1870s–1880s
Greenlee, William F. (Miles & Greenlee)	Belle Plaine	1880s
Greenwood, William H. (1838–?)	Manchester	1860s–1870s
Groneman, Fred C.	Fort Dodge	1870s–1890s
Grosvenor (Grosvenor & Harger)	Dubuque	1880s
Gurnsey, B. H. (1842–?) (Gurnsey & Illingsworth)	Sioux City	1860s–1870s
Haddock (Haddock & Bowen)	Waterloo	1890s
Hale, De Witt C. (1857–1934)	Elkader	1870s–1920s
Hall, John R.	Monroe	1878–1890s
	Newton	1860s

PHOTOGRAPHER	TOWN	STUDIO EXISTED
Hall, William W.	Northwood	1879–1883
	Mitchell	1870s
Halvorsen, John R.	St. Ansgar	1878–1884
Hamilton, Isaac B.	Shenandoah	1884–1900
Hamilton, James H. (Hamilton & Hoyt) (Hamilton & Kodylek)	Sioux City	1870s–1890s
Hampton (Hampton & Gamble)	Whittier	1890s–1900s
Harger (Grosvenor & Harger)	Dubuque	?
Harper, Christopher C. (1848–1928)	Audubon	1880s–1890s
Harper, Otis L.	Bancroft	1890s
Harvey, Mrs. H. P.	Maquoketa	1870s–1880s
Harwood, Burritt (1855–?) (Harwood & Mooney)	Charles City	1880s
Hassel, N.	Decorah	1870s?
Hawkes, E. M.	West Union	1880s–1890s
Hickox, R. A.	Waterloo	1870s
Hildreth (Hildreth, Young & Co.)	Clinton	1870s–1880s?
Hill, George (1840–?) (Monfort & Hill) (Schoonmaker & Hill)	Burlington	1870s–1890s
Holbrook, N. M. (Holbrook & Slocum)	Charles City	1870s–1880s
	Nora Springs	1870s
Holden, Herman T.	Keota	1880s
Holmes, Benjamin A.	Hampton	1900s
Hoot, Howard S. (Hoot & Read)	Waterloo	1870s–1880s
	Morning Sun	1880s–1890s
	Adair	

PHOTOGRAPHER	TOWN	STUDIO EXISTED
Hopkins, F. E.	Wyoming	1890–1900
Horton, J. A.	West Des Moines	1880s
Houghton, Amasa A. (Houghton & Powell)	Lansing	1880s
Hover, E. O. (1839–1916?) (Hover & Wyer)	Decorah	1880s
Hoyt	Sac City	?
Hoyt, B. F. (1853–1902?)	Manchester	1890s
Hoyt, Charles Franklin (1842–?) (Hamilton & Hoyt)	Sioux City	1870s
Hudson, Joseph L. (1828–1906)	Tama	1880s–1890s
Huffman, Chasta M. Baird (P. C. Huffman & Lady)	Waukon	1870s
Huffman, Perrin Cuppy (1854–1894)	Waukon	1870s–1890s
(P. C. Huffman & Lady) (Huffman & Barnard)	Frankville	
(P. C. Huffman & Son)		
Hunter, William (1842–1910) (Fosnot & Hunter)	Keosauqua	1880s–1890s
Hutchings, S. H.	Hamburg	1870s–1880s
	Villisca	1880
Illingsworth (Gurnsey & Illingsworth)	Sioux City	1870s?
Jacoby, J. Frank (Jacoby & Barnes)	West Liberty	1890s
James	Des Moines	1880s–1890s
James, William Henry (1857–1937?)	Iowa City	1874–1909
Jarvis, Benjamin (1836?–?) (Manville & Jarvis)	Marshalltown	1870s–1880s
Jessup, S. E. (Beverage & Jessup)	Marshalltown	1890s
Johnson, John E.	Sioux City	1880s–1890s
Johnson, P.	Rockford	1870s?

PHOTOGRAPHER	TOWN	STUDIO EXISTED
Jones, C. E. (Jones & Elliott)	Davenport	1870s–1880s
Jones, J. G. F.	Muscatine	1880s
Jones, Paul B.	Davenport	1865–1870
Jordan, Henry A. (1837–?) (Jordan & Macy)	Vinton	1870s
	Cedar Rapids	1870s
	Cedar Falls	1870s–1880s
	Dubuque	1880s–1890s
Julius, E. D.	Manson	?
Kellett, T. A.	La Porte City	1880s
Kennedy, Arthur L. (Barnes & Kennedy)	Newton	1870s
Kent, Frederick W.	Iowa City	1920s–1970s
Keyser	Belle Plaine	1880s–1890s
Kilborn, William Franklin (1854–?)	Cedar Rapids	1870s–1890s
(F. W. Kilborn & Ritenburg)		
Kilbourne, James F.	Tipton	1870s–1880s
King, Johnson P. (1849–1930?)	Waterloo	1886–1912
(Simmons, Latier & King)		
Kirk, Horace P. (Hod)	Mason City	1870s–1880s
Kline, E. R.	Sioux City	1871–1891
Kodylek, John (Hamilton & Kodylek)	Sioux City	1870s
Kramer, Isaac W.	Des Moines	1880s–1890s
Lancaster, Hahnemann	Cedar Falls	1880s–1890s
Latier, James D. (1848?–1926)	Waterloo	1880s–1900s
(Simmons, Latier & King)		

PHOTOGRAPHER	TOWN	STUDIO EXISTED
Leach, F. M.	Fort Dodge	1880s?
Leisenring, James B.	Fort Dodge	1873–1880s
	Mount Pleasant	1860s
Leisenring & Bros. (John R., W. Kare, Joseph)	Mount Pleasant	1860s–1890s
Lewis, M. C.	Des Moines	1870s
Libby, Evelen Porter	Keokuk	1860s–1880s
Little, Ernest	Oskaloosa	1870s
Little, Hiram N.	Oskaloosa	1870s?
Littlefield, Charles E.	Anamosa	1880s
Lohrer, O. F.	Dubuque	1870s
Lovell, John S. (1844?–?)	Davenport	1870s–1880s
Mac Arthur, M. H.	Hopkinton	1900s
Macy, Oliver W. (1850–?) (Jordan & Macy)	Cedar Falls	1870s–1880s
	Vinton	
	Cedar Rapids	
	Belle Plaine	
	Dysart	
Manville, W. A. (Manville & Jarvis)	Marshalltown	1870s
Martin, J. Paul (1846?–?)	Boone	1870s–1890s
Mather, Henry S. (1836–1908)	Clear Lake	1880s
McAdam Brothers (James & William)	Mount Pleasant	1870s–1880s
McCarty, J. H.	Hiteman	1900
McKay, Arthur L.	Decorah	1880s
	Cresco	

PHOTOGRAPHER	TOWN	STUDIO EXISTED
McManus, C. C.	Nevada	1870s
Melendy, C. B.	Cedar Falls	1870s
Miles, Joseph A. (Miles & Greenlee)	Belle Plaine	1880s
Miles, Wm.	West Branch	1860s?
Mill, Bert P.	Correctionville	1900s
Miller, Clinton U.	Davenport	1880s
Miller, John W. (1858−1898) or Jacob W. (1841−1907)	Anamosa	1870s−1880s
Mills, Charles B. (1858−1924)	Manchester	1870s−1890s
Monfort, Aschylus (Monfort & Hill)	Burlington	1860s−1890s
Mooney, John Arthur (1857−?) (Harwood & Mooney)	Charles City	1880s−1890s
Moore	Newell	1880s
Moran, Edgar	Ackley	1860s−1880s
	Red Oak	
Morgan, G. W.	Lansing	1860s−1870s
Morlan, Micazah M. (Morlan & Nichols)	Clinton	1880s
Morrison, Martin (1860−1895)	Ames	1884−1891
Mott, Merritt Morgan (1844−1910)	Anamosa	1860s−1890s
Moxley, Almon E.	Boone	1910s
Mueller, Jos.	Council Bluffs	1860s−1870s
Neff (Scarff & Neff)	Pella	1880s
Nelson, N. A.	Dike	1890s
Newbury, C. S.	Davenport	1870s−1880s
Newton, John J.	Council Bluffs	1880s

PHOTOGRAPHER	TOWN	STUDIO EXISTED
Nichols, George B. (Morlan & Nichols)	Clinton	1880s
Niconlin, Joseph F.	Algona	1870s–1890s
Norton, A. C.	Monona	1880s–1890s
Nott, Arthur	Maquoketa	1870s–1880s
Oberholtzer, J. W.	Webster City	1880s
Olmstead, Philander O.	Davenport	1860s–1870s
Orr (Thomas & Orr)	Columbus Junction	1870s–1880s
Orvis, James R.	Fayette	1880s–1890s
	Decorah	
	West Union	
	Brush Creek	
Owens, M. W.	Washington	1870s
Oyloe, Gilbert G. (?–1927)	Ossian	1880s–1890s
Palmer	Lansing	1870s
Palmer, S. D.	Marshalltown	1880s
Parker, Damascus	Humboldt	1870s–1890s
Parson, J. R.	Wheatland	?
Peavey, Louis	McGregor	1870s–1880s
	Ossian	
	Decorah	
Perry, Henry B.	Le Mars	1880s
Phelps, Joseph P.	Muscatine	1860s–1890s
Phillips, J.	Fort Madison	1870s

PHOTOGRAPHER	TOWN	STUDIO EXISTED
Phillips, L. H.	Independence	1880s–1890s
Pierce, Norman E.	Waverly	1870s–1890s
	Hopkinton	1860s
Pinckney, J. W.	Sioux City	1870s
Post, A. B.	Ottumwa	1870s–1880s
Powell (Houghton & Powell)	Lansing	1870s–1880s
Pratt, F. W. (James & Pratt)	Des Moines	1880s
Read (Smith and Read)	Osceola	1870s–1880s
Read, Luther B. (Hoot & Read)	Waterloo	1870s–1880s
	Waverly	1897
	Ames	1892
Reed, James H. (1836–?)	Clinton	1870s–1890s
Relf Brothers (James T. & Will)	Decorah	1870s–1880s
Reuvers, J. H. (Reuvers & Scarff)	Pella	1880s–1890s
	New Sharon	1884
	Marion	1880–1882
Reynolds & Co. (Albert C. & Frank M.)	Harlan	1880s
	Des Moines	1879
	Griswold	
Reynolds, Bartley J. (1853–1927)	Decorah	1890s
Reynolds, Hugh M.	Alden	1870s–1880s
Rice, H. B.	Lovilia	1880s
Rich, James E.	Charles City	1870s–1880s

PHOTOGRAPHER	TOWN	STUDIO EXISTED
Rifenburg, Alonzo G. (W. F. Kilborn & Rifenburg)	Cedar Rapids	1870s
Ritcher, William C.	Sioux City	1880s–1890s
	Hamburg	1880s
Robinson	Bedford	?
Roblin, Frank F. (1854?–?)	Spirit Lake	1880s
	Ackley	1880–1882
Rood, Wm. J.	Spencer	1880s
Root, Samuel (1820–1889)	Dubuque	1860s–1880s
Roth, E. H.	Strawberry Point	1900s
Samson, Lou Colbeigh (1835–?)	Osage	1860s–1880s
Samson, William H. (1831–1885)	Osage	1860s–1880s
Sayre, John S. (Sayre & Turlburt)	Des Moines	1870s–1880s
Scarff (Scarff & Neff) (Reuvers & Scarff)	Pella	1880s
Schaub, Otto	Des Moines	1870s–1880s
Schmidt, Harry	Council Bluffs	1880s–1890s
Schmitt (Scott and Schmitt)	Waterloo	
	Osage	1860–1870s
Schooley, Lydia A. (1839–1923)	Indianola	1879–1890s
Schoonmaker (Schoonmaker & Hill)	Burlington	1880s
Schoonover, Mr. and Mrs. L. W.	Vinton	1880s
Scott, Uriah (Scott and Schmitt)	Waterloo	1860s–1870s
	Osage	
Shanafelt	Sigourney	1870s–1880s

PHOTOGRAPHER	TOWN	STUDIO EXISTED
Shaw, David C.	Maquoketa	1870s–1880s
Shear, S. R. (1832–?)	New Hampton	1875–1880s
	Decorah	
	Ossian	
Shepard, F.	Iowa Falls	1870s?
Sheridan, Charles H.	Council Bluffs	1870s–1890s
Simmons, Vellas L. (1855–1926) (Simmons & Latier)	Waterloo	1880s–1890s
(Simmons, Latier & King)		
Slocum, Orville W.	Clear Lake	1880s
	Nora Springs	1870s
Smith, Dwight	Hopkinton	1900s
Smith, Sylvester	De Witt	1880s
Smith, William H. (Smith & Read)	Osceola	1870s–1880s
Smith, Williard M. (Green & Smith)	Ottumwa	1880s
Sorensen, Claus	Cedar Falls	1880s–1890s
Sperry, George (1821–1902)	Iowa City	1870s–1880s
Stallings, W. F.	Grinnell	1880s
Stark, M. W. (1851–?)	Sioux City	1880s–1890s
Staunton, Edwin A.	Davenport	1870s–1900s
Streuser, Mathias J.	Bellevue	1870s–1880s
Stubbs	Storm Lake	1880s–1890s
Stubbs, C. J.	Marshalltown	1880s
Susong, Joseph D.	Des Moines	1880s–1890s
Swartz, Adam	Stuart	1870s–1890s

PHOTOGRAPHER	TOWN	STUDIO EXISTED
Tewksbury, Joseph R. (1831–?)	Fort Madison	1870s–1890s
Tewksbury, R. W.	Farmington	1870s?
Thomas, George L.	Columbus Junction	1860s–1890s
Thomas, J. W.	Lansing	1870s?
Thornburg, E. R.	Ames	1900s
Tierney, H.	Clinton	1870s?
Townsend, Israel L. (1839–1921)	Iowa Falls	1880s
Townsend, James Arthur	Iowa Falls	1870s–1880s
Townsend, Lewis M.	West Liberty	1880s
	Muscatine	1890
Townsend, Timothy Wesley (1844–1912)	Iowa City	1870s–1890s
Troth, W. H.	Hampton	1870s–1880s
Turlburt (Sayre & Turlburt)	Des Moines	1870s–1880s
Turner, Elmer E.	Rockford	1880s
Twiford, Archibald	Burlington	1860s
Twining, H. N.	Burlington	1860s
Vosburgh, Martin H.	Charles City	1890s
	Osage	1910
Wait, George S. (Brown & Wait)	Sioux City	1890s
Waldron, George F. (Waldron & Wilson)	Marion	1880s
	Keokuk	1889
Walker, Charles L.	Grinnell	1870s–1880s

PHOTOGRAPHER	TOWN	STUDIO EXISTED
Walline, Andrew Larson	Gowrie	1900s
	Ogden	
	Clarion	
Walter, Harvey L. (1833–?)	Manchester	1870s–1890s
Warner, Peter H.	Hopkinton	1860s
	Sand Springs	1860s
	Mount Vernon	1860s
Warrington, A. W.	Oskaloosa	1860s–1880s
Washburn, W. W.	Cresco	1870s–1880s
Webb, Julius Frank	Strawberry Point	1880s
	Coon Rapids	1890s
	Shell Rock	
Weed, Tyler E.	Cedar Rapids	1890s
Wetherby, Isaac A.	Iowa City	1860s–1870s
	Rock Valley	1890s
Whiting	Boone	1870s
Wiggins, Silas T. (1831–1908)	Cedar Rapids	1870s–1890s
Wilkin (Gilbert & Wilkin)	Nashua	1880s
	Charles City	1880s
Williams, Butler S.	Manson	1870s–1880s
Wilson, Fred (?–1934?)	Gravity	1880s
Wilson, John C.	Cherokee	1870s–1890
Wilson, William M. (Waldron & Wilson)	Marion	1880s
	Keokuk	1889
Wiltse, Jerome (Fox & Wiltse)	Osage	1880s

PHOTOGRAPHER	TOWN	STUDIO EXISTED
Winslow, L. B.	Osage	1870s–1880s
	Charles City	1890s
Wise, Samuel H. (1842–1924)	Wilton	1860s–1890s
Wyer (Hover & Wyer)	Decorah	1880s
Young, Edward S.	Cedar Rapids	1876
	Leon	1880s
	Lewis	1884–1887
Young, John W. (Hildreth, Young & Co.)	Clinton	1880s
	Clarence	1890s
	Mechanicsville	1890s

OUT-OF-STATE STEREO PHOTOGRAPHERS

Photographers from other states came to Iowa to take stereographs. Photographers also came as representatives of national stereograph companies, which often distributed stereographs from throughout the United States and from other countries. Out-of-state distributors sometimes commissioned work from local photographers or bought rights to use a copy negative.

PHOTOGRAPHER	TOWN
Bennett, H. H.	Kilbourn City, Wisconsin
Bingham, F. V.	Northfield, Minnesota
Burdick, E. H.	Milton, Wisconsin
Butterfield, L. T.	Prairie du Chien, Wisconsin
Clemmer & Pooler	Austin, Minnesota
Dahl, A. L.	De Forest, Wisconsin
Doremus, John P.	Paterson, New Jersey
Farr, H. R.	Prairie du Chien, Wisconsin
Mangold, J. G.	Rock Island, Illinois
Newberry, C. S.	Rock Island, Illinois
Upton	Minneapolis, Minnesota

COMPANY	TOWN
Charles Bierstadt Company	Niagara Falls, New York
International Stereograph Company	Decatur, Illinois
Keystone View Company	Meadville, Pennsylvania (also New York, Chicago, and London)
B. W. Kilburn Company	Littleton, New Hampshire
PresKo BiNocular Company	Chicago, Illinois
D. E. Smith	Oneida, New York
Underwood & Underwood	Ottawa, Kansas
Universal Photo Art Company	Philadelphia, Pennsylvania (and Naperville, Illinois)

BIBLIOGRAPHY

IOWA HISTORY

A. T. Andreas Illustrated Historical Atlas of the State of Iowa, 1875. Chicago: Andreas Atlas Company, 1875.

Atherton, Lewis. *Main Street on the Middle Border.* Bloomington: Indiana University Press, 1954.

Atlas History of Allamakee County, Iowa from 1859 to 1978. Evansville, Ind.: Unigraphics, 1982.

Beebee, Lois. *The Farmer's Daughter, A True Story.* Tyler, Tex.: Intermedia, 1985.

Bennett, Mary. *An Iowa Album: A Photographic History, 1860 –1920.* Iowa City: University of Iowa Press, 1990.

Biographical History of Page County, Iowa. Chicago: Lewis and Dunbar Publishers, 1890.

The Biographical Record of Linn County, Iowa, part 2. Chicago: S. J. Clarke Publishing Co., 1901.

The Biographical Record of Linn County, Iowa, vol. 2. Chicago: Pioneer Publishing Co., 1911.

Bogue, Allan G. *From Prairie to Corn Belt: Farming on the Illinois and Iowa Prairies in the Nineteenth Century.* Chicago: Quadrangle Books, 1963.

Dawson, Patricia, and David Hudson, comps. *Iowa History and Culture: A Bibliography of Materials Published between 1952 and 1986.* Ames: State Historical Society of Iowa in conjunction with the Iowa State University Press, 1989.

Fort Madison Illustrated. Fort Madison: Democrat Steam Press, 1887.

Gue, Benjamin F. *History of Iowa.* 4 vols. New York: Century History Company, 1903.

Harlan, Edgar R. *A Narrative History of the People of Iowa.* 5 vols. Chicago: American Historical Society, 1931.

History of Buchanan County, Iowa. Williams Bros., 1881.

History of Butler and Bremer Counties, Iowa. Springfield, Ill.: Union Publishing Co., 1883.

History of Franklin and Cerro Gordo Counties, Iowa. Springfield, Ill.: Union Publishing Co., 1883.

History of Hardin County, Iowa. Springfield, Ill.: Union Publishing Co., 1883.

The History of Iowa County, Iowa. Des Moines: Union Historical Co., 1881.

History of Jones County, Iowa, vol. 2. Chicago: S. J. Clarke Publishing Co., 1910.

History of Linn County, Iowa, vol. 2. Chicago: S. J. Clarke Publishing Co., 1911.

History of Muscatine County, Iowa, Biographical, vol. 2. Chicago: S. J. Clarke Publishing Co., 1911.

The History of Warren County. Des Moines: Union Historical Co., 1879.

Iowa State Gazetteer and Business Directory (1880–81).

Lingeman, Richard. *Small Town America: A Narrative History 1620–Present.* New York: G. P. Putnam's Sons, 1980.

Noun, Louise R. *Strong-Minded Women: The Emergence of the Woman-Suffrage Movement in Iowa.* Ames: Iowa State University Press, 1969.

Percival, C. S., and Percival, Elizabeth, eds. *History of Buchanan County Iowa, with Illustrations and Biographical Sketches.* Cleveland: Williams Bros., 1881.

Persons, Stow. *American Minds.* Huntington, N.Y.: Robert E. Krieger, 1975.

Petersen, William J. *Iowa History Reference Guide.* Iowa City: State Historical Society of Iowa, 1952.

Portrait and Biographical Album of Benton County, Iowa. Chicago: Chapman Bros., 1887.

Portrait and Biographical Album of Polk County, Iowa. Chicago: Lake City Publishing Co., 1890.

Carrie Dean Pruyn Collection, State Historical Society of Iowa, Iowa City.

Rifkind, Carole. *Main Street: The Face of Urban America.* New York: Harper and Row, 1977.

Riley, Glenda. *Frontierswomen: The Iowa Experience.* Ames: Iowa State University Press, 1981.

Sage, Leland L. *History of Iowa.* Ames: Iowa State University Press, 1974.

Schwieder, Dorothy. *Iowa: The Middle Land.* Ames: Iowa State University Press, 1996.

Springer, Arthur. *History of Louisa County Iowa.* 2 vols. Chicago: S. J. Clarke Publishing Co., 1912.

Isaac A. Wetherby Collection, State Historical Society of Iowa, Iowa City.

HISTORICAL PHOTOGRAPHY

American Stereographs: A Selection from Private Collections. New York: Grey Art Gallery, 1980.

Anderson, Arthur J. *The Artistic Side of Photography: In Theory and Practice.* New York: Arno Press, 1973.

Andrews, Ralph W. *Photographers of the Frontier West: Their Lives and Works, 1875 to 1915.* Seattle: Superior Publishing Company, 1965.

Borchert, James. "Analysis of Historical Photographs: A Method and a Case Study." *Studies in Visual Communication* 7, no. 4 (Fall 1981): 30–63.

———. "Historical Photo-Analysis: A Research Method." *Historical Methods* 15, no. 2 (Spring 1982): 35–44.

———. "Photographs and Historical Research: Prospects and Problems." Unpublished paper from Conference on Photographs and History, Center for the Study of Recent History of the United States, University of Iowa, April 21–22, 1989. Copy at State Historical Society of Iowa.

Brey, William. *Carbutt, John: On the Frontiers of Photography*. Cherry Hill, N.J.: Willowdale Press, 1984.

Buckland, Gail. *Reality Recorded: Early Documentary Photography*. Greenwich, Conn.: New York Graphics Society, 1974.

Burgess, N. G. *The Photograph Manual: A Practical Treatise, Containing the Carte de Visite Process, and the Method of Taking Stereoscopic Pictures*. New York: Arno Press, 1973.

Carter, John E. "The Trained Eye: Photography and Historical Context." *Public Historian* 15, no. 1 (Winter 1993).

Darrah, William C. *Cartes de Visite in Nineteenth Century Photography*. Gettysburg, Pa.: W. C. Darrah, 1981.

———. *The World of Stereographs*. Gettysburg, Pa.: W. C. Darrah, 1977.

Darrah, William C., and T. K. Treadwell. *Stereographers of the World*. Vol. 2, *United States*. Columbus: National Stereoscopic Association, 1994.

Directory of Civil War Photographers. Vol. 3, *Western States and Territories*. Baltimore: Ross J. Kelbaugh Historic Graphics, n.d.

Earle, Edward W., ed. *Points of View: The Stereograph in America—A Cultural History*. Rochester, N.Y.: Visual Studies Workshop, 1979.

Doremus Floating Down the Mississippi: A Work Descriptive of the Past and Proposed Journeyings of an Artist engaged in Photographing the Magnificent Scenery Along the Father of Waters, 1877 pamphlet quoted in *S&D Reflector*, March 1988.

Ford, Colin, ed. *The Kodak Museum: The Story of Popular Photography*. London: Century, 1989.

Hanging Out: Stereographic Prints from the Collection of Samuel Wagstaff, Jr. at the J. Paul Getty Museum. Providence: Brown University, 1984.

Howarth-Loomes, B. E. C. *Victorian Photography: An Introduction for Collectors and Connoisseurs*. New York: St. Martin's Press, 1974.

Journal of the West (January 1989).

Judge, Arthur W. *Stereoscopic Photography*. Boston: American Photographic Publishing Company, 1926.

Juhl, Paul C. "'The Brigade of Beauty in Advertising Costumes': Merchants' Carnivals in Iowa." *Iowa History Illustrated* 77, no. 4 (Winter 1996): 146–51.

———. "J. P. Doremus and His Floating Photograph Gallery." *Palimpsest* 73, no. 2 (Summer 1992): 62–83.

Loke, Margarett. *The World As It Was, 1865–1921: A Photographic Portrait from the Keystone-Mast Collection*. New York: Summit Books, 1980.

Mace, O. Henry. *Collector's Guide to Early Photographs*. Radnor, Pa.: Wallace-Homestead Book Company, 1990.

Malan, Nancy E. "Interpreting Historical Photographs: Pitfalls and Possibilities." *Picturescope* 26, no. 1 (Spring 1980): 9–11, 22.

Morgan, Willard D. *Stereo Realist Manual*. New York: Morgan and Lester, 1954.

Moss, George H., Jr. *Double Exposure: Early Stereo-graphic Views of Historic Monmouth County, New Jersey, and Their Relationship to Pioneer Photography.* Sea Bright, N.J.: Ploughshare Press, 1971.

Murray, Janet, and Julia Van Haaften. "American Victorianism through the Stereoscope." *Humanities* (July/August 1991).

Newhall, Beaumont. *The Daguerreotype in America,* 3d ed. New York: Dover, 1976.

———. *The History of Photography,* completely revised and enlarged edition. New York: Museum of Modern Art, 1982.

Noble, Mary L. "Iowa's Woman Professional Photographers." *Books at Iowa,* no. 65 (November 1996): 2–16.

Ostroff, Eugene. *Western Views and Eastern Visions.* Washington, D.C.: Smithsonian Institution Traveling Exhibition Service, 1981.

Palmquist, Peter E. *J. J. Reilly: A Stereoscopic Odyssey, 1838–1894.* Yuba City, Calif.: Community Memorial Museum, 1989.

Paxson, Richard. "Des Moines: 1870s in Three Dimensions." *Des Moines Sunday Register,* November 6, 1993.

Ries, Scott J. "Photographers and City Photographs." Unpublished manuscript.

Robinson, Henry P. *Letters on Landscape Photography.* New York: Arno Press, 1973.

Scharf, Aaron. *Art and Photography.* Baltimore: Penguin Books, 1974.

Schlereth, Thomas J. *Artifacts and the American Past.* Nashville: American Association for State and Local History, 1980.

Seale, William. *The Tasteful Interlude: American Interiors through the Camera's Eye.* New York: Praeger Publishers, 1975.

Taft, Robert. *Photography and the American Scene: A Social History, 1839–1889.* New York: Dover, 1964.

Talbot, George. *At Home: Domestic Life in the Post-Centennial Era, 1876–1920.* Madison: State Historical Society of Wisconsin, 1976.

Thomas, Alan. *Time in a Frame: Photography and the Nineteenth-Century Mind.* New York: Schocken Books, 1977.

Trachtenberg, Alan. "Introduction: Photographs as Symbolic History." *The American Image: Photographs from the National Archives, 1860–1960.* New York: Pantheon Books, 1979.

Vanderbilt, Paul. *Evaluating Historical Photographs: A Personal Perspective.* AASLH Technical Leaflet 120. Nashville: American Association for State and Local History, 1979.

Wajda, Shirley. "A Room with a Viewer: The Parlor Stereoscope, Comic Stereographs, and the Psychic Role of Play in Victorian America." In Kathryn Grover,

ed., *Hard at Play: Leisure in America, 1840–1940*. Amherst: University of Massachusetts Press, 1992.

Wall, Alfred H. *Artistic Landscape Photography*. New York: Arno Press, 1973.

Weinstein, Robert A., and Larry Booth. *Collection, Use, and Care of Historical Photographs*. Nashville: American Association for State and Local History, 1979.

Welling, William B. *Collectors' Guide to Nineteenth-Century Photographs*. New York: Macmillan, 1976.

———. *Photography in America: The Formative Years, 1839–1900*. New York: Thomas Y. Crowell Company, 1978.

Wendorf, Richard. "The Artful Encounter." *Humanities* (July/August 1993): 9–12.

Wilkie, William E. *Dubuque on the Mississippi, 1788–1988*. Dubuque: Loras College Press, 1987.

Witt, Bill. "The Photographic Legacy of D. C. Hale." *Iowan*, March 1978, pp. 36–43.

INDEX

OTHER BUR OAK BOOKS OF RELATED INTEREST

"All Will Yet Be Well":
The Diary of Sarah Gillespie Huftalen, 1873–1952
 By Suzanne L. Bunkers

A Country So Full of Game:
The Story of Wildlife in Iowa
 By James J. Dinsmore

The Folks
 By Ruth Suckow

An Iowa Album: A Photographic History, 1860–1920
 By Mary Bennett

More han Ola og han Per
 By Peter J. Rosendahl

Nineteenth Century Home Architecture of Iowa City:
A Silver Anniversary Edition
 By Margaret N. Keyes

Nothing to Do but Stay: My Pioneer Mother
 By Carrie Young

Old Capitol: Portrait of an Iowa Landmark
 By Margaret N. Keyes

A Place of Sense: Essays in Search of the Midwest
 Edited by Michael Martone

Sarah's Seasons: An Amish Diary and Conversation
 By Martha Moore Davis

"A Secret to Be Burried": The Diary and Life of Emily
Hawley Gillespie, 1858–1888
 By Judy Nolte Lensink

State Fair
 By Phil Stong

The Tattooed Countess
 By Carl Van Vechten

"This State of Wonders": The Letters of an Iowa Frontier
Family, 1858–1861
 Edited by John Kent Folmar

Townships
 Edited by Michael Martone

Was This Heaven? A Self-Portrait of Iowa
on Early Postcards
 By Lyell D. Henry, Jr.

Weathering Winter: A Gardener's Daybook
 By Carl H. Klaus